PICASSO'S PICASSOS

AN EXHIBITION FROM THE MUSÉE PICASSO, PARIS

Selected by
Sir Roland Penrose
Dr John Golding
M. Dominique Bozo *Conservateur du Musée Picasso*

Hayward Gallery, London

17 July – 11 October 1981

Arts Council
OF GREAT BRITAIN

Exhibition organised by Susan Ferleger Brades,
assisted by Evie Chondros

Catalogue edited by Michael Raeburn
Designed by Dennis Bailey
Printed in England by Westerham Press Limited

ISBN Soft cover 0 7287 0281 9
ISBN Hard cover 0 7287 0282 7

Colour photographs for catalogue numbers 209, 255,
279, 280, 281 and black-and-white photographs for
numbers 375, 376, 393, 401, 408, 409, 439 Strüwing,
Birkerød, Denmark.
All other colour and black-and-white photography by
Réunion des Musées Nationaux, Paris.

A list of Arts Council publications, including all
exhibition catalogues in print, can be obtained from
the Publications Officer, Arts Council of Great Britain,
105 Piccadilly, London W1V 0AU.

Contents

ACKNOWLEDGEMENTS

There is nothing quite like a Picasso exhibition! The recent and magnificent retrospective staged by the Museum of Modern Art in New York confirmed his preeminent place in the public's imagination. And yet Picasso exhibitions are fewer than one might suppose. The present exhibition, taking place in Picasso's centenary year, is the first major presentation of his work in Britain since the Arts Council's shows of paintings in 1960 and sculpture in 1967 at the Tate Gallery. As such it offers a unique opportunity to a new generation of gallery visitors in this country, an opportunity which we owe to the exceptional generosity of our colleagues in France. Our first and most important acknowledgement is therefore to M. Hubert Landais, Directeur des Musées de France, and to M. Dominique Bozo, Conservateur du Musée Picasso, for having made available a major part of the works from Picasso's personal collection which were acquired by the French state after his death and which will form the future Musée Picasso at the Hôtel Aubert de Fontenay (Hôtel Salé) in Paris. M. Bozo's sympathetic collaboration has been fully supported by that of Mlle. Michèle Richet, whose helpfulness and efficiency has ensured the smooth running of all the arrangements, and of her colleagues, Mlle. Paule Mazouet, Mlle. Catherine David and M. Jean Habert. We would also like to record our special thanks to Mlle. Irène Bizot, Administrateur délégué de la Réunion des Musées Nationaux for her advice and help. We would also like to express our appreciation of the interest and support we have received from His Excellency the French Ambassador, M. Emmanuel de Margerie.

The exhibition has been selected by Sir Roland Penrose and Dr John Golding in consultation with M. Bozo. Neither Sir Roland nor Dr Golding needs any introduction, for they have both contributed decisively to our knowledge and appreciation of Picasso. It has been the happiest of collaborations and we are greatly in their debt. The installation of the exhibition has also been planned by Roland Penrose and John Golding in consultation with David Sylvester, Chairman of the Art Advisory Panel of the Arts Council, and with John Miller and Richard Brearley of Colquhoun and Miller Architects.

Our catalogue has been devised in two parts, the first of which contains contributions from Dominique Bozo on the history and future of the Musée Picasso and from Timothy Hilton on the paintings and sculpture in the exhibition. Mr Hilton's essay is intended to link these works with the life of the artist and does so with considerable erudition and readability, a sadly uncommon conjunction. The second part reproduces all of the exhibited drawings, many hitherto unpublished, and is introduced by Roland Penrose. We have been fortunate in preparing our catalogue to be able to rely to a great extent on the information contained in the catalogues of the recent Paris and New York exhibitions.

On the occasion of the exhibition the Arts Council has also published an anthology of reminiscences, documents and critical writings on Picasso, which has been edited by Marilyn McCully.

The exhibition comes to the Hayward Gallery after a most successful showing at the Louisiana Museum in Denmark and we have throughout worked closely with Knud Jensen, Director of the Museum, and his colleague Steingrim Laursen. To everyone else involved, not least to our editor Michael Raeburn, we offer our most grateful thanks.

Joanna Drew *Director of Art*

FOREWORD

The recent entry into the French national collections of a large number of works from the Picasso legacy is an event of international importance. A distinctive group of masterworks has been assembled, honouring the most celebrated artist of the century.

It was decided that immediately following its first showing, at the Grand Palais in Paris, a selection from this collection should be shown in two American museums, the Walker Art Center in Minneapolis and the Museum of Modern Art in New York, and in two places in Europe, the Louisiana Museum in Denmark and the Arts Council of Great Britain's Hayward Gallery in London. In making this group of works available, the French government is pleased to offer the American and European public the opportunity to see many of the most important pieces that will subsequently be installed in the new Musée Picasso, whose site will be the Hôtel Salé in the Marais district.

Although other French collections already contain important works by Picasso (the Musée d'Art Moderne and the Walter Guillaume collection in Paris, and the municipal museums of Antibes, Grenoble and Vallauris), it nevertheless became evident that France should establish a museum in Paris dedicated to the study and comprehensive presentation of Picasso's work.

A rigorous and representative selection of the masterpieces of the future Picasso museum was entrusted to the four art galleries, but several exceptional works had to remain in Paris because of the delicate conservation problems posed by their transport; those the public will eventually be able to see installed in the new museum.

The collection has a unique origin. For the first time in the history of French museums, a law passed on 31 December 1968 enabled the government to accept works of art in lieu of death duties. This has allowed us to assemble in one action an extraordinary group of works. Five years were required to overcome the many obstacles related to so complex an inheritance situation. Among these were the total lack of an inventory of objects stored in Picasso's various residences, as well as the difficulty of choosing cohesive groups of works of high quality that would reflect the heterogeneous character of Picasso's production. Such an awesome project could not have been realized without the support of government officials, including M. Maurice Aicardi, Président de la Commission Interministérielle d'Agrément, the cooperation of the heirs – especially the constant assistance of Madame Jacqueline Picasso – and, during the selection process, the thorough expertise of Jean Leymarie and Dominique Bozo.

As a result of such efforts the public can now contemplate works of art which speak for themselves and, better than any written commentary, render the homage due to Picasso.

Hubert Landais *Directeur des Musées de France*

9

Our friends in Britain know Picasso's work so well that they will fully understand the importance of the exhibition that they are now able to see and the exceptional effort it represents on the part of the authorities of the Musées de France. They recognise this, because on the occasion of the centenary of Picasso's birth they are again honouring him, as they have in the past, notably in the important exhibitions organised by Sir Roland Penrose. Picasso recognised this honour, and although he was always reluctant to part with the historic works in his own collection, he nevertheless allowed the Tate Gallery to acquire that great masterpiece *The Dance*, thanks again to Sir Roland's friendly persuasion.

When, in 1979, the French nation became the owner of the amazing collection which comprises the greater part of what were called 'Picasso's Picassos', it was decided to allow the public to see it at once and not wait for the opening of the museum in which it was to be housed. Many people, especially artists, were astonished by the revelation of one of the most extraordinary creative investigations of the present century. As we have pointed out elsewhere, the exhibition at the Grand Palais in Paris was not a retrospective in the usual sense but a presentation 'in the raw' of the *grand atelier* which contained the painter's personal collection. Although his most famous works were already in museums, the exhibition was in itself an exact and complete reconstruction of the development of the life's work of the artist, displaying all that was needed for the understanding of Picasso's unique and colossal achievement. The myth of his 'facility' was dispelled: what we saw bore witness to the firm, unfaltering determination with which Picasso strove to effect the transformation of the material world, of life and of history, by means of the most diverse media, themes and forms, but always with the aim of freeing himself from the burdensome talent of precocious genius. It was because he was conscious of himself as a twentieth-century Raphael that Picasso vowed to invent, manipulate, transform and endow our civilization with the plastic forms and methods best suited to restore the spiritual and sensual space of the present age, which has been shaken to its foundations by changes whose speed, intensity and extent we know well.

After the Paris exhibition, Minneapolis enjoyed the benefit of a collaboration between the Musée Picasso and the New York Museum of Modern Art. The New York retrospective made possible what will never be seen again, a unique assemblage of almost all the masterpieces, or rather monuments, with which Picasso's career is studded, and which our collection served to place in perspective, to explain and support, or rather to enrich and make still more lucid. Those who saw that memorable exhibition discovered an artist who, like Tintoretto, never ceased to develop, and who remained creative to the last. The revelation of Picasso's last works showed that in his

old age he still made a personal contribution to the most unconventional yet most powerful creative work of the second half of the century. What strikes us today is the energy with which he went on painting and creating, and in so doing integrated the art of the past, his own work and that of his contemporaries and younger artists into a new statement that was personal to himself. We realise too that Picasso was no less an innovator from, say, 1960 onwards than when he was at the height of his powers. The only difference between him and the new generation of artists lies perhaps in his concern for great thematic compositions and also in a difference of 'scale', since Picasso belonged to a generation of artists who did not, like those of today, automatically envisage their work as confined within the spatial limits of a museum.

Paris, Minneapolis and New York – a threefold homage, but varying in intention and content. Paris showed what might be called Picasso's hidden work, above all in its richness. At Minneapolis there was a small but significant choice of exceptional works; a retrospective but not a discursive selection, each work sufficient to itself. Finally, at New York, an almost perfect and unrepeatable collection: a unique experience, inconceivable in the case of any other artist. The present exhibition in London (almost all of which has also been shown at the Louisiana Museum in Denmark) is planned on somewhat different lines. Apart from the major works which it includes, Roland Penrose and John Golding have been at pains to assemble an important collection of Picasso's drawings, illustrating the significance of his work in this medium to his development as an artist, to his dialogue with painting and sculpture, and above all from the point of view of his personal themes. The selection bears witness to these two scholars' exceptional knowledge of Picasso's work. Sir Roland has always been interested in its essential 'human' content, in understanding the problem of artistic creation and the contradictory gifts of a temperament – I would rather say, a 'soul' – which can only be revealed by the artist's genius and which are still far too deep for us to comprehend fully.

The fact that we were working with Roland Penrose, John Golding and Joanna Drew made it easier for us to accede to their wishes and make possible this last exhibition, which the British public deserves perhaps more than any other because of its attachment to Picasso's work. The small team involved in planning the future museum was all the more ready to help despite the pressure of their own work, because they knew that the organisers and compilers of the catalogue would be rendering an important service to scholars and to the public.

This, then, is the last exhibition that will take place before the Musée Picasso is opened in Paris. We have no space here to describe the museum, but all who visit the exhibition should consider themselves invited to it. The confrontation between

Picasso's work and the architecture of the Hôtel Aubert de Fontenay will no doubt be one of the most appropriate and successful in the whole history of art. The contrast between the seventeenth-century building and its contents will provide a synthesis of art history on lines that Picasso himself was one of the first to trace. We should remember that much of his work was itself created in such time-honoured surroundings as these, where Picasso liked to juxtapose his own art with that of the great masters of every age. Moreover, the historical dialogue will be continued over and beyond Picasso's *oeuvre* by the inclusion of his own collection, including major works by Cézanne, Renoir, Matisse and Douanier Rousseau as well as objects of primitive art. Such is the importance of the future museum which will, we hope, open its doors in 1983.

Dominique Bozo *Conservateur du Musée Picasso*

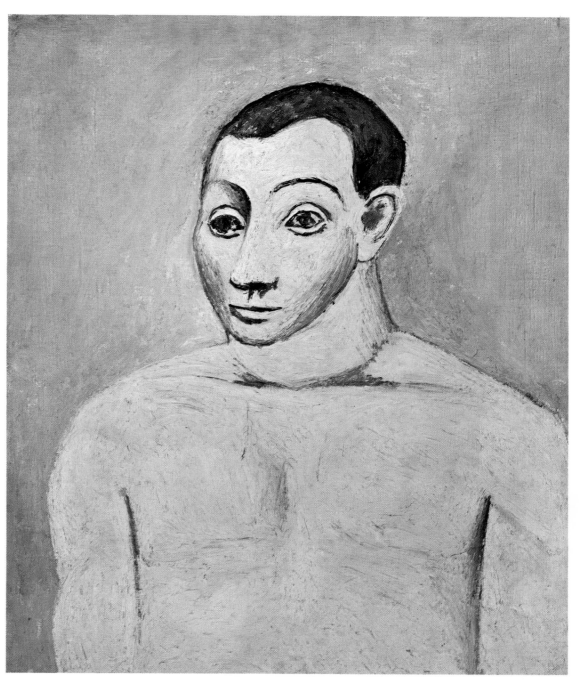

6 Self-portrait. Paris, autumn 1906

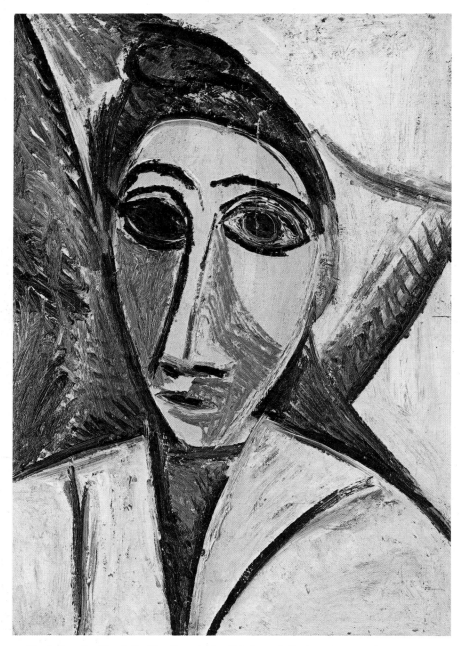

10 Head of a sailor (Study for 'Les Demoiselles d'Avignon'). Paris, spring 1907

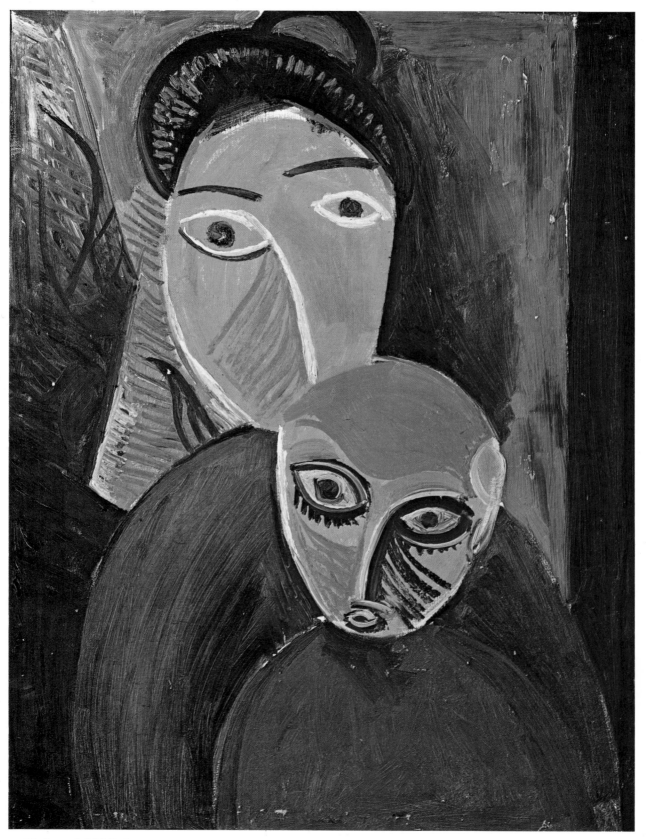

12 Mother and child. Paris, summer 1907

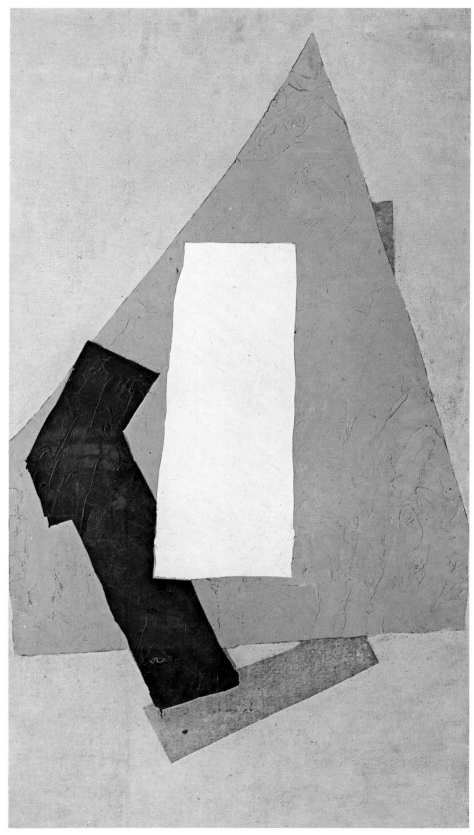

27 Geometric composition: the guitar. [Céret, spring 1913]

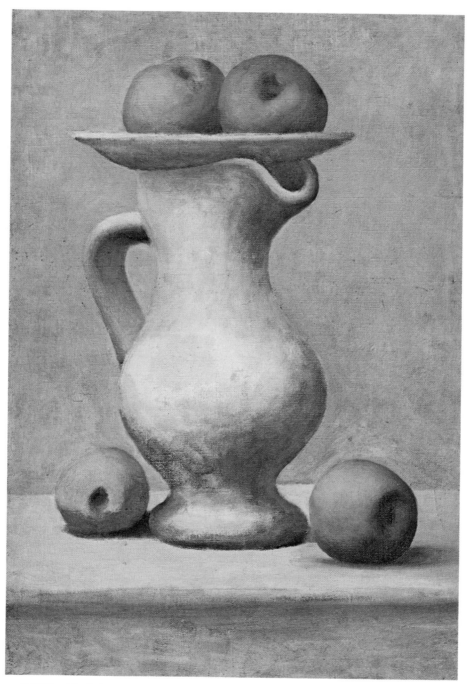

44 Still life with pitcher and apples. [Paris], 1919

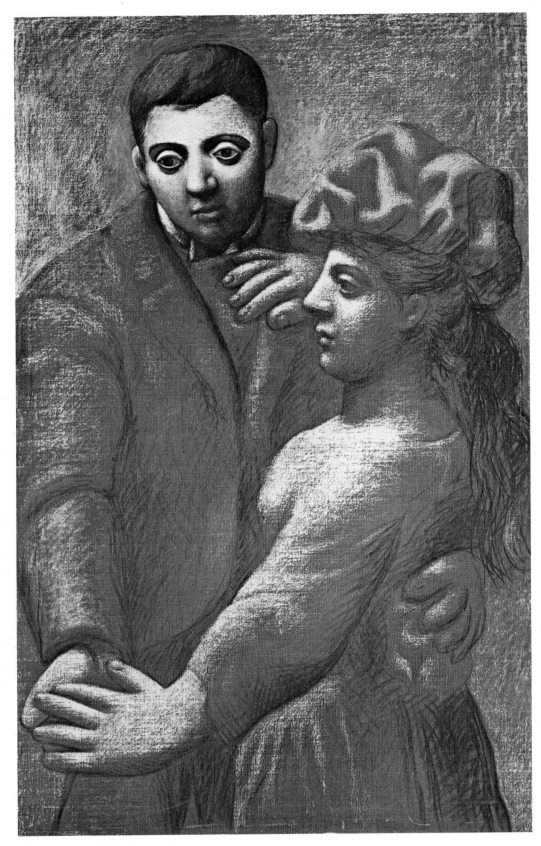

50 Dancing couple. [Paris, 1921–2]

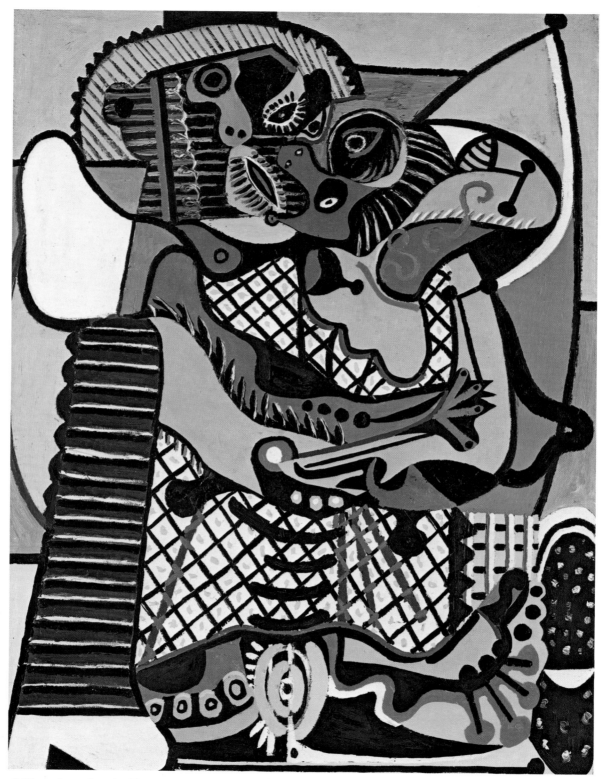

58 The embrace. Juan-les-Pins, summer 1925

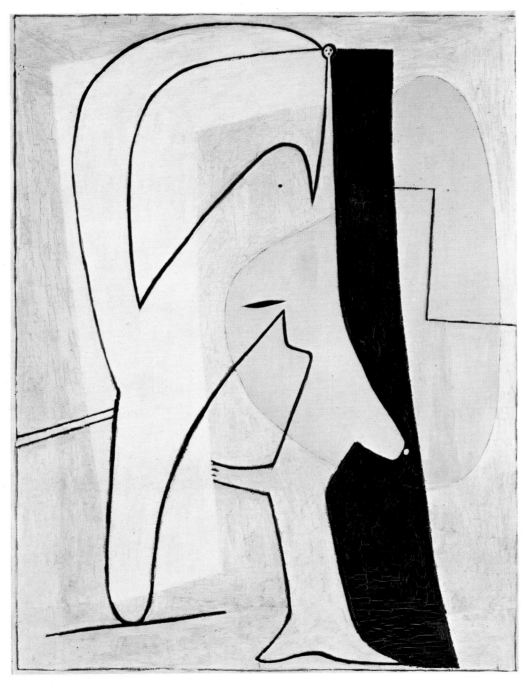

64 Figure. [1927–8]

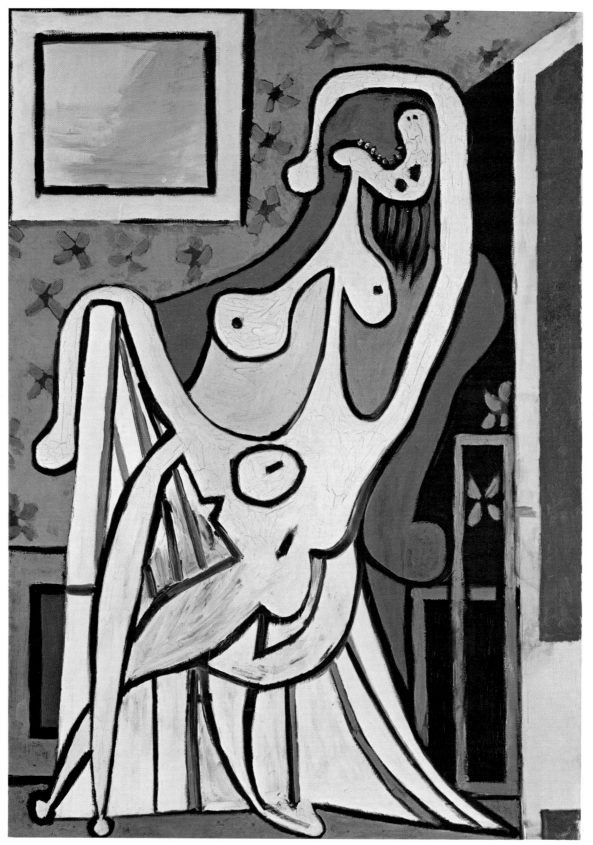

73 Nude in a red armchair. Paris, 5 May 1929

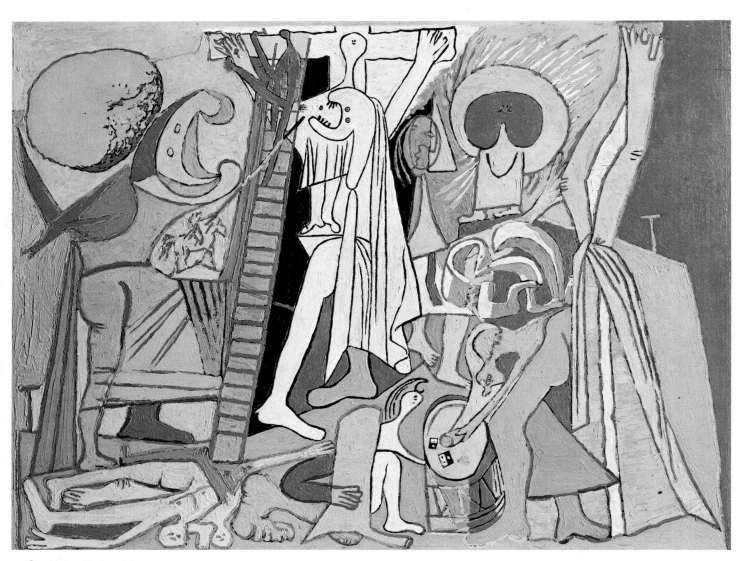

77 Crucifixion. Paris, 7 February 1930

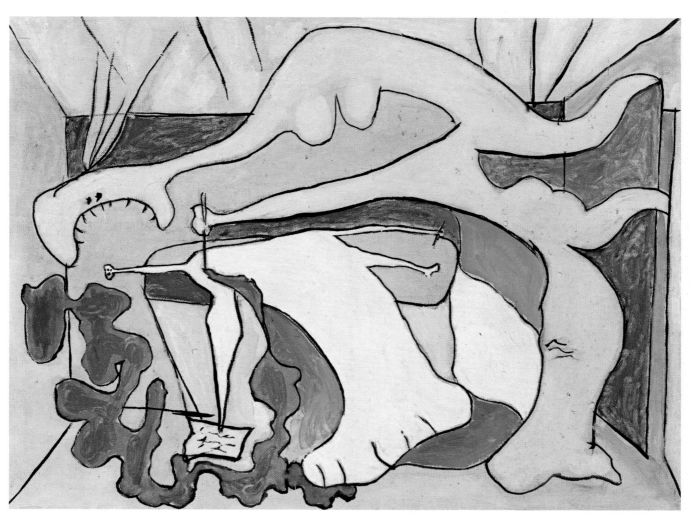

83 Woman with stiletto, after David's 'Death of Marat'. [Paris], 19–25 December 1931

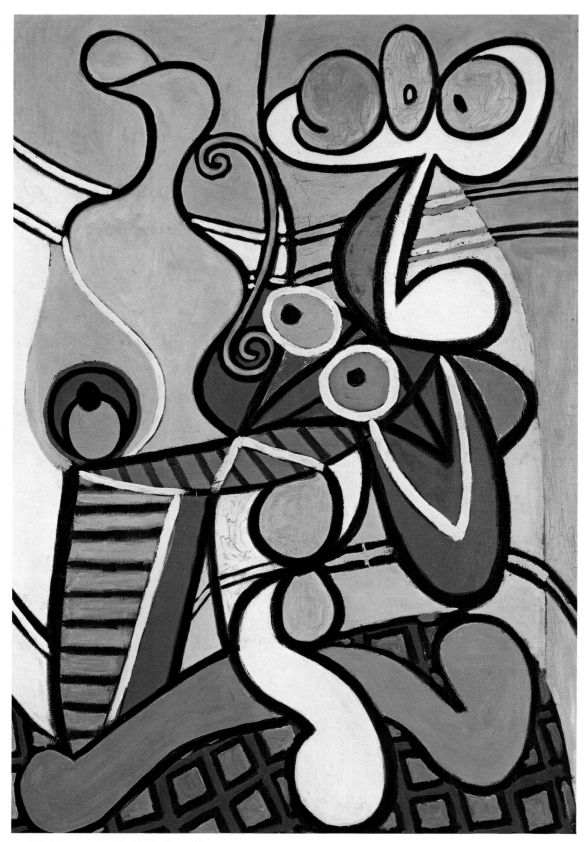

82 Still life on a pedestal table. Paris, 11 March 1931

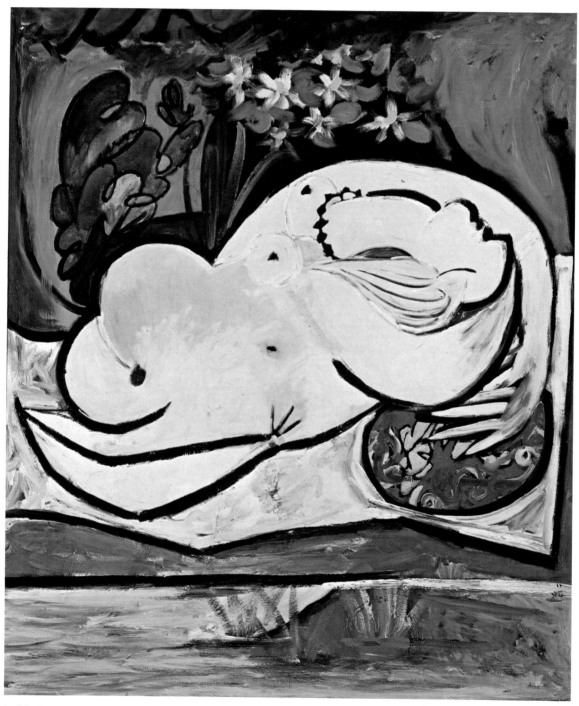

89 Nude asleep in a landscape. Boisgeloup, 4 August 1934

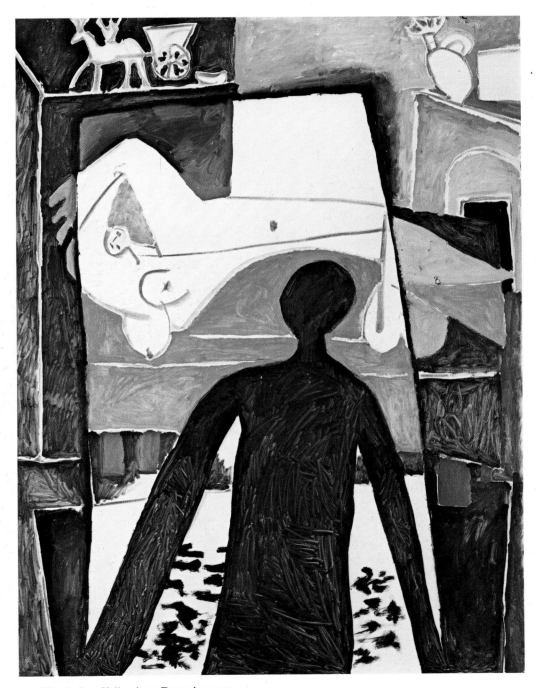

117 The shadow. Vallauris, 29 December 1953

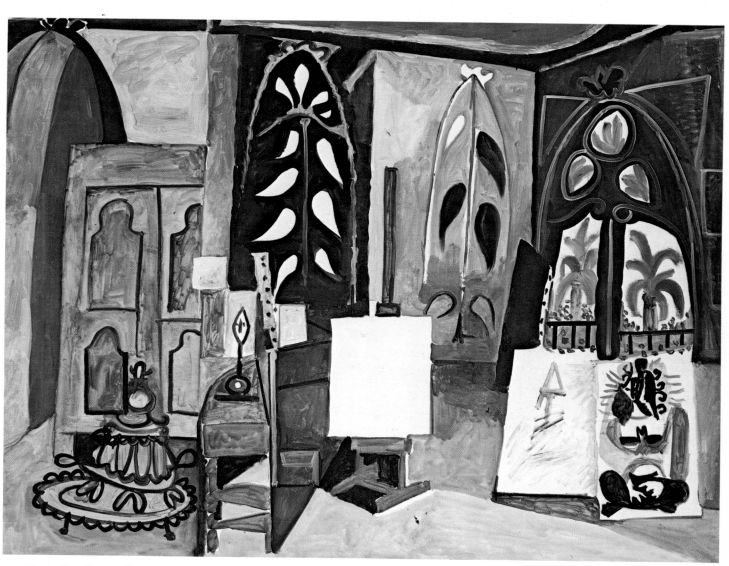

119 The studio at Cannes. Cannes, 30 March 1956

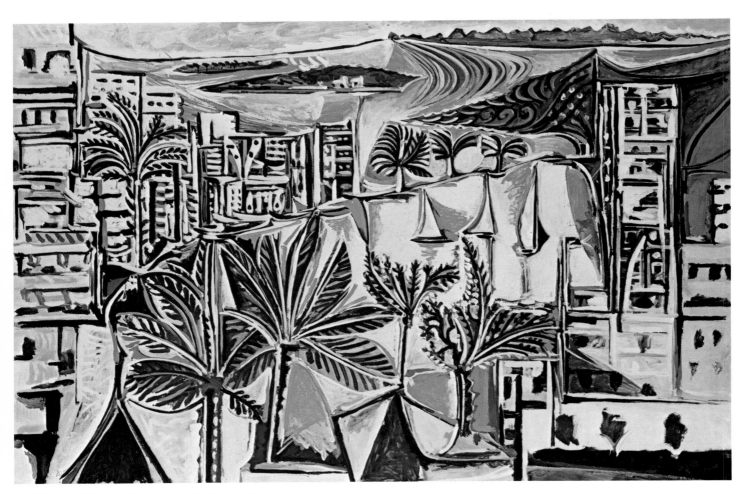

120 The bay of Cannes. Cannes 19 April–9 June 1958

INTRODUCTION

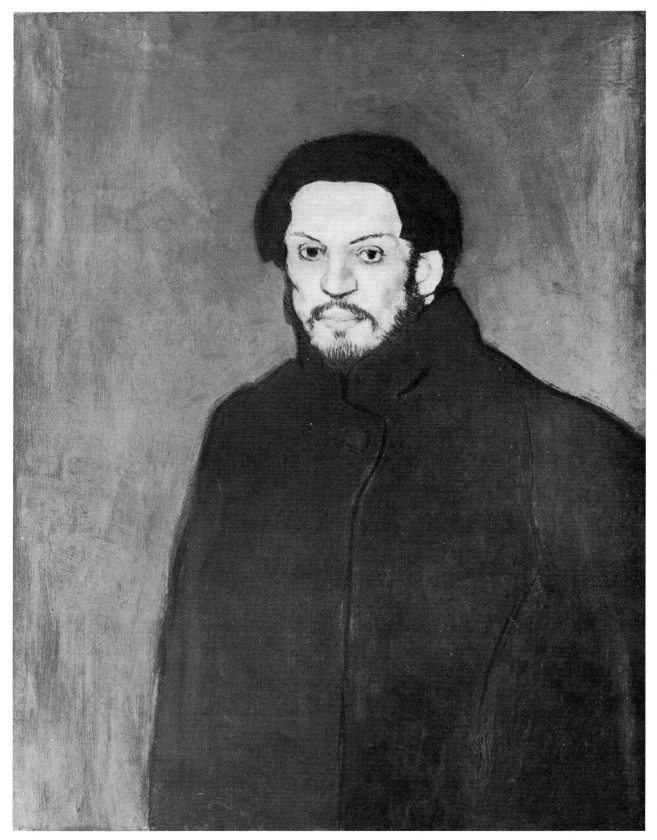

3 Self-portrait. Paris, late 1901

INTRODUCTION *TIMOTHY HILTON*

'It is not sufficient to know an artist's works – it is also necessary to know when he did them, why, how, under what circumstances ... Some day there will undoubtedly be a science – it may be called the science of man – which will seek to learn more about man in general through the study of creative man. I often think about such a science, and I want to leave to posterity a documentation that will be as complete as possible. That's why I put a date on everything I do ...'

So spoke Picasso in 1943, in occupied Paris, at a time when the future of 'creative man' must have seemed more threatened than at any time in his life. He was of course thinking of himself, but the 'documentation' he wished to bequeath us was incomplete, partial, and sometimes baffling. He never gave titles to his paintings, did not much like talking about them, and would never discuss their interpretation. In many ways he was open and helpful to those who were eager to know about his art: in other ways he was secretive. He never exhibited or sold much of the best art he made. His favourite form of explanation was the paradox. He was unique among major painters in keeping a significant part of his work to himself; not necessarily away from other people's eyes, or from public esteem, but keeping it physically, closely, near to himself, or locked in places that he knew and owned. Picasso is uniquely self-revelatory among major artists. No other painter has told us, as an integral part of his painting, so much about himself. We could call him an auto-biographical artist: but with this difference, that autobiography implies retrospection, while Picasso's art is in direct response to the events of his life. We might expect that his personal collection would tell us more about this. But it is not at all a direct route to his innermost feelings. We are all of us a mixture of the public and private, and this is especially so of artists. So it is with Picasso's art, sometimes so frank and sometimes so guarded and ambiguous: so it is too with his collection.

The introverted and the challenging are combined in Picasso's *Self-portrait* (3) of the end of 1901. We are in the middle of the Blue Period.

Like many another work in this exhibition, this is a very famous picture; for although he kept things in his own collection they were usually photographed and thus had wide currency in reproduction. The blend of the intimate and the theatrical is characteristic of Picasso (a man who loved posing for photographs). A *fin-de-siècle* melancholy may be attributed to the fashions of the day, and the implied identification with Van Gogh might be thought presumptuous in an artist aged twenty. But the picture is, so to speak, so much a master of itself that neither its influence nor its ambitions are obtrusive. Instead, we are simply riveted by the personality.

More of Picasso's formative years may be found in his early drawings than in this glowering self-portrait. Looking at the work of his childhood, one notices immediately his desire to tell people of events, of what is going on. This first little newspaper (187) is a report of the annual August festivities in La Coruña. Artistically, it shows a neat ability to reproduce the style of the humorous and commercial graphics of the day. And then we find a *Corrida* (186), which is almost mature. It is drawn with the developed instinct of an artist who is more than a child, and who sees that the bullfight's spectators are part of its drama. Picasso had already begun his lifelong transformation of the occasional or anecdotal into potent singular images. This is the first thing an 'autobiographical' artist would need to learn, and such an artist could only learn it by himself. In fact, Picasso could scarcely be taught. He flew effortlessly beyond his teachers. 'When I was a child I could draw like Raphael,' he once said. That is not quite true, for nobody would think of drawing like Raphael who had not been to an art school. Picasso did, but it was a brief episode. A more modern culture was there to be joined. And it is fascinating, in these early drawings, to see how decisively Picasso made himself a part of the provincial Spanish renaissance – as though between his childhood and his young manhood there was the opportunity not only to supersede the academicism of the cast room but to obliterate the

mere seventy years of bourgeois life and clericalism since Goya had died.

Such attitudes were not simply adolescent, for with Picasso they were lifelong. He was always radical, and he did not believe that organized religion knew about what he considered his themes, his litany of 'birth, pregnancy, suffering, murder, the couple, death, rebellion, and, perhaps, the kiss'. He seized on things around him but his sense of time beyond his own lifetime had great imaginative scope. Even when he was young he had the sense that death was not the end of life but of creativity. When he made his early expeditions to Paris his comrade was a fellow artist, Carles Casagemas, and here is a quick painting on wood, still in its cheap frame, which is his portrait (2). It is painted as if from his corpse, although Picasso was in Madrid at the time that Casagemas killed himself in Paris as the result of a disappointment in love. This little picture Picasso kept hidden for half a century. The suicide affected him deeply. The Blue Period masterpiece *La Vie* (Cleveland Museum of Art, see 197) is concerned with it and so is some of Picasso's later art. Forty years later, as a 'lesson' in mortality and lost beauty, he took a young mistress of his own to see the aged and bedridden woman Casagemas had loved. For this early loss had flung over all his life a fear that at any moment he himself might be allowed to paint no more.

It is not surprising that the first characteristic of Picasso's art should be its abundance. Its variety was nurtured by the diversity of advanced art in Paris in the early years of the century.

Picasso then put his own stamp on work that derives from a dozen different artists. There was so much to see, to consider and outpaint. For a time Picasso seems jackdaw-like, more constant to his friends – often poets like Apollinaire and Max Jacob – than to a single path for his painting. Yet he also felt an isolation, and those same friends are portrayed with him as outcasts, destitute entertainers with no possessions beyond their tents and their costumes. Such paintings, which came to be known as Picasso's 'circus period', were in one way a useful commercial success. He bargained them away to the dealer Vollard. His purpose was artistic, for he wanted the money to leave Paris for a while and to try in seclusion to form a timeless and heroic style that would be genuinely his own.

The place Picasso chose for this endeavour was Gosol, a remote village in the Spanish Pyrenees. He took with him Fernande Olivier, with whom he lived in the 'Bateau-Lavoir', the bohemian colony in Montmartre. The extent of his self-willed progress at Gosol can be seen by contrasting the gouache of *The two brothers* (4) with the paintings that come immediately afterwards. The gouache, with its naturalistic lighting, soft brushwork and props of flowers and drum, belongs emotionally and technically to the Rose Period. All this Picasso wished to lose. As contemporary work shows, he was thinking of Ingres: but at the same time he sought an individual expression inspired by ancient Iberian art. Fernande sat for some impatient exercises based on Ingres, while Picasso took the ancient and anonymous art upon his own features (5, 6 colour plate). All young artists should know how to surprise themselves by their own self-portraits. Picasso now found an extraordinary way to do so. It is as though he were not primitivizing art but primitivizing his own self. This is seen not only in the boldness of the stylization. Here is one of Picasso's ineffable and poetic touches: the age of the artist is now made strangely ungraspable, as though he could be adolescent, or younger, or quite out of time and without age.

These two pictures – and one must believe that the smaller of them is also a self-portrait – were probably conceived in Gosol and completed on the return to Paris in the autumn of 1906. Picasso, excited by his discoveries, surer of his own direction, knew he had a big picture to prepare. He therefore swept through the portrait of Gertrude Stein – that onlooker – and made a beginning of the paintings which were to lead to, and surround, the *Demoiselles d'Avignon*. More than any other work of art, the *Demoiselles* has been held up as

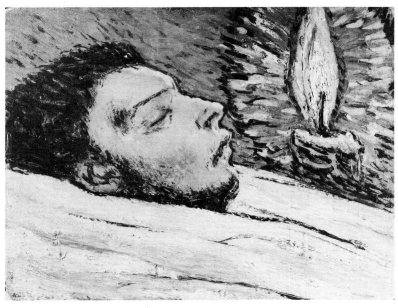

2 The death of Casagemas. Paris, summer 1901

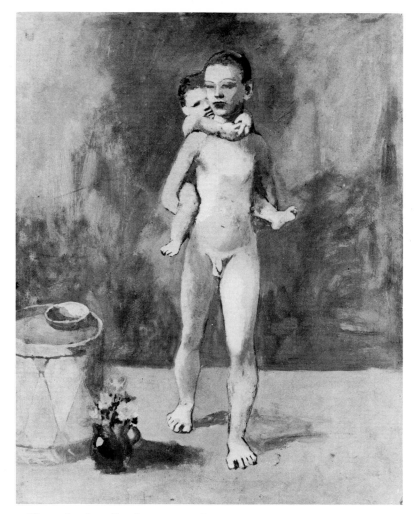

4 The two brothers. Gosol, summer 1906

5 Young nude boy. Paris, autumn 1906

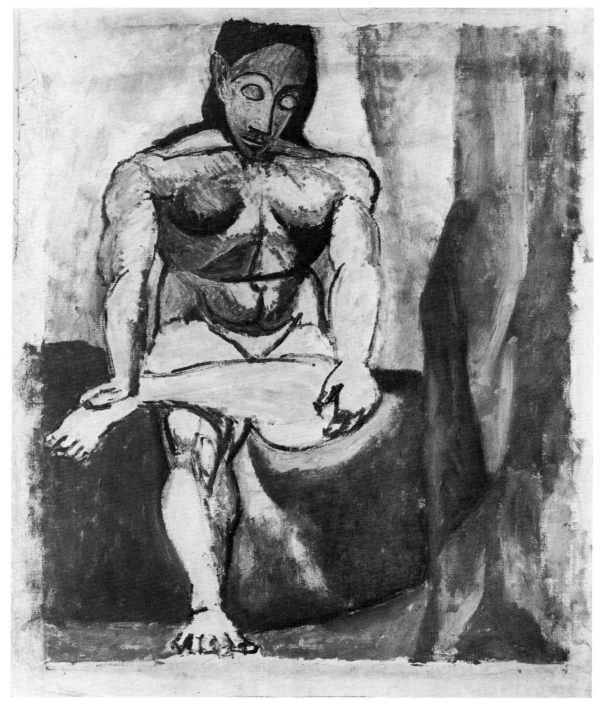

7 Seated nude (Study for 'Les Demoiselles d'Avignon'). Paris, winter 1906–7

the first painting of the twentieth century, the great turning-point and triumph of the modern spirit. This may be so, but students of modern art have long had difficulty in saying why it should be so. We do not know much about the immediate circumstances in which the painting was made. Picasso was not helpful. He was quite disinclined to talk about its formation, for this was territory he preferred to keep private. Preparatory note-books, drawing and pictures that have a relevance to the *Demoiselles* were kept by him in his own possession. A number of them are in the present exhibition. They help to answer the questions art historians ask themselves about the picture, which for the most part are iconographic and stylistic. The painting's original 'subject', which to some extent persists, was of a sailor or sailors and a student among five naked women in a brothel. The purport of the themes thus stated is still a matter of inquiry. Stylistically, the *Demoiselles* exercises the art historian because of its complex relationships with the classical tradition, with Ingres, Cézanne, and also Matisse. These relation-ships, and the question of Picasso's acquaintance

with African sculpture at the time of the painting, are also in dispute.

Some of the pictures of the *Demoiselles* period obviously belong to its earlier iconographical con-ception. Such a one, from the spring of 1907, is the *Head of a sailor* (10 colour plate). It replaced two or three earlier versions of a sailor which showed him as a rather *insouciant* person, sitting rolling a cigarette. The present painting is clearly not one that could be reabsorbed into the big canvas. This blue – how different from a 'Blue Period' blue; the hatching and ruffling of brush-strokes and striations; the curving divisions that suggest dramatic draperies; the organization of the features to make a head that is primitive enough, yet sweet more than it is savage: all these suggest concerns which are not those of the big picture itself, or not exclusively. Work on the *Demoiselles* threw out many such suggestions for other kinds of art. One reason why Picasso never returned to the picture was that it had early established for him a freedom of creation, a realm of differing possibilities. How unlike the *Head of a sailor*, for instance, is the *Mother and child* (12

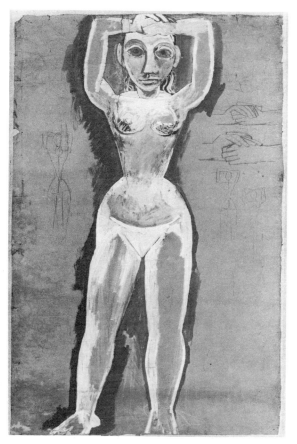

9 Nude with raised arms. Paris, spring 1907

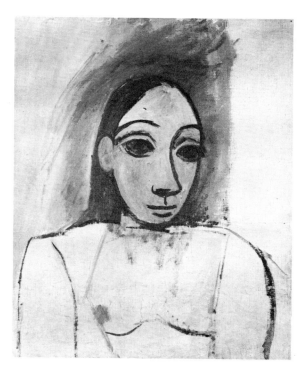

11 Bust of a woman. Paris, spring 1907

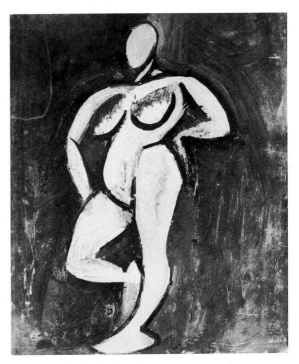

15 Standing nude. Paris, spring 1908

13 Landscape. Paris, summer 1907

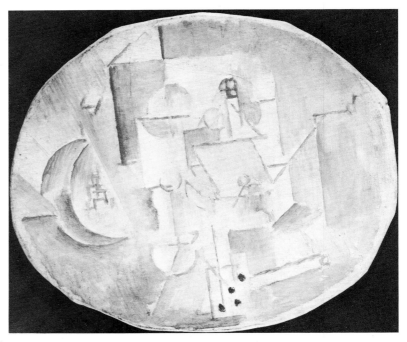

20 Pomegranate, glass and pipe. Paris, [autumn] 1911

colour plate) of the same year. It gives one the feeling that an actual mask was used as a model. Seventy years later, this picture is still as fiercely striking as anything in modern art. That the painting is a maternity makes it sit even more awkwardly in the European tradition. So does its palette, which is not very typical of Picasso at any time. The colour was probably heightened in this way through emulation of or competition with Picasso's new friend Derain, and of his and other fauve paintings shown at the Salon des Indépendants in March of 1907, just before the first bout of work on the *Demoiselles*.

That sort of local influence is common in Picasso, and often occurs after he had first met people. He had recently been introduced to Derain through their mutual friend Apollinaire; and it was at about this time that he also met Matisse and exchanged paintings with him. Picasso's collection of work by his contemporaries and admired old masters could scarcely fail to be of interest: yet in truth, given his opportunities for purchase and exchange, it is desultory. As always, he was resolute and ferocious in pursuit of his own vision, and this marked his collections too. Passionate and egotistical from the earliest – he had written the words *yo el rey*, 'I am the king', on his own painting just as soon as he had developed the power to assess other people's – how he could form his partnership with such a man as Braque is a mystery to this day. And yet we know that it was the Norman's influence on Picasso that led to Cubism, the most unlikely and the most fruitful collaboration in the history of art.

In the months following the cessation of work (we do not know whether it was finished or abandoned) on the *Demoiselles d'Avignon* Picasso made numerous beginnings of landscape and figure compositions. They are all wonderfully assured, and yet there was in him a hesitancy about embarking on another large-scale picture. It seems that he was thinking of a sizeable scene of women in a wood: but this was not done; and the progress towards the developed Cubism he shared with Braque was concentrated on plainer and less resonant subjects. Picasso's and Braque's tense and sensitive relationship, their mutual help, rivalry and self-abnegation are quite simply not recorded in Picasso's collection of his own work. Nor indeed did he treasure any painting he kept by Braque. If we did not know the history of Cubism we could not reconstruct it from the cluster of works of the Analytical Cubist period that are in this collection. The razor picture, the pomegranate picture, the guitar and mandolin

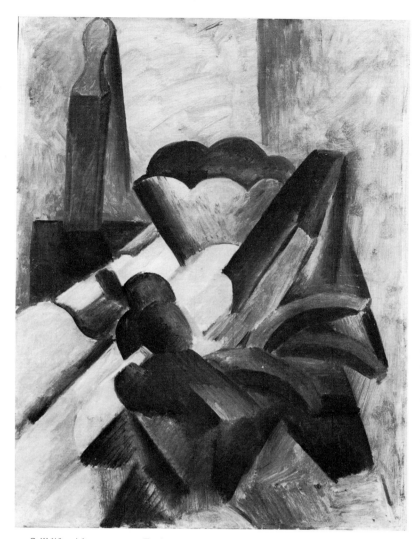

19 Still life with razor strop. Paris, 1909

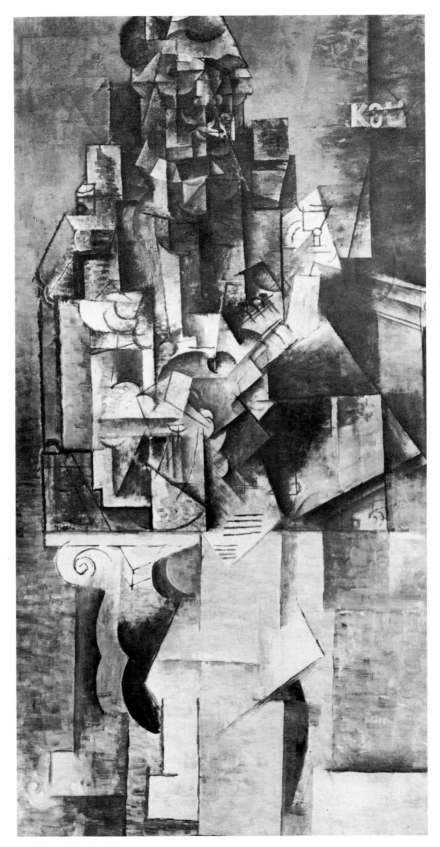

21 Man with guitar. Paris, 1911–13

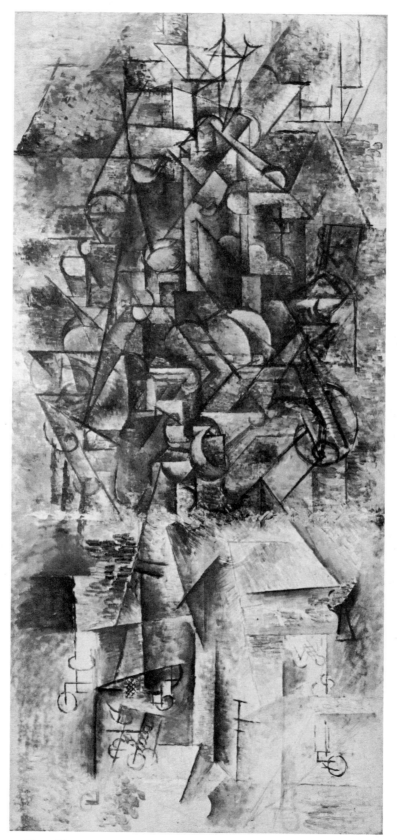

22 Man with mandolin. Paris, autumn 1911

pictures are in different ways marvellous, but un-satisfying in their present context. There surely is a Picassian motive here, a desire not to encumber himself with that part of his art he most owed to someone else: and this could also be why we have the tremendous boon of all that part of Cubism which was his alone, the sculpture.

Picasso had been making sculpture on occasion since at least 1902. But he had done so only sporadically and certainly as an adjunct to his primary work in oil on canvas. That we possess any of this early work is probably because Picasso sold it to Vollard when he needed money: the dealer had it cast. Among the pieces was this exhibition's bust of *The jester* (131), which has also been known as *Harlequin* or *Madman*. It belongs to the circus period of 1905 and was modelled in clay late one night after returning with Max Jacob from the circus: it may originally have been a portrait of the poet which turned into a circus character as Picasso felt his way into the clay. However instinctive this modelling, the piece could not quite escape the massive influence of Rodin. Picasso's first really assertive sculpture is the hewn piece (134) which is probably contem-porary with work on the *Demoiselles*. Here Picasso carved into oak. That the piece is unfinished is no doubt due to the obdurate nature of the material. Perhaps the red chalk drawing, still faintly visible, is to be associated not only with the pastel (212)

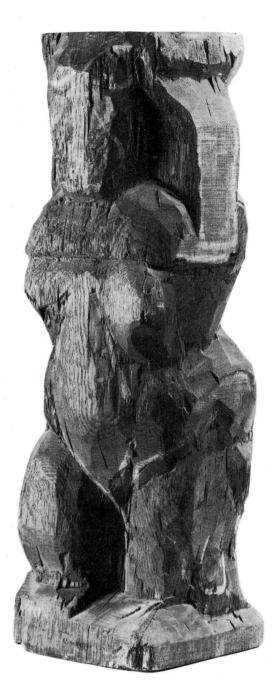

134 Figure. Paris, 1907

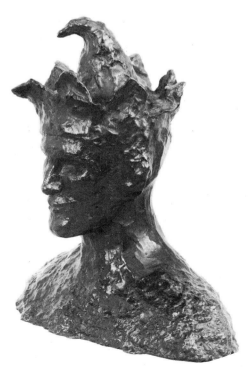

131 The jester. Paris, 1905

but with the hieratic poses that can be seen in such paintings as the *Nude with raised arms seen from behind* (8). All this suggests that there was no compelling need for Picasso to express himself through sculpture. However much the head of Fernande (137) appears to be the equivalent of cubist painting of the time, its feel is much more conservative than that of the painting. The radical sculpture – and this was far more radical than

8 Nude with raised arms seen from behind. Paris, spring 1907

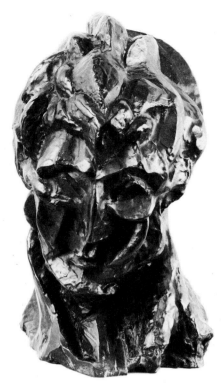

137 Head of a woman (Fernande). Paris, autumn 1909

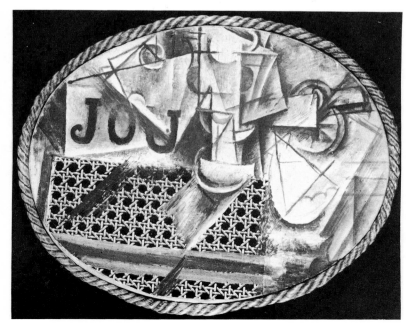

23 Still life with chair caning. Paris, May 1912

anything to do with primitivism – came with Synthetic Cubism.

In the spring of 1912 Picasso first affixed a piece of alien material to the surface of a picture. This was the invention of collage. The picture was the *Still life with chair caning* (23), in which the piece of commercial oilcloth gummed to the canvas begins a whole range and repertoire of pictorial and sculptural innovation. For to make collage in this way was to break the centuries-old tradition of illusionism in pictorial art: and to make sculpture by a collage method was to dispense with the traditional methods of carving and modelling.

Picasso now found that sculpture could be made by bringing together and joining previously disparate elements, therefore opening the sculpture and giving a new kind of volume. Such elements were originally metal, but Picasso soon showed a preference for wood and cardboard, rough and temporary materials that were naturally likely to fall under his hand and might be quickly and not too deliberately made into three-dimensional art. Thus began the sequence of sparkling variations on guitars and all the rest of the cubist table-top still-life repertoire, works that appear almost modest, and certainly as if their safe survival is owed to Picasso's instinct for hoarding; but whose implications were to reach far beyond the extensive confines of his own art.

In Picasso's career as *amateur de femmes* – English has no equivalent expression – biographical studies have given an especial place to some seven or eight women. They are the wives and mistresses who 'shared his life', as these accounts put it, bore his sons and daughters, and play a part in his painting. Many Picassian themes are inspired by them. But their role was also to be subordinate to his imagination, and this could be ruthless. Picasso's amatory painting, the most emotionally variable part of his art, could switch very suddenly from the tender to the murderous. No woman who knew him well could feel unequivocally pleased to be his model.

Among these women Eva Gouel stands unobtrusively, yet poignantly. Of all Picasso's mistresses we know least about Eva. She died young and she does not much appear in the memoirs of the Picasso circle. And she belongs to that period of Cubism which was least open to description, anecdote or figuration. We should date her life with Picasso from the autumn of 1911. This was the time when he took an extra studio back at the Bateau-Lavoir. He used it to

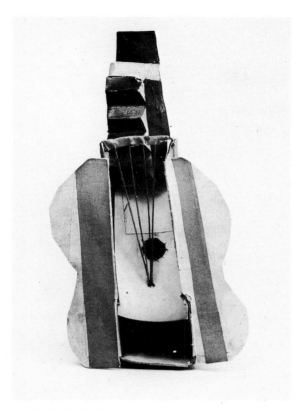

138 Guitar. Paris, [autumn] 1912

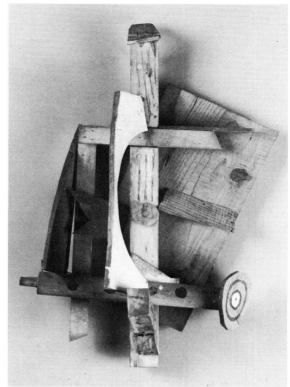

139 Mandolin and clarinet. Paris, 1914

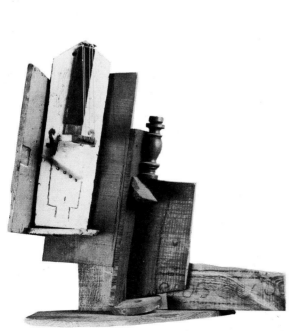

143 Violin and bottle on a table. Paris, winter 1915–16

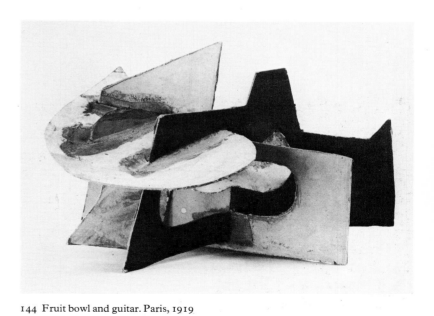

144 Fruit bowl and guitar. Paris, 1919

store work but also to give his movements privacy and flexibility – a practice he was to continue, with increasing complication, for the rest of his life. Eva is celebrated in Picasso's Cubism, but not at first in a forthright manner. Picasso thought of her as *'ma jolie'* after a popular song of the day and its refrain *'O Manon, ma jolie, mon coeur te dit bonjour'*; and from 1911 there are numerous paintings in which the phrase is written onto the picture – or, rather, *into* the picture, so closely and quietly is the phrase a part of the formal expression. *The Autobiography of Alice B. Toklas* records a visit to this new studio where 'Picasso was at work on a picture on which was written ma jolie.... As we went away Gertrude Stein said, Fernande is certainly not ma jolie, I wonder who it is. In a few days we knew. Pablo had gone off with Eva.'

A little later we find the words *'j'aime Eva'* written on the paintings, and since these pictures are generally without figures one has the impression of art that is dedicated to a loved one rather than representing her for purposes of its own. Those words were written on this exhibition's *Guitar: I love Eva* (24), which dates from a long summer spent in 1912 in Sorgues, north of Avignon, where she and Picasso were joined by Braque and his new wife. The inscription was in fact on a piece of gingerbread stuck on to the canvas: it has long since disappeared. The more serious implications of collage were not pursued at Sorgues. These last, extended days of Analytical Cubism were in fact a holiday, and for the Braques a honeymoon. Picasso made some majestic paintings there, but kept for himself the sequence of drawings from that year (238–51) which are grave and happy by turns, sometimes lingering and sometimes playful, showing with unaffected virtuosity how one turn of the pen or one section of hatching might open worlds of possibilities beyond the simple statement of the cubist armature.

The historian of Cubism, however much he would wish to pore over these marvellous drawings, often feels almost obliged to press on to the next month and the next innovation. In the same way we tend to think, as Picasso himself certainly did not, of 'gaps' in the personal collection, as though the impetus of this undeniably exploratory art ought to be illustrated. But Picasso was not concerned to explain the history of his art in his own holdings: for why would he need to explain it to himself? From the Synthetic Cubist paintings and *papiers collés* he made after his return to Paris in the autumn of 1912 he appears to have retained the works that were especially limpid and relaxed. They are formed from a very few elements and lines. We might call the *Violin* (25) and the *Violin and sheet of music* (26) the most 'minimal' of all Picasso's works. It is as though the hand of the artist had brushed only ever so lightly across the materials of this world, to change them to art. In this respect they resemble the contemporary constructions. If collage was physical and manipulative in comparison with the traditional means of painting, even a more complex work like the *Man with a moustache* (33) seems nonetheless delightful. Broader forms and a heavier touch were to be one of the legacies of Synthetic Cubism; but so too were decoration and jaunty rhythms. Living with Eva in the rue Schoelcher from the autumn of 1913 Picasso made further constructions and developed that kind of Cubism which from its decorative qualities has been called 'rococo'. Some pieces, like the *Bottle of Bass, glass and newspaper* (140) and the circular *Glass, pipe, playing card and die* (37) – which we might like to think of as anticipating Picasso's ceramics – combine these aspects of his work.

In these otherwise fruitful months Picasso was disquieted to see how his most heartfelt labour was likely to escape from the world he knew. The Peau de l'Ours sale gave him a sharp lesson in the fate of his own art. At this auction the *Family of saltimbanques* (now National Gallery of Art, Washington, D.C.) was sold for a large sum to a German dealer. Not long previously Vollard had published and sold graphics from the same period.

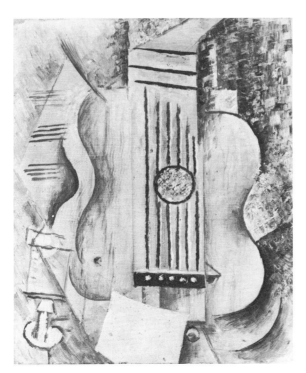

24 Guitar: I love Eva. Sorgues, summer 1912

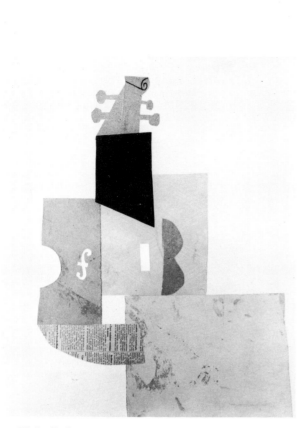

25 Violin. Paris, autumn 1912

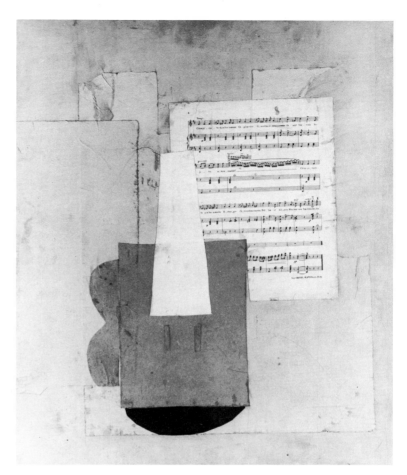

26 Violin and sheet of music. Paris, autumn 1912

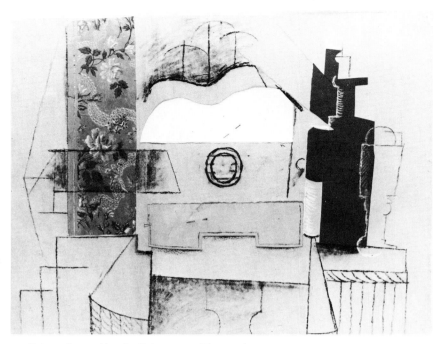

29 Guitar, glass and bottle of vieux marc. Céret, spring 1913

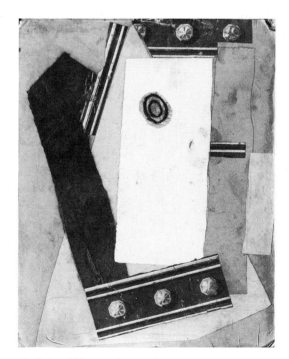

28 Guitar. [Céret, spring 1913]

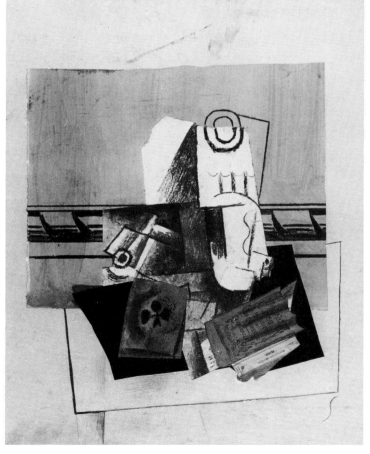

31 Glass, playing card and packet of cigarettes. Paris, spring 1914

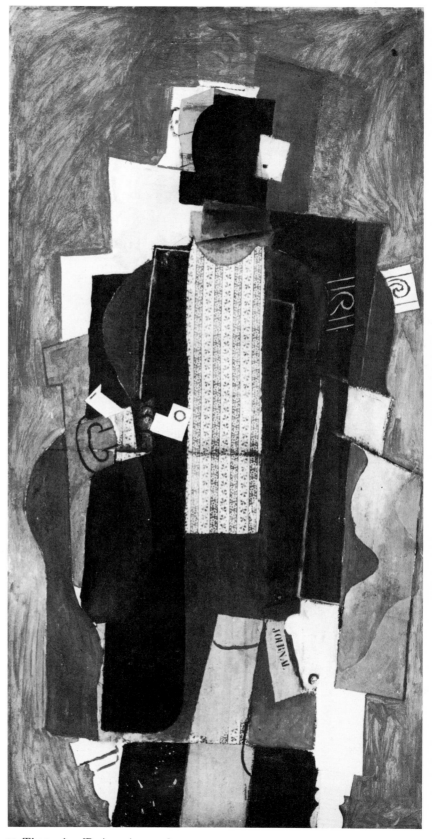

32 The smoker. [Paris, spring 1914]

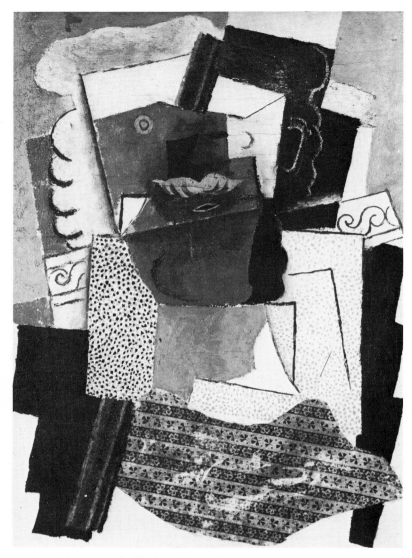

33 Man with a moustache. [Paris, spring 1914]

Picasso must have been reminded how he had given Vollard everything in order to finance the expedition to Gosol. This in fact is why there were so few Rose Period pictures in Picasso's own collection. If the *Saltimbanques*, the masterpiece of that period, is indeed a picture about the 'alienation' of Picasso and his friends, artists in a hostile society, then Picasso must have reflected that the painting's financial success now doubly alienated it from the circumstances of its production. However rich Picasso became, he was always relentlessly concerned with raising his prices. This was not cupidity. He was sure that all dealers were avaricious. He was a painter of his own life and he was not going to give away his life to others cheaply.

These considerations have some bearing on the formation of the Picasso collection. There were other reasons why he now became more reserved about his art. The first was Eva's frailty. It had the effect of enclosing them. The second was an unexpected direction in his painting. Picasso now began to reintroduce realistic elements. When this was revealed it did some damage to his reputation among the avant-garde. But Picasso had little interest in such criticisms. When he told people, years later, that in certain pictures he had gone '*le plus loin*' he did not mean that in them he had most nearly approached abstraction: he meant that he had done as much as his own Cubism allowed him. He was never to believe that the creation of abstract art of any type was as radical a step as the invention of Cubism. That invention gave him more right, not less, to use realist styles just as he might wish: *yo el rey*. Meanwhile there was Eva to think of. Picasso had a fear of illness that made him indifferent to anyone else's suffering: he felt it threatened his own life and creativity. With the tubercular Eva, though, he was gentle. He took her to Avignon, in the warm south, and in their rented villa began the series of drawings (258, 260–3) which alternate naturalistic and cubist language in treating of a man leaning on a table. He is a painter, probably; and the reason why he is not quite to be identified as Picasso himself is our strong sense that he has something to do with Cézanne, the father of so much in Picasso's art. Perhaps Picasso realized that he was at a turning-point. Other drawings from this year, as war was declared and it became obvious that the partnership with Braque was over, seem to point towards Picasso's later styles and pre-occupations. Two drawings (264–5) put us in mind of the ballet *Parade* and of the first designs for the 1930 *Crucifixion*. In 1926 Picasso allowed them to be published. This gave many people

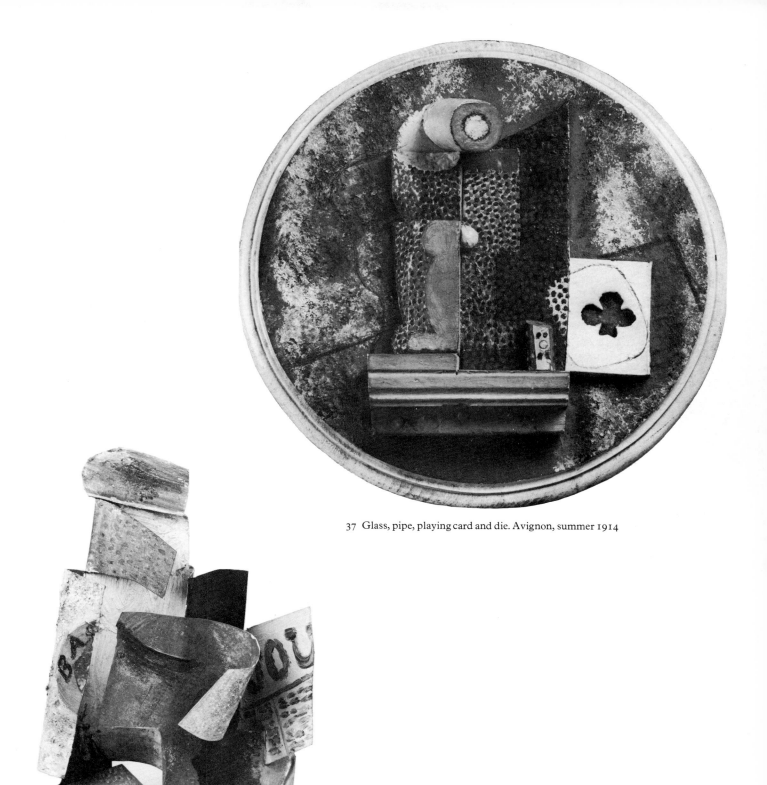

37 Glass, pipe, playing card and die. Avignon, summer 1914

140 Bottle of Bass, glass and newspaper. Paris, spring 1914

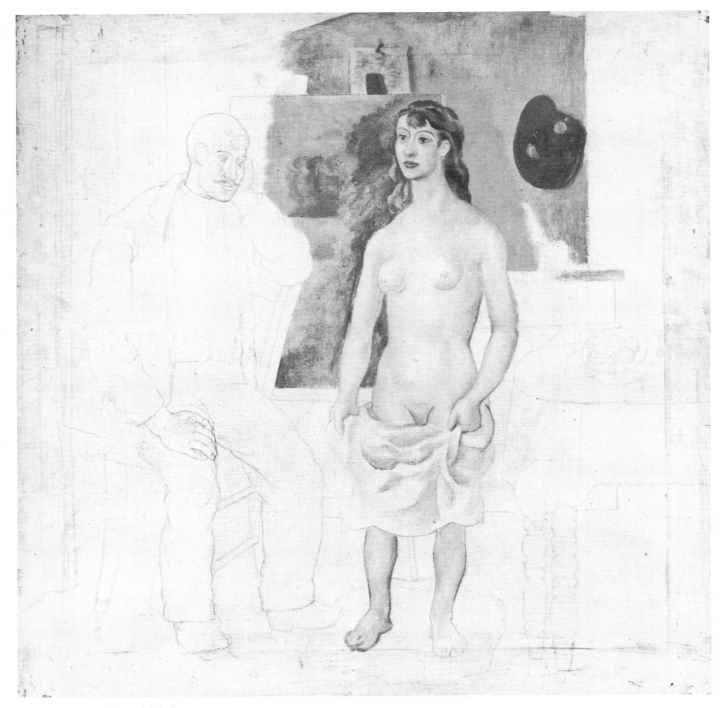

38 The painter and his model. Avignon, summer 1914

the idea that they had been secretly prophetic of Surrealism, and helped to foster the myth that Picasso's imagination had some uncanny presentiment of the wonders and terrors of the modern age.

Eva died in a nursing home in the sedate Parisian suburb of Auteuil in December of 1915. The unfinished painting of *The painter and his model* (38), quite unknown before the inventory of his studios was made after Picasso's death, was his memento of their months together in Avignon. Its relationship to the drawings of the man leaning on a table is evident. And if Eva's is not the small face that looks out from the preparatory drawing (255) for the 1913 *Woman in an armchair*, then perhaps this may be the only picture of her. Alone, Picasso found that the war greatly changed his life. As a Spaniard, he was in one way unconcerned by it. But Apollinaire, Braque and other old friends were gone to the front. The German Kahnweiler was in Switzerland, and the fate of many of Picasso's pictures which he held was uncertain. Picasso now began a different commercial relationship with the dealer Léonce Rosenberg, with a different network of promises. Picasso began to have a reputation for caprice. It was thought reprehensible that he should take his pleasure in the fashionable world of modern ballet. He had been beguiled by the young Jean Cocteau, a poet and *entrepreneur* in whose reminiscences we find a genuine dislike of the old, serious avantgarde. He compared it to a dictatorship: 'we were going through the puritanical phase of Cubism.' Picasso would not have recognized such a dictatorship, did not much mind what Cocteau or anyone else said, and quite cheerfully accompanied him to Rome to work on the ballet 'Parade'.

Thus began a number of collaborations with the theatre and ballet which brought him into contact with such people as Stravinsky, Satie and Massine in productions of 'Parade', 'Le Tricorne' and 'Pulcinella'. These enterprises also introduced Picasso to his wife. She was Olga Koklova, a young dancer in the Ballets Russes. In his collection there are several portraits of such associates. But he felt an instinctive hostility to other people's theatrical souvenirs. It is important that his collection of art was not made to invoke memories. For memories of events and places are not like the experience of art, and the memory of the experience is not like the experience itself. Just as Picasso felt that the whole of the history of art was available to him, his new realism (in truth, different types of realism) was less in accord with the ballet than with the museum. This, for Picasso, was always a more vital and creative encounter. In 1917, be-

39 The happy family, after Le Nain. [Paris], 1917–18

tween Barcelona (he had followed Olga there) and Paris, he began a number of paintings in which tessellated brushstrokes combine with naturalistic subject matter. Not all of these pictures were completed. One that was belongs to his own collection, the initially startling *Happy family, after Le Nain* (39). It seems to issue from a feeling that by an effort of his own will he could bring off a painting that would be quite unreasonable and yet still convincing. The picture is not an oddity: it is merely extremist. It seems more natural within the context of Picasso's art than does Picasso himself in the surroundings in which we now find him. He spent his honeymoon with Olga in Biarritz at the villa of a Chilean patroness. High society there at the end of the First World War takes some imagining. As he had done in

51

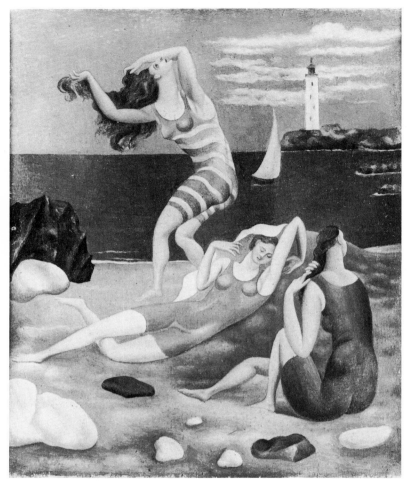

40 Bathers. Biarritz, summer 1918

various places before, Picasso decorated the walls of the villa. In his design he included some lines from Apollinaire's *Saisons*:

C'était un temps béni nous étions sur les plages
Va-t'en de bon matin pieds nus et sans chapeau
Et vite comme va la langue d'un crapaud
L'amour blessait au coeur les fous comme les sages ...

If this is Picasso's pastoral, then it is not the one familiar to us from the *doux pays* of previous art. A small painting of the time, the *Bathers* (40), makes this quite clear. The picture resumes and concentrates the celebrated drawing of bathers now in the Fogg Museum: that drawing is itself an elastic recasting of Ingres' *L'âge d'or*. Thinking of this, we are also put in mind of similar scenes by Matisse (in his *Bonheur de vivre*); or by Signac (*Au temps d'harmonie*); or by Derain (*Composition: L'âge d'or*). Such paintings were well known to Picasso: they had continued the old tradition of the evocation of the Golden Age in new art of the previous two decades. Picasso, characteristically, treats the theme with less than total respect. He is evidently unconcerned with the formal developments that gave life to his predecessors' paintings. Nor is his view of 'timelessness' like theirs. By fixing on the contemporary fad for sunbathing (and see how the fair-complexioned girl is protecting her face with her towel) he introduces a slightly discordant and Apollinairean mingling of the elysian with the modern. It is not genial. The standing figure in the Biarritz bathers derives from one on the left-hand side of Ingres' *Bain turc* (Louvre). In that picture she merely displays voluptuousness: in Picasso's she is possessed. We ought to note here that Picasso was not in any positive sense a landscape artist, and that the outdoor setting native to his art is the beach. This was appropriate to him in many ways. The shore separates the known, the civilized and the cultivated from the untamed. Beaches appear timeless, and no one can tell the age of the bones washed up on them. Sand and shingle are desert, technically, yet give room for social gathering. In Picasso, that gathering is often unclothed, and not much separates swimming from drowning, or play from terrified flight.

Back in Paris, married, the Picassos moved into a new *appartement* in the rue La Boëtie. Many of his possessions were to remain there until 1951. The layout of this large flat is significant. It was on two floors. Upstairs, Picasso worked. Downstairs, Olga received. After a while, she never set

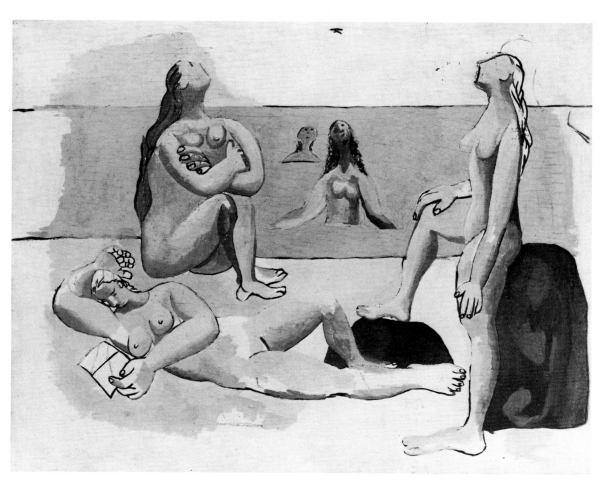

48 Bathers looking at an aeroplane. Juan-les-Pins, summer 1920

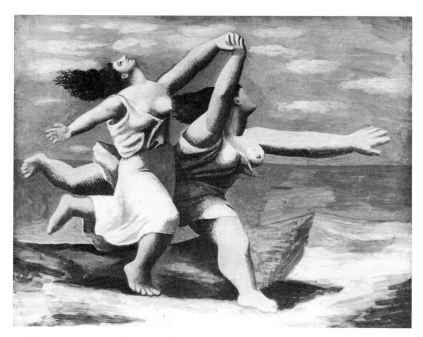

53 Women running on the beach. Dinard, summer 1922

foot in the studios above her. Her neat domain is almost mockingly recorded by Picasso in the drawing of his wife, Cocteau, Erik Satie and Clive Bell in November of 1919 (275). The author of *Civilisation*, who in this drawing may be identified by his spats, left an account of the circumstances. 'After lunch we were set in a row, for all the world as if we were posing for the village photographer, and Picasso "took our likenesses". I wish I could get hold of that drawing or a reproduction even. Years ago I asked Picasso what had become of it. He felt sure it was not lost; but as to where it was, of that he was far from sure: probably somewhere in the studio, not easily to be come at.' And indeed it would not have been easy to find. There must have been thousands of drawings up there. In no attempt at order, and quite uncatalogued, were very many paintings by Picasso himself, together with works by Cézanne, Corot, Matisse, the Douanier Rousseau, Le Nain and others; there was all his own sculpture, and his collection of African masks; and there too were all the other things that he had ever picked up, treasures or dross. Picasso was a hoarder, and much that he kept was of no particular value. Nothing was ever thrown away, and the rooms were never cleaned. The photographer Brassaï was invited upstairs, as apparently Bell had not been:

> I began then to survey my strange surroundings. I had expected an artist's studio, and this was an apartment converted into a kind of warehouse. Certainly no characteristically middle-class dwelling was ever so uncharacteristically furnished. There were four or five rooms – each with a marble fireplace surmounted by a mirror – entirely emptied of any customary furniture and littered with stacks of paintings, cartons, wrapped packages, pails of all sizes, many of them containing the moulds for his statues, piles of books, reams of paper, odds and ends of everything, placed wherever there was an inch of space, along the walls and even spread across the floors, all covered with a thick layer of dust ... Madame Picasso never came up to this apartment. With the exception of a few friends, Picasso admitted no one to it ...

The circumstances of Picasso's unhappy marriage were to have a formative effect on both the shape and the occlusion of Picasso's collection. In the first case, of course, while the marriage was amiable, he naturally made portraits of those near to him. Family pictures and a renewed interest in children as a subject occur quite frequently in these years, and especially after the birth of Paulo

Picasso in 1921. For obvious reasons these works were not released on to the art market, though they have become familiar in reproduction over the years. But what are we to make of such a painting as *Family by the sea* (55) of 1923? It is small in size: its presence is undramatic. But it beckons us towards a vision of some utterly personal significance. Olga, if she saw it, must have wondered what lay in the mind of the man she had married. It was painted in Antibes, in the one summer when Picasso's mother visited them, the first time they had met since his visits to Barcelona in 1917. This may or may not have a bearing on the picture. We know little about such matters. But it is worth repeating the commonplace observation that Picasso was once again displaying his ability to make human images which are alike memorable and obscure. This painting was never exhibited or photographed while Picasso lived. And yet, once seen, it appears to have been known to us all our lives.

That is a feeling we often have in front of those paintings made in the early-to-mid 1920s in the manner known as 'Pompeian'. The sources of the style are various. They include the Pompeian frescoes Picasso saw when in Italy in 1917, the late figure paintings of Renoir, many pieces from the Louvre, and any amount of classical and neo-classical art. Such an eclectic interest is one way in which Picasso's 1920s classicism is comparable to his Blue Period. Now, however, he was able to weld his influences into a quite singular style. The hybrid became individual. Although they are broadly classical, there is also a strain of realism in these works (and some of them were worked from photographs). It is an emblematic fidelity to social circumstances rather than a fidelity to nature. Here are two pictures (they are not a pair) which are aggrandized depictions of contemporary life. As emblems must, *Reading the letter* (49) and *Dancing couple* (50 colour plate) seem to exist almost without a context. Yet the first contains a salute to Courbet, and the second must have some republican and populist overtones. *Reading the letter* also refers to popular art – not 'folk art' (in which Picasso had very little interest), but the industrialized processes which produced posters and the cheap *images d'Epinal*. In this respect its *facture* is of great interest, a superb application of negative and positive shapes which is evocative of stencilling and printing. It is tempting to compare this picture with some other occasions in modern art where an advanced language is suddenly dropped, usually temporarily, for a realism with more immediate political eloquence. Miró's *Still life with old shoe* (Museum

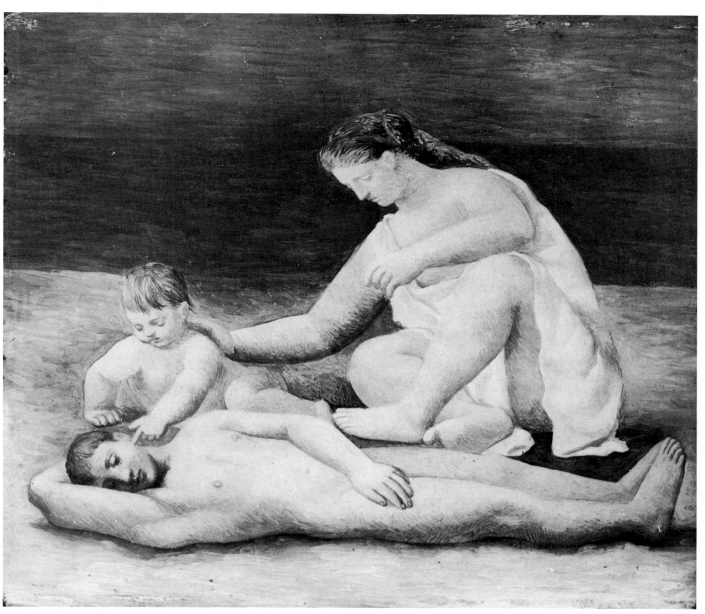

55 Family by the sea. Antibes, summer 1923

of Modern Art, New York), for instance, which was painted at the time of the Spanish Civil War, provides a parallel. But Picasso was always more interested in himself than in politics, and always calls us back to himself. And even if we reflect, as we look at the *Dancing couple*, how Renoir had painted the same subject, and even if we are confident that the girl's hat is a republican phrygian bonnet, the picture strikes a deeper and stranger note as we realize that her profile is Picasso's own.

His most ambitious recasting of antique motifs is represented in the collection by the *Three women at the spring* (51). This canvas now takes its place beside three others of the same large dimensions, all of which were executed at Fontainebleau in 1921. One is another, painted, version of this subject: the others are alternative versions, painted in a late Synthetic Cubist style, of the

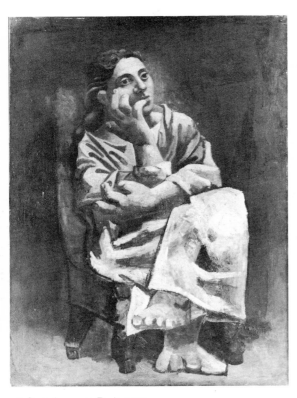

46 Seated woman. Paris, 1920

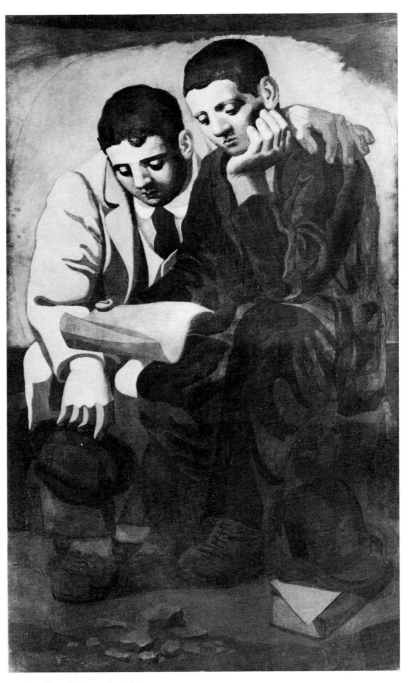

49 Reading the letter. [Paris], 1921

56

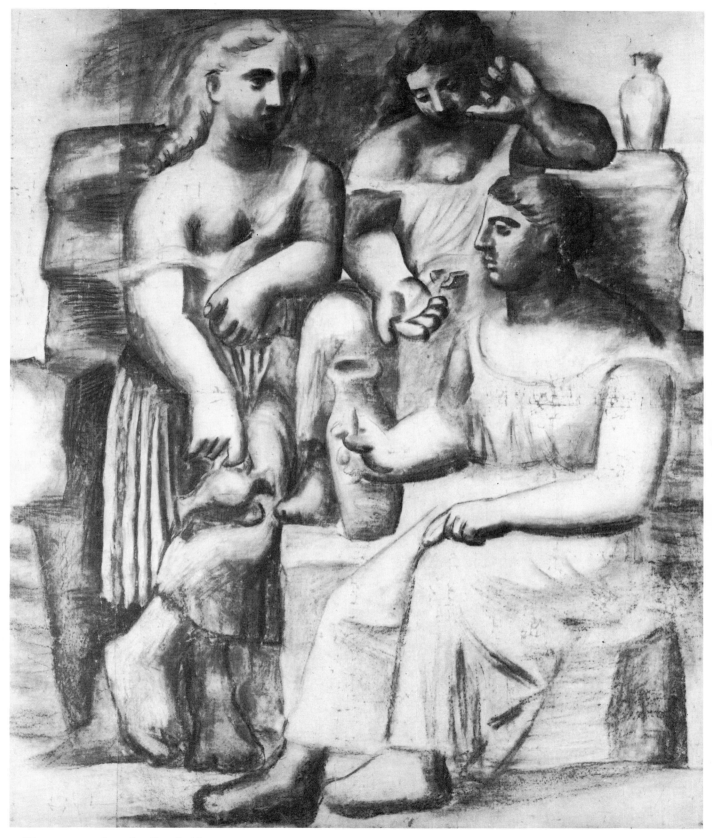

51 Three women at the spring. Fontainebleau, summer 1921

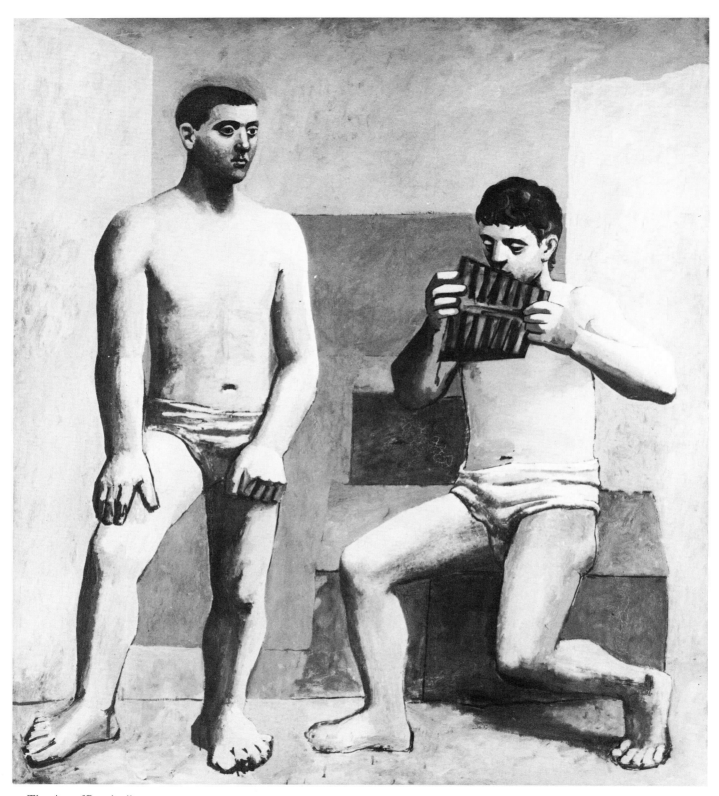

54 The pipes of Pan. Antibes, summer 1923

Three Musicians (Philadelphia Museum of Art and Museum of Modern Art, New York). The present picture is in sanguine, a red chalk much favoured in the eighteenth century, but of course used largely for drawing. It may be right to call this picture a drawing. Numerous normally-sized drawings accompany it (e.g. 286–7). They do not seem to have been made to clarify or further advance pictorial notions, but rather to dwell on them.

It seems that Picasso felt *The pipes of Pan* (54) to have been the summit of his classical style. It was painted on the same seaside holiday that produced the *Family by the sea*, and contains similar Picassian reminiscence of previous themes. If the *Family by the sea* has something of *La Vie* in it, then *The pipes of Pan* resumes something of *The two brothers* and other work of 1905–6. The suggestion of classical architecture is also a suggestion of stage flats; but the die on which the fluting boy sits harks back to the Rose Period. As usual, one cannot tell whether Picasso meant his mythological references to be overt. But we cannot ignore them, if we know (as he knew) the classical story. Pan's pipes are made of the reed that once was the nymph Syrinx: she, pursued by the horned god, had turned herself into that reed, which he plucked and thereafter played upon. Here already, then, are hints of Picasso's Arcady. His enchanted land would be more feral and less statuesque than this: but his themes of flight and physical possession, of art and metamorphosis, have now been stated.

Soon after this summer in Antibes Picasso's portraits of Olga ceased. Paulo was still painted. He is first of all seen drawing, then dressed as Pierrot and Harlequin (57). That his innocence should thus act as a vehicle for the concerns of his father is not surprising. Picasso's position as family man and father was at odds with what we might without absurdity call his *daemon*, a driving spirit in his art that is not divine. It has something to do with death. When Picasso wrote out those lines from Apollinaire in the Biarritz villa he was not to know that his old comrade was soon to die, before they met again. It is possible that the unexplained picture known as *The lovers* (42) has something to do with the loss of Apollinaire: the infernal couple are seen dancing over *L'Intransigeant*, whose art critic the poet once had been. We know that in 1925, when he learned of the death of his friend from the days of the Quatre Gats, Ramon Pichot, Picasso painted the crucificial *The dance* now in the Tate Gallery. That canvas is in a sense one of

the pictures that belong to the personal collection, for it remained in Picasso's hands until, through the good offices of Roland Penrose, it passed to the British collection. Contemporary with that bitter and funerary expression is the painting known as *The embrace* (58 colour plate). It is passionate, and yet it is a picture that has not only to do with human physicality. We are compelled to read it for the enclosed bravura of its decoration. The ladders, striations, chequerboards, everywhere seem to announce a regularity which is then negated. But the negations themselves mean balance, and the picture sits quite comfortably, rather like a still life on a *guéridon*.

This settled composition perhaps led, by way of reaction, to one of those works in which Picasso experimented with a quite different format. This is the large, elongated, and comparatively airy *The painter and his model* (62). It is probably the first concerted approach to the subject since the

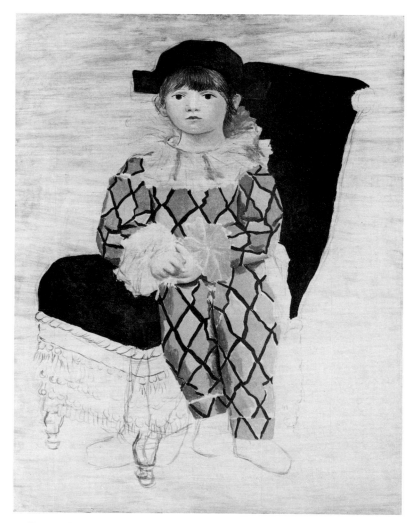

57 Paulo as Harlequin. Paris, 1924

59

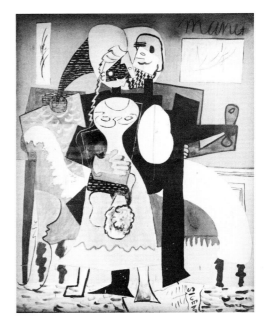

42 The lovers. Paris, 1919

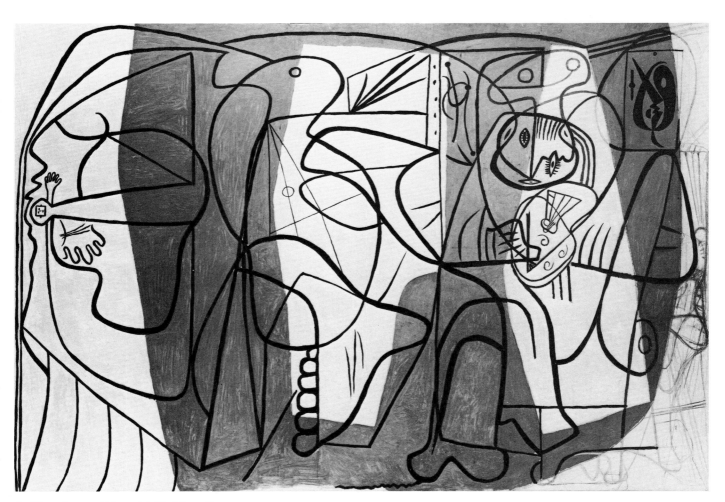

62 The painter and his model. [Paris], 1926

little unfinished painting from Avignon in 1914. It is a theme that will become most familiar in the next few years. The artist, the woman who sits for him, and what the artist makes of her image; with these three properties Picasso found that he could improvise any number of variations on the differences between reality and artifice. It suited his love of paradox so well that on occasion he overemphasized such paradox. In this case, however, the conception and the mastery are equally fresh. A free-flowing but not meandering line creates silhouetted, open shapes which – in great flourishes or neat turns – contract or distend both artist and model and also the furniture (easel, palette, rocking chair) in this imaginary and somehow aerial space. More declamatory, and to be read negatively or positively, are the quite abstract areas which seem either to underlie or to be superimposed on the drawing. They are (except in shape) banner-like, for they assert a different kind of drama when the picture is seen from about the distance necessary to read the figuration in its entirety. It is a device Picasso would use again: so would Léger.

The art historian will observe that the very small or alternatively enormous parts of the body in this painting derive from suggestions in the surrealism of Miró. But there have been other ways of looking at the matter. '"When I was a child I often had a dream that used to frighten me greatly. I dreamed that my legs and arms grew to an enormous size and then shrank back just as much in the other direction. And all around me, in my dream, I saw other people going through the same transformations, getting huge or very tiny. I felt terribly anguished when I dreamed about that." When he told me that, I understood the origin of those many paintings and drawings he did in the early 1920s ...' The reporter here is Françoise Gilot, and we must respect her intimate knowledge of Picasso. But we must not think that Picasso painted his dreams. Contrary to some beliefs, modern art is not well equipped to express the unconscious. If it were, it would not be art. When Picasso painted, he knew what he was doing. Otherwise we would not have the control and judgement of the *Woman in an armchair* (63), in which Synthetic Cubism is almost given a kind of freedom, or the important *Figure* (64 colour plate), painted a few months afterwards. *Figure* is perfect, and its perfection is such that one is hardly aware of the extravagance of its treatment of the female human form. As John Golding has shown, its style is in part derived from the neolithic art given currency in Paris by the interest of the surrealists in primitive expression. But its spirit is

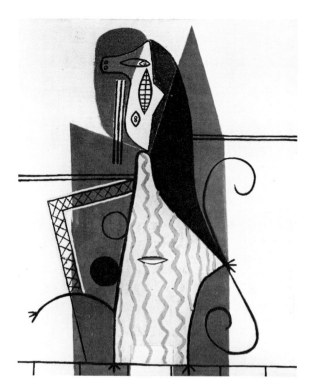

63 Woman in an armchair. Cannes, summer 1927

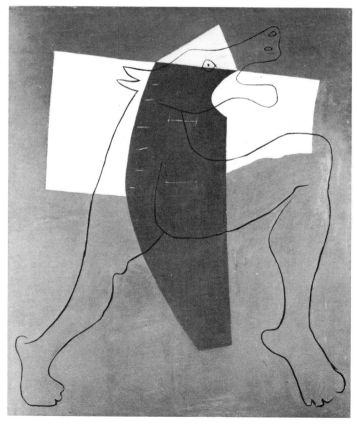

65 Minotauromachy: horse. [Paris], April 1928

not surrealist. It is closer to the best *papiers collés* of 1912–13. The *Nude in a red armchair* (73 colour plate) is a disturbing contrast. Its more baroque conception, a different way with creams and off-whites, seems almost to belong to a different artist. But this of course is in Picasso's nature, especially in his middle years, when we do not know whether it is balance or alternation that regulates his impulses, swinging as they do between violence and calm, containment or wildness, the meditative or the declamatory.

However unexpected Picasso's inventions were, nobody with a sense of modern art believed that they were merely wayward. Among those people in Paris who knew his work well it was felt that everything he made was the manifestation of a genius the like of which had never been seen before. Therefore, every single thing he created had great evidential value. Towards the end of the twenties began the attempts to come to terms with the already immense *oeuvre*. Given its variety and quantity, it was first necessary to make a catalogue. This was a quasi-scientific homage never before accorded to a living artist. The task of making the catalogue fell to the Swiss publisher Christian Zervos, who was the editor of the magazine *Cahiers d'Art*. His dated photographs of everything Picasso had ever painted were published in the form of supplements or special numbers of this journal. This is the reason why so much of Picasso's private collection has been known to us in reproduction for many years. Nonetheless, there were works that Picasso reserved from Zervos, and other things were packed away or lost in the chaos of the studio; and so the record is incomplete and occasionally inaccurate.

Since his every move was now being photographed by the leading magazine of the avant-garde one can see how Picasso felt misgivings about the privacy of his work. As the cataloguing began, a new love in Picasso's life made more complex the differences between his public and private existence. At the beginning of 1927 he approached the seventeen-year-old Marie-Thérèse Walter in the street. Some six months later, according to Marie-Thérèse, they became lovers. She recalled their joyous privacy, how they were 'tellement heureux de notre secret, vivant un amour totalement non bourgeois, un amour de bohème, ... vous savez ce que c'est d'être vraiment amoureux.... Alors on n'a besoin de rien d'autre.' This sounds as if she had forgotten Picasso's artistic needs. They were real. He needed to express his love in his art, but for three or four years, before the first overt portraits, we find only oblique reference to her, including sculpture such as the *Metamorphosis* (146) and the *Woman in a Garden* (Marina Picasso Foundation), and almost certainly the large biomorphic *Still life on a pedestal table* (82 colour plate) of March 1931, which has been called a 'secret portrait' of her. But would it not have been easy to paint Marie-Thérèse in as straightforward a fashion as Picasso pleased? All he had to do was to keep the paintings from Olga, who scarcely looked at his art anyway. And so this almost covert expression tends to show that Picasso's art was so filled by his life that there was no question of a separate art that would serve only one part of that life. Commentators rarely mention (though he often did) that this could give him great pain.

When Picasso went *en famille* to Dinard in 1928 Marie-Thérèse was clandestinely installed in the same town. This surely has relevance to the group of bathers and bathing huts of that year, a number of which have potent sensual overtones and depict naked figures unlocking beach cabins (66–70). More than anything else in the collection these pictures awaken in the spectator a sense of intrusion, of seeing something one has no right to see. Psychoanalytical interpretations of keys, though not mundane, are commonplace: they need not be dwelt on here. Picasso himself frankly admitted to a fixation. 'It's true that keys have often haunted me. In the series of bather pictures

146 Bather (Metamorphosis I). Paris, 1928

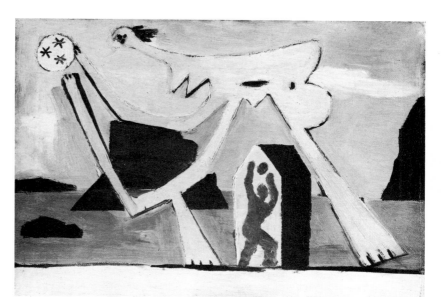

69 Bathers with beach ball. Dinard, 15 August 1928

67 Bather opening a beach cabin. Dinard, 9 August 1928

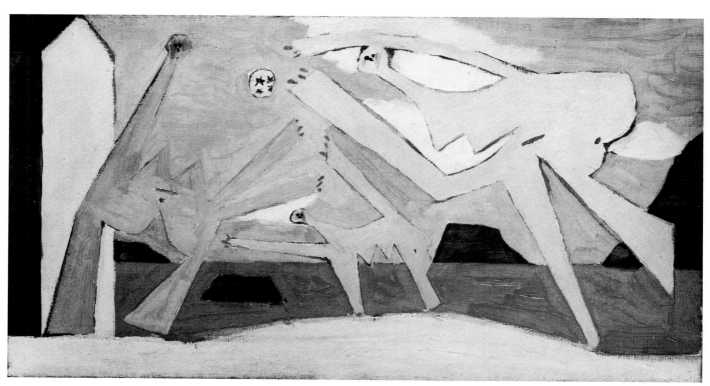

70 Bathers playing with a beach ball. Dinard, 20 August 1928

292 Guitar. Juan-les-Pins, 1924

there is always a door which the bathers try to open with a huge key.' His instincts for hoarding, for locking and hiding things away, explain some aspects of the existence of this collection. But one notices these keys for a different reason. It is that tools of any sort, like machines, are rather rare in Picasso's art (the other ones are paintbrushes, weapons and bicycles). The imaginative range of this great master of the modern age was almost exclusively pre-industrial.

In only one way was Picasso quite at ease with industrial processes: in foundries or print-making shops, or latterly in the depressed (because of new techniques) pottery-making town of Vallauris. When he returned to sculpture in the late 1920s, at which time there was also an efflorescence of print-making, it was in part through the pleasure he took in sharing a manual activity with artisans who felt for artistic processes. Foremost among them was the Spanish sculptor Julio Gonzalez (the son of a Catalan blacksmith): in his shop in Paris Picasso made the three open wire sculptures known as *Constructions* (148).

These popular pieces are often associated with drawings made a few years earlier, such as the *Guitar* (292), though they also take up more recent compositional motifs from certain artist-and-model paintings. Indeed, the constructions look rather like the abstracted variations on reality that we see in such paintings on the artist's easel. In this respect, as in others, the constructions are extremely pictorial. They also give the impression that they would be more sculptural, and would have an equal or even greater artistic effect, if their scale were enlarged. They put us in mind of maquettes. Perhaps this is because there was so much talk at the time about a monument to Apollinaire. Many of Picasso's drawings of the period – which indeed show as it were putative sculpture – have been classified as 'project for a monument' or the like. But Picasso's utterly original attitude to sculpture – and, after all, it was he who had for the first time made it into still life, and thus domestic – precluded the traditional mode of the monumental. In any case it was not in his character to provide an anonymous and solemn token of someone else's achievements. He was by nature attracted to the *memento mori*, and to that kind of painting which strikes the spectator as an angry, clenched lamentation.

Thus it had been with *The Dance*, painted after Pichot's death in 1925. So was it with the *Crucifixion* of 1930, though this picture does not mark the death of any individual known to Picasso. The *Crucifixion* (77 colour plate) is easier to elucidate than to understand. Though complex, its

147 Head. Paris, October 1928

150 Head of woman. Paris, 1930–1

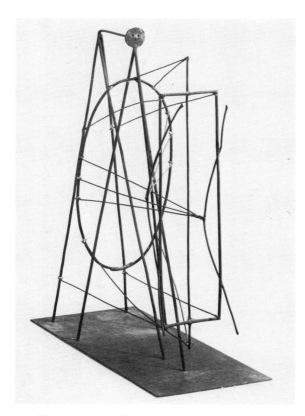

148 Wire construction. Paris, late 1928

imagery is relatively transparent. It intermingles the central Christian image of the calvary with the bullfight, with various kinds of primitive art and with Mithraic ritual. Some preparatory drawings are known. They show how Picasso had been thinking of the picture for more than a year before he suddenly and then swiftly took up the panel and painted on it the assertion that all art and all ritual could be his own. The confidence and rapidity of execution are so striking as to restrain one from thinking of the picture's destructive ambition. A companion panel has some relevance. Upstairs in the rue La Boëtie Picasso had two identical pieces of wood. One he used for this *Crucifixion* and on the other he painted a comparatively mild picture of an artist in front of a canvas containing figures that might be acrobats but whose enclosed disequilibrium also indicate the foetal. This is a suggestion he had made before, in the Blue Period picture of a studio, *La Vie*. This theme of the artist and model is so potent that it even enters the unconnected world of the calvary. It is as though the little

picador is painting the tortured Christ, for his lance doubles as the long brush suitable for painting a mural, and the white areas can be read as those parts of the painting which are incompleted, and will be completed when Christ himself is painted and dead. No other work of Picasso's so much illustrates his dictum that a painting is 'a sum of destructions'.

At this midway stage in Picasso's life we find a multiplication of such paradoxes and alternative meanings. We are drawn into a Picassian world of increasing iconographic complexity, in which one set of themes can be interchanged or interwoven with another, and in which Picasso's memory of his own life and art is enmeshed with reactions both to old master paintings and to his younger contemporaries. In the *Woman with stiletto* (83 colour plate), for instance, David's picture of the dead Marat is made frighteningly active by a paraphrase in which the murderess is introduced and Marat himself reduced to a victim without nobility. But Picasso was thinking of Miró as well as David. His compatriot had recently produced some

78 Construction with bather and profile. Juan-les-Pins, 14 August 1930

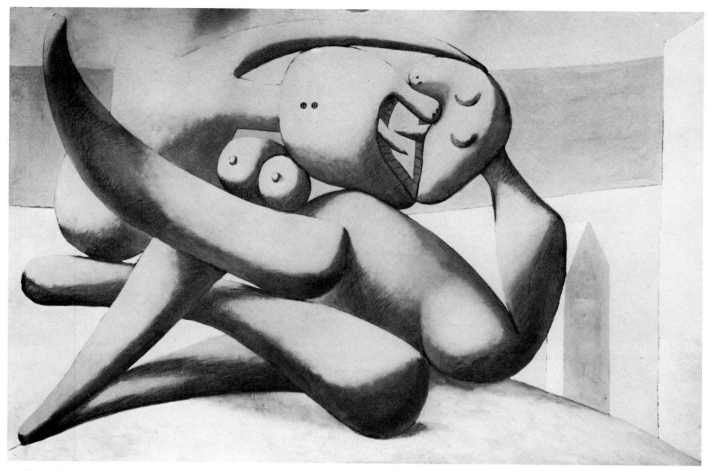

80 Figures by the sea. Paris, 12 January 1931

recastings of museum pictures; and the lighter handling, pools of colour and swollen drawing all point to an interest in the surrealist artist.

Woman with stiletto was not given to Christian Zervos for photography. We do not know why it was kept from him, but it seems that Picasso had decided that a different photographer should now record a new phase in his career. This was dominated by sculpture. The choice was Brassaï, a failed artist who had taken up the camera two years beforehand. Brassaï felt privileged, as we have seen, to enter the upstairs studio, and even more privileged to be asked to photograph sculpture that had been made 'in the utmost privacy'. His photographs (like David Douglas Duncan's, in later years) differ from Zervos's in that they are environmental: Picasso had decided that he wanted his work to be recorded as it was casually disposed in the studio. This was rather like the way he used to hold a kind of exhibition. Brassaï calls them 'presentations'. Picasso would put some

new work around the studio, on easels, chairs, packing cases, and then invite a dozen friends or friends of friends to come to see it. Such an exhibition was of course direct and intimate: it also prohibited criticism.

The new sculpture that Brassaï was to photograph was generally made at the château of Boisgeloup, a property Picasso bought in the early thirties. It was accessible from Paris and close enough to northern coastal towns like Dinard. Picasso made the whole castle, stables and all, into studios. Only two small attic rooms were left for his life with Olga, who soon enough decided not to go there again. One does not think of the years spent at Boisgeloup as a definable period in Picasso's art but rather as a time dedicated to one person, Marie-Thérèse. Though it took time for her to enter his art, it was of course a visual attraction that brought her to him in the

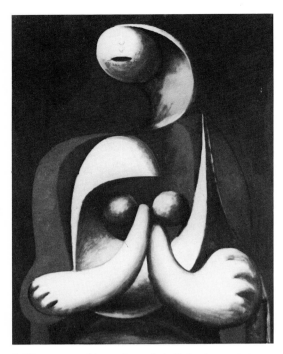

85 Woman seated in a red armchair. Boisgeloup, 1932

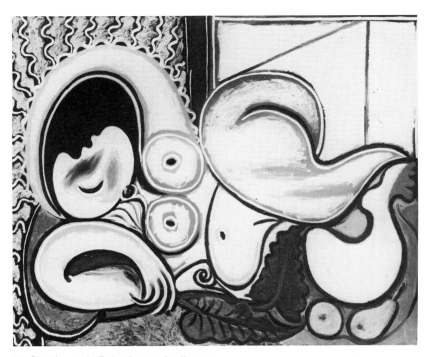

87 Sleeping nude. Boisgeloup, 4 April 1932

first place. Such it remained. As Picasso himself hinted, there was something about his love for her that transformed otherwise neutral subject matter. In the 1931 *Still life on a pedestal table* (82) the rounded and swirling forms of furniture and *compotier* begin to approximate to his vocabulary of the human form. The shorthand indications of corners and skirting board with which the post-cubist Picasso habitually marked out space are set to undulate; and there is a relaxation from the usual tension of his painting. Compare, for instance, this *Still life* with the identically sized *Nude in a red armchair* (73) of two years earlier, when he first knew Marie-Thérèse. But this is not so much lyricism as a searching for lyricism. Here is an early appearance of the lavender colour that in pictures to come will signal a longing for poetry in painting. It is a colour that feels as if it were looking for a different palette, and this is one of the reasons why it is not possible to think of the paintings of Marie-Thérèse without also thinking of Matisse.

As Picasso was such a master of alternative ways of depiction it is remarkable that Marie-Thérèse's features were scarcely ever drawn naturalistically. She was the palpable model for so much, and yet for us she exists solely in a realm of artistic style. Perhaps she is most familiar from the sculptured heads that were made in the Boisgeloup stables (158–9, 162–4). They exhibit

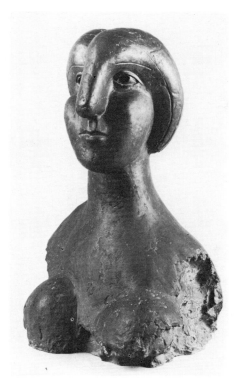

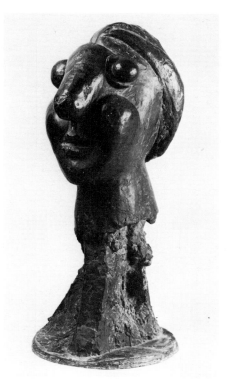

158 Bust of a woman. Boisgeloup, 1931

159 Head of a woman. Boisgeloup, 1931–2

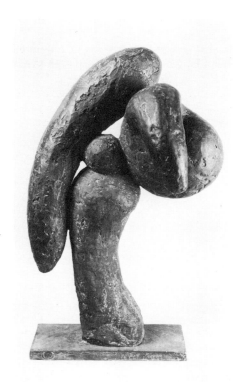

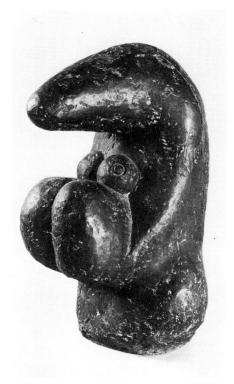

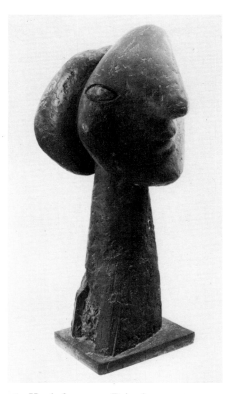

162 Head of a woman. Boisgeloup, 1932

163 Bust of a woman. Boisgeloup, 1932

164 Head of a woman. Boisgeloup, 1932

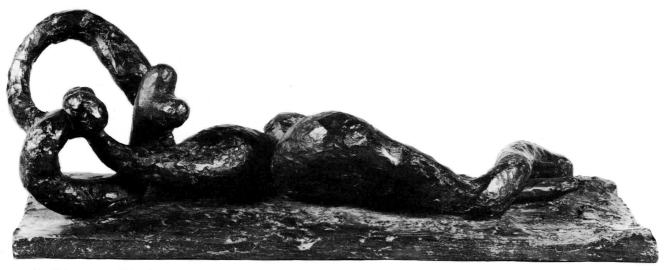

161 Reclining woman. Boisgeloup, 1932

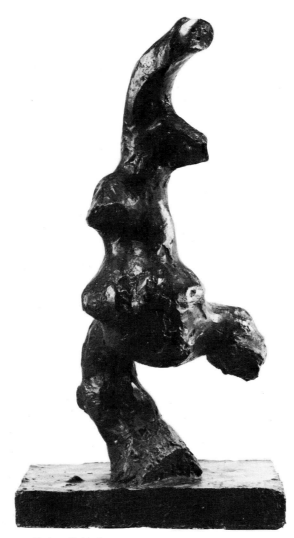

165 Bather. Boisgeloup, 1932

a kind of progress towards abstraction, and yet she seems to be more portrayed in the most extreme of the series than in the original, plainer statement. The whole sequence is in some kind of competition with the recently completed series of heads of Jeanette by Matisse. The wonderful little *Reclining woman* (161) is also Matissean: it recalls not only his early sculpture but also the *Nu Bleu* of 1907, one of the first of his paintings that Picasso had examined with real care, back in the days of their first acquaintance. All in all it is right that Picasso should have invoked Matisse, the great painter of the nude, as he embarked on the dozens of pictures of Marie-Thérèse which now followed.

In 1932, in the rather sumptuous surroundings of the Galeries Georges Petit, Picasso held a significant retrospective exhibition. It was probably the most important of his shows before Alfred Barr's thoughtful and balanced 'Picasso: Forty Years of his Art' at the Museum of Modern Art, New York, in 1939. Picasso, who on this earlier occasion selected his own show, borrowed back from various owners and used some of his personal pictures. The effect was electric. The exhibition was thoughtful in Picasso's way of being thoughtful, and was not balanced in the slightest. Most astonishingly of all, it did not seem like a retrospective: Picasso had somehow managed matters so that all the work seemed to have been painted yesterday. It was a pugnacious declaration that he was eternally young. Perhaps he thought that a new life was about to begin. Olga had gone away and taken Paulo with her. In all respects other than the legal the marriage was over. Picasso's work now tended to vary between repeated paintings of Marie-Thérèse, often reclining, often asleep, and an art of tense and violent iconography: this was usually graphic. It is an undercurrent that would come to the surface in *Guernica*. We find it in the drawings after the Grünewald crucifixion (299–306), in the drawing after the Marat picture (322), in the rapes that occur in the Vollard suite, in the numerous imaginings of slaughter and evisceration that are inseparable from the bullfight pictures. When less fierce, such subjects are often primitive: the drawing of a couple making love (312) was evidently made one day when the 1907 painting of the *Mother and child* (12) was in his mind. The approach to the primitive is most to be seen in Picasso's adoption of the minotaur. Half man and half beast, guardian of subterranean secrets, the minotaur had been a favourite figure for the surrealists. But their interest was only illustrational. For Picasso the monster was more than that. It

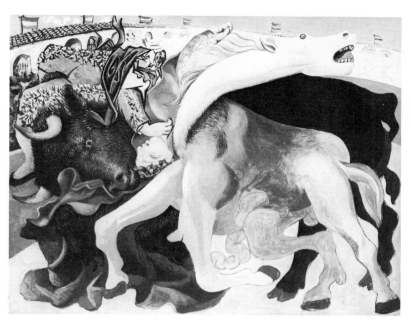

88 Bullfight: death of the bullfighter. Boisgeloup, 19 September 1933

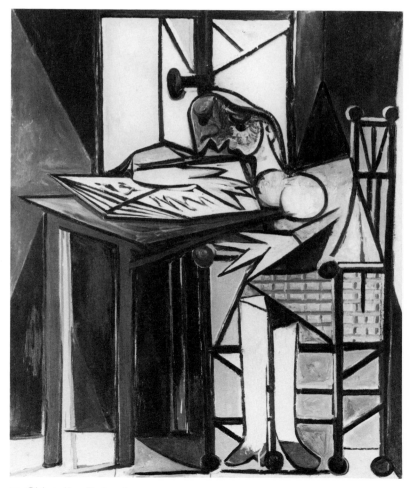

90 Girl reading. Paris, 9 January 1935

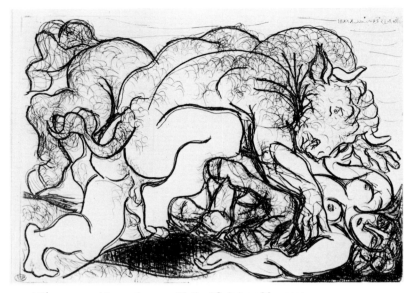

393 Minotaur attacking an Amazon (Vollard Suite). 23 May 1933

401 Blind minotaur guided by a little girl in the night (Vollard Suite). November 1934

was himself. The man who had made some of the most elevated art of our century could consider his nature to be only half human. What Picasso really thought about human life can scarcely bear contemplation: that is one reason why his political painting is a relatively minor part of his art. In one of the latest engravings of the Vollard Suite (400–2) the monster, who has been blinded, is guided by a little girl: he stretches out his hand either to touch or to fend off a diagrammatic sketch of the painting of Marat stabbed in his bath, a sketch which on the plate has itself been scored over, as though to destroy it.

In all these images of aggression and pain there are softer moments. There is no triumph over darkness, but there are occasions of respite, or escape. A group of drawings and paintings, represented here by two rather unassuming prints (375–6), are collectively known as *The rescue*. They have something to do with Marie-Thérèse, with drowning or escape from drowning, with water and reconciliation. But any optimistic aspect of Picasso's vision (and these images are more to do with deliverance than optimism) was submerged in domestic vexations, the depression, and war. The print of the *Minotauromachy* (405) belongs to the time when Olga finally left Picasso (though in a deranged way she would follow him everywhere he went) and Marie-Thérèse became pregnant. There was a crisis in Picasso's life the like of which he had not known before. Between May 1935 and February 1936 he did no painting at all but wrote experimental surrealist poetry. He appealed to a friend of his Barcelona youth, Jaime Sabartés, to come to look after his affairs. Gradually, Picasso resumed café life in Saint-Germain. He had some important exhibitions. One of them was in Barcelona: but very soon the Spanish war would start.

There is a sense in which the great absentee from this collection of Picasso's own work is *Guernica*. Most public of paintings, it is in another way personal and private to Picasso himself. For many years now it has been realized that the mural is not an immediate reaction to an outrage which it symbolically depicts. Rather, it is a résumé of many themes which lay deep in that part of Picasso's mind and personality we call his inspiration. Some of those themes we can trace in this exhibition: they go as far back as the 1902 drawing of the *Death of the bullfighter* (193). The question of the photographic record of *Guernica* is of interest. It had become a primary concern. This time all the preparatory drawings and the various states of the canvas were photographed by Dora Maar, who had become Picasso's new

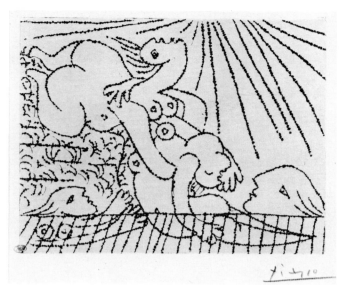

375 The rescue II. 18 December 1932

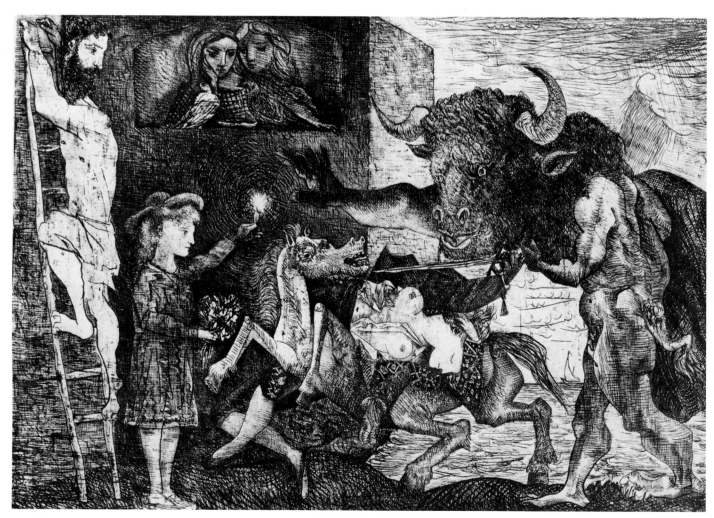

405 Minotauromachy. 1935

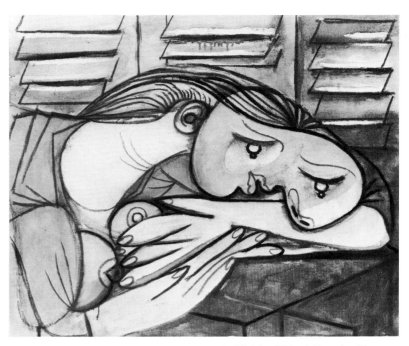

91 Portrait of a young girl. Juan-les-Pins, 3 April 1936

92 Sleeping woman before green shutters (Marie-Thérèse Walter). Juan-les-Pins, 25 April 1936

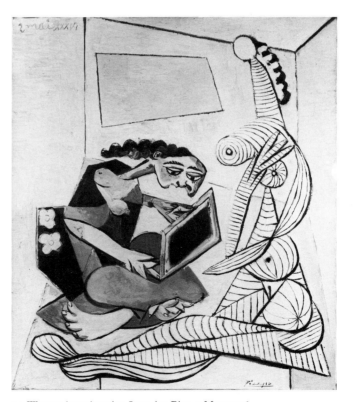

94 Women in an interior. Juan-les-Pins, 2 May 1936

mistress: and she had even found for him the big new studio in the rue des Grands Augustins in which the mural was painted. The various satellite paintings which surround *Guernica* left Picasso's hands. He retained some works which have a valedictory flavour. The moving *Sleeping woman before green shutters* (92) belongs to his last holiday with Marie-Thérèse before the Spanish Civil War broke out. They stayed at Juan-les-Pins, Picasso using his paternal name of Ruiz. A few days later came the gouache of the minotaur in front of a grotto (324). Has the drawing something to do with a farewell to innocence? The girl is holding up what appears to be her communion veil, through which she observes the beast and the dead horse. The

mysterious hands have an origin in some hands which appear in a prompter's box in a Rose Period painting of an actor (Metropolitan Museum of Art, New York). And indeed there is another precedent: the girl's gesture with the veil is that in the drawing of 1922 (289), where she sits in the encampment of wandering players.

Picasso's liaison with Dora Maar brought him no especial comfort or relaxation from the *ennuis* of his position as a married man. This collection of his own works does not exist for solely personal reasons. Legal entanglements have helped to keep it together. Since he had married under the French law of *communauté des biens*, a divorce from Olga would involve the loss of Boisgeloup, unimaginable amounts of money and unimagin-

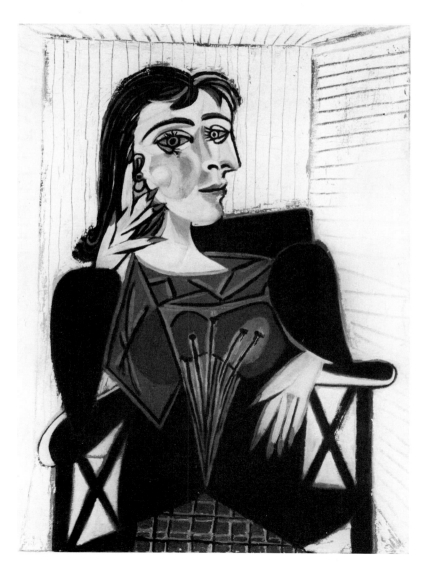

95 Dora Maar seated. [Paris-Mougins], 1937

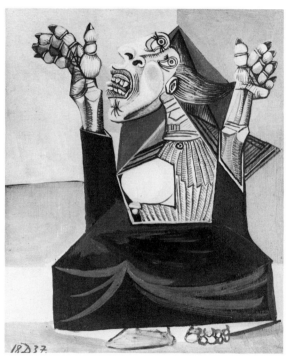

98 Suppliant. Paris, 18 December 1937

able quantities of art. The prospect was intolerable to Picasso, as it was to his dealers. Now, with the approach of war, all manner of things were deliberately hidden. Sabartés and Picasso between them devised ever more arcane and superstitious rituals, as if to keep the world at bay. Picasso was finding it harder to live as a normal person among other people. This was not only on account of his fame. It also had to do with his inability, after *Guernica*, to resume the normal rhythms of his creation: much work just before Hitler's war was liable to fall into mannerism and remain in mannerism.

In a way, the enforced stasis of the occupation put a stop to the agitation of Picasso's work in the late thirties. The personal collection was not much disturbed while the Germans held Paris,

and in its present form it gives us a representative view of the work of the occupation years. The art is not as political as one might have expected from the author of *The dream and lie of Franco* (408–10) and *Guernica*: nor is it as political as some of Picasso's work after the liberation. There are patriotic French overtones and many a reference to such matters as food shortages, but these things are not in themselves highly political: it was his presence in Paris, not his work, that counted. Picasso's painting in the war years is often rather blunt. The occupation put an end to the deep elaboration of his iconography. For a time, it looked as if his long career as an *animalier* was to be put to the service of themes of death and sacrifice: in the end, the theme is simply of killing. The unfinished horizontal painting known as *The*

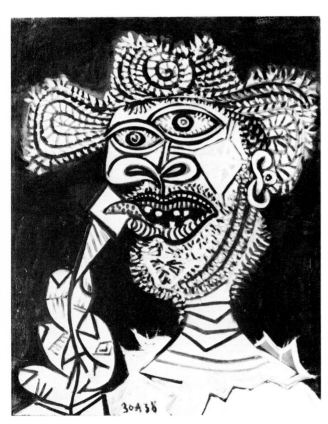

101 Man with an ice-cream cone. [Mougins], 30 August 1938

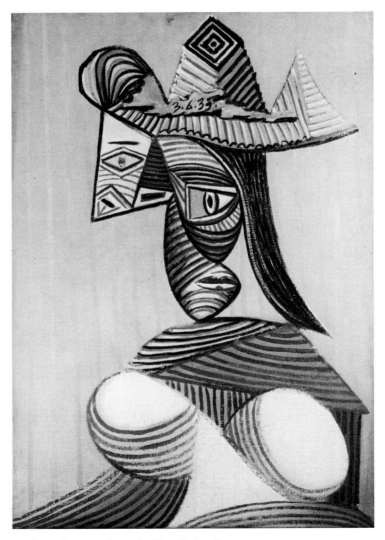

103 Bust of a woman in a striped hat. Paris, 3 June 1939

76

408 Dream and lie of Franco I. 8 January 1937

409 Dream and lie of Franco II. 8–9 January 1937

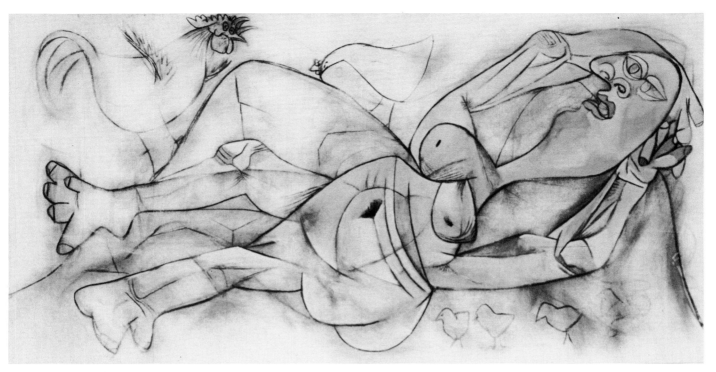

100 The farmer's wife. Paris, 23 March 1938

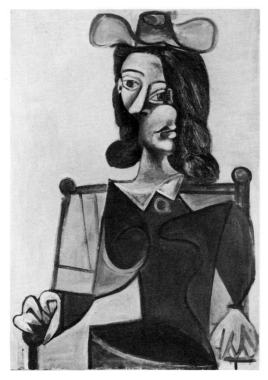

105 Woman in a hat. Paris, 9 June 1941

106 Child with lobster. Paris, 21 June 1941

farmer's wife (100) had already introduced the theme of the cock. Here is a farmyard animal, sexually active and a French patriotic symbol. But paintings and drawings of the war period show the animal with a girl, and in these the bird's legs are bound in preparation for a sacrifice. There is also a drawing of a sacrifice which is a reworking of the *Woman with stiletto*. But however much Picasso's mythological imagination was occupied with ritual, augury and appeasement of the gods, the bound cock could not but have appeared a defeatist statement at the time of the war. Finished paintings tend to be of such things as cats (wild: Picasso disliked domestic cats) that have caught birds, and still lifes with candles, skulls, and decapitated bulls' heads.

The sense of oppression inherent in such imagery is not much lightened by the paintings of the infant Maïa; and Picasso's wartime sculpture has not the nimbleness that was attractive in the *poupées* made for her in 1939. The theme of death underlies most of the sculpture. The popular *Head of a bull* (172) made out of a bicycle's saddle and handlebars is famous for the quickness with which Picasso realized that he could put the two together to make an image. He himself liked to stress the instant metamorphosis. But he must have had to laboriously unpick the saddle leather from its *chassis* in order to guarantee the outline of the bull's head when the piece is hung, as it must be, on a wall. The emotional point is that Picasso had transformed his son's wholesome interest in racing cyclists into his own obsessions (in this it is reminiscent of him dressing the child as Harlequin), had made a sort of fetish of death, a *memento mori*; for this is not a bull's head but a bull's skull.

Perhaps the piece concerns the recent death of Julio Gonzalez. But amid so much death, why think only of him? The human skull (170) of 1943 seems all-encompassing, the ultimate absence of iconography. Picasso's commentators

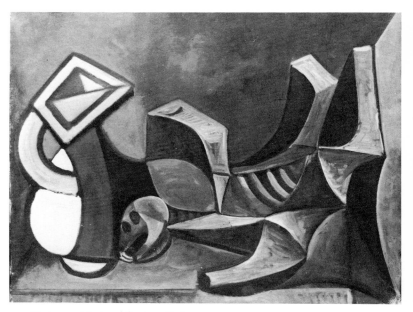

109 Pitcher and skeleton. Paris, 18 February 1945

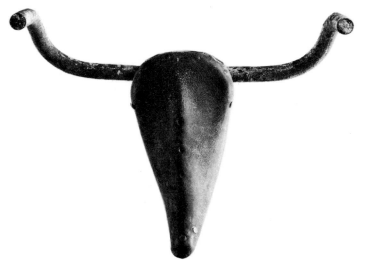

172 Head of a bull. Paris, 1943

173 Man with a sheep. Paris, 1944

have seldom dwelt on this extraordinary work. They prefer the dove of peace. The desire to interpret Picasso as a humanist is a strong one. The *Man with a sheep* (173) is often cited as evidence of his wide and kind concerns. More than one hundred drawings preceded the sculpture. As sometimes happened, Picasso was slow to begin work on a significant piece, then made it quite suddenly. Although the *Man with a sheep* is said to be humanitarian, that is far from being one's experience in front of it, and the assertion is not much supported by the iconographical evidence. Is this a king who is the shepherd of his people? Or a priest of some unknown religion who strides towards us, implacably set on some atavistic rite? In the drawings the lamb appears to have bound feet, and the purport of the piece is surely more to do with sacrifice than deliverance.

This forbidding work dominated Picasso's studio at the time of the liberation. There, for Americans and everyone else, he held the most extensive of those 'presentations' of his work that in former years had been confined to a few intimates. Some paintings were even buoyant. The landscape of *Le Vert-Galant* (107), painted during the war, represents a corner of the Île St-Louis much used by lovers. The trees in this nice picture stretch and jump in just the fashion of Picasso's ball-playing bathers of years before. Its plain but far from artless style was the sort of manner that might have been suitable for a communist painter, had he wished to be such a thing.

Picasso was a symbol of the liberation and would soon become, however imperfectly, a symbol of international communism. The tone of his work lightened considerably, not necessarily with the liberation, perhaps with the recognition that the young Françoise Gilot – who lived with him for ten years and is the mother of Claude and Paloma Picasso – offered him a new youth.

L'Humanité, the French communist newspaper, announced that he had joined the party just two days before the opening of a retrospective of his work of the war years at the Salon d'Automne. It was the first time he had ever exhibited there. Picasso had never been such public property as he was now. He felt no new obligations. In the summer of 1946 he took Françoise down to the Midi for the first of his increasingly long sojourns in the different atmosphere of the Mediterranean.

Picasso's post-war pastoral is not much represented in the collection as it stands today. Nymphs, fauns, centaurs replace the minotaur. Animals such as the goat, the owl and the dove have less deathlike implications. They were all pets around the various houses in which Picasso and Françoise

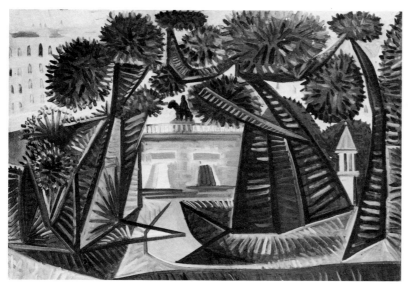

107 Square Henri IV ('Le Vert-Galant'). Paris, 25 June 1943

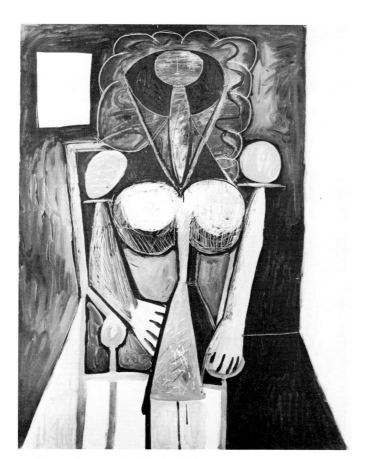

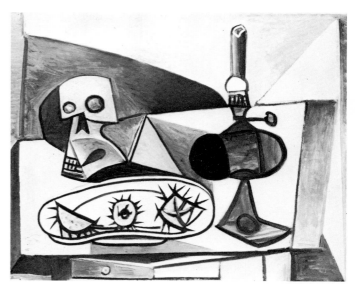

111 Skull, sea urchins and lamp on a table. [Antibes-Paris], 27 November 1946

110 Woman in an armchair. Paris, 3 July 1946

113 The kitchen. Paris, 9 February 1948

176 Pregnant woman. Vallauris, 1950–9

lived. In Paris, their kitchen (with caged birds which are reproduced in the picture) became the subject of a work which Picasso regarded as a challenge (113). So sparsely furnished was this room that Picasso thought that to depict it was to make a painting 'out of nothing'. He might also have been slightly stung by the new abstract art in Paris, made by the generation to which Françoise (she was a painter) belonged. Not surprisingly, Picasso took up *The kitchen* with his most abstracted previous large-scale pictures in mind, *The painter and his model* (62) and *The milliner's workshop*, both of 1926 and still in his own collection at this time. The latter of these paintings, with some others, Picasso shortly afterwards gave to the Paris Musée d'Art Moderne.

It is a surprising fact that Picasso's work was still without official museum recognition in France. There were not more than a handful of his pictures in any public collection. As this gift was made, the then Director of the Louvre invited Picasso there on a day when it was closed to the public. The idea was that Picasso would match his own work against the old masters. Françoise records that he was especially eager to see how his still lifes looked beside Zurbarán and Delacroix. But whatever the interest of this exercise, the results were bound to be inconclusive. One feels rather the same about the transcriptions from old masters that occupied Picasso in his late years, especially in the 1950s. They are not quite landmarks in his career, and while only an exceptional artist could have executed them they are not achievements in the way that so many of Picasso's independent pictures had been. Picasso worried about their difficulties but he also took simple pleasure in them. In some ways they are rather simple pictures. It was not particularly Picasso's purpose to further elaborate on the implications of Velázquez's *Las Meninas* or to make more gorgeous Delacroix's already exotic *Femmes d'Alger*. These variations (342–56) show a contentment on Picasso's part. The energy of application is undiminished: but the dash and brio of Picasso's brush, becoming on occasion now more ragged, is what we would expect to find of him in old age, restless yet habitual, as much predictable as searching.

Picasso still made unerring pictures by looking at his own contemporaries. *Smoke over Vallauris* (115), for instance, is rather more than a view of the pottery-making, communist town which was frequented by Picasso in the post-war years, and where he made the large part of his ceramics. For there are some pictures by Derain which are very like it. If Derain had long since disappeared from

116 Goat's skull, bottle and candle. Paris, 25 March 1952

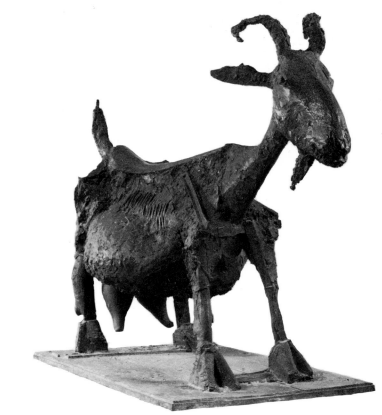

177 She-goat. Vallauris, 1950

115 Smoke over Vallauris. Vallauris, 12 January 1951

his life, Picasso still had vivid memories of their early cubist days together. Other paintings inevitably recall Matisse. *The shadow* (117 colour plate) otherwise known as *The artist's bedroom* is of the winter of 1953 and seems To record how Françoise had left him a month or two earlier. Once again the evidence of a photographer is of use. David Douglas Duncan (whose picture book *Picasso's Picassos* first told the world at large of the riches of this collection) was told by Picasso, in front of this canvas 'It was our bedroom. See my shadow? I'd just turned from the window – *now* do you see my shadow and the sunlight falling onto the bed and across the floor? See the toy cart on the dresser, and the little vase over the fireplace? They're from Sicily and still around the house.' The toys were useless, for Françoise had taken the children with her. Their departure left Picasso with a mixture of desires and a new realization of his age. *The shadow* has a black self-dramatization in it. A suite of drawings followed. But now the nature of the artist's transformations is not so potently a theme as is his senility and his model's vivacity. The artist is transparently a self-portrait. These were very frank works, and in comparison to them Françoise's book *Life with Picasso* (which was published some years later) appeared to be not only misleading but also inimical to art. It was not a contribution to Picasso's 'science of mankind'.

Picasso did not long live alone after Françoise had left him. Jacqueline Roque, whom he had met at the Vallauris pottery, moved in to look after him. They were married in 1961, when Picasso was nearly eighty. Their life together can be regarded as Picasso's retirement. But he was only retired in the sense that his life became less turbulent. For he continued to work ceaselessly. In terms of their numbers, he may have produced more paintings now than at any time in his life. The really successful pictures are fewer by far, but still he produced the works of a master. None of them is resigned to physical retirement. *The studio at Cannes* (119 colour plate) is a most touching painting but it is also optimistic. It is a picture of one of the rooms in the large villa 'La Californie', above Cannes, to which he and Jacqueline removed in 1955. At long last, he gave in this picture an untroubled reaction to Matisse. It is his recognition of his old rival's many Côte d'Azur interiors and his work on the chapel at Vence. But the virgin white canvas on the easel is a rather pointed statement that there was more work by Picasso to come; and the way that the colour on the right-hand canvas is made to jump from its grey and bistre surroundings is emble-

84

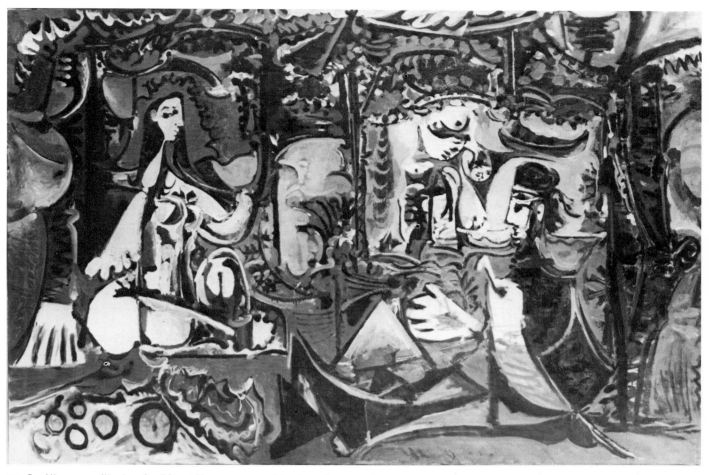

122 Le déjeuner sur l'herbe, after Manet. Vauvenargues, 3 March–20 August 1960

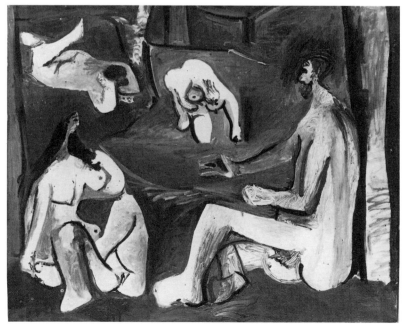

123 Le déjeuner sur l'herbe, after Manet. Mougins, 13 July 1961

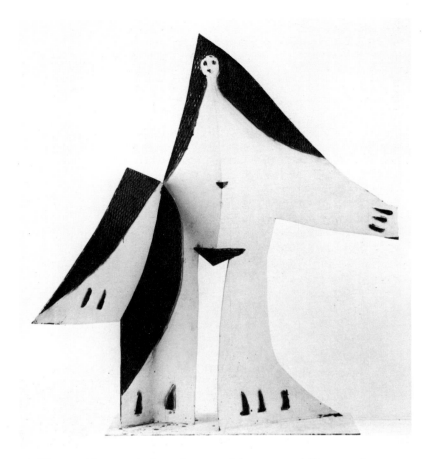

182 Woman with outstreched arms (maquette for a monument). Cannes, 1961

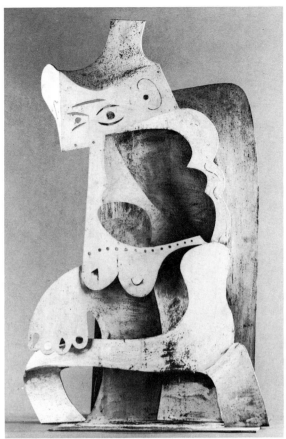

184 Woman with hat. Cannes, 1961 (painted Mougins, 1963)

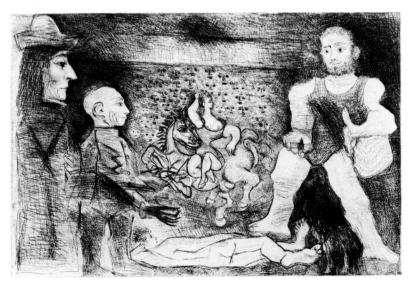

439 Etching. 16–22 March 1968

matic of a vigorous light-heartedness that came to Picasso in old age.

His new surroundings in 'La Californie' made only minor differences to Picasso's habits with his possessions. They simply occupied more rooms. Soon the villa was transformed into what one visitor described as 'a camp-site for millionaire gipsies'. But the gates had to be locked against the outside world and the streams of visitors. The high-rise blocks and speculative building that soon were to force Picasso into further isolation can be seen in the dazzling *Bay of Cannes* (120 colour plate). Its vibrant and unerring application reminds us that, even in old age, Picasso never made a painting casually. His incisiveness, however, and that neatness which had made him such a miniaturist in years gone by, is now found more frequently in pen drawings and graphics. His last concerted achievement was in a series of no fewer than 347 engravings that were made in seven months in 1968 (439–42). If the *Vollard Suite* was rich and various, then this series (made in a much shorter space of time) is richer still. Artistic and personal preoccupations are mingled, but Picasso now was able to be autobiographical to an extent we have not seen before. The series contains numerous self-portraits of himself both young and old; it resumes his favourite old themes from circus, bullfight and Spanish theatre. There are masks, models, animals and erotic encounters. It is as though the technique of the graphics not only gave zip to Picasso's expression but also acted (as the softer paintbrush did not) as the agent of memory of all his art. Some people have maintained that Picasso's genius, all his life, was essentially graphic. Perhaps it was. But he was also a born sculptor, and some of the cut metal pieces from the early sixties, in particular the *Woman with outstretched arms* (182) and the *Woman with hat* (184), have an excellent simplicity

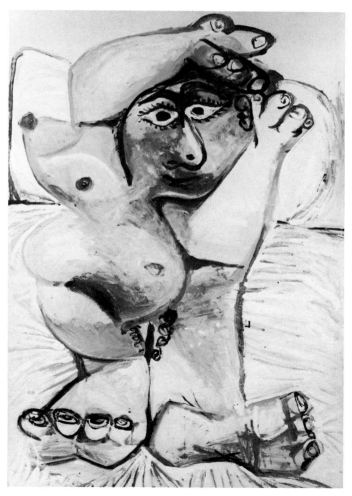

124 Sleeping nude. Mougins, 14 June 1967

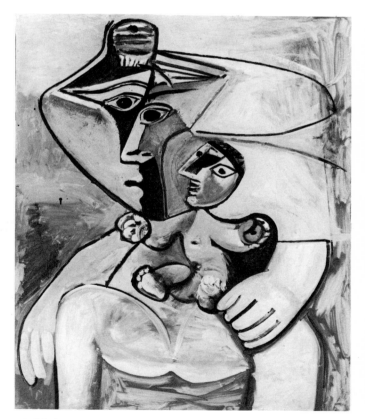

128 Mother and child. Mougins, 30 August 1971

that seems to strike back to the old heart of his three-dimensional originality.

It is still not possible, even in his final years, to imagine Picasso without a paintbrush in his hand. In his last two resting places, the château of Vauvenargues and then 'Notre-Dame-de-Vie', at Mougins, he was as restless as he always had been if he was not painting. He painted his own old subjects time and again, with the result that their thematic content was practically neutralized, and what was left was simply the unending practice of painting. In the *Sleeping nude* (124) of 1967 the creamed whites and greys, the touches of maroon and hints of lavender, the loading and stroking of the brush, its turns and dabs, all seem more important than the image of the woman herself. It is a lesson that she was mortal, while his art was not.

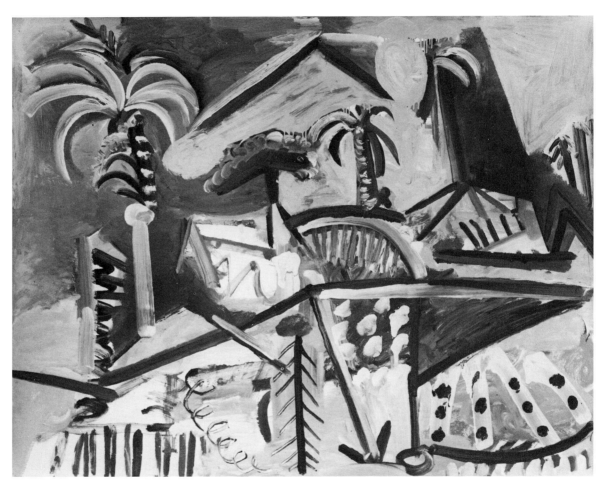

129 Landscape. Mougins, 31 March 1972

THE DRAWINGS OF PICASSO

THE DRAWINGS OF PICASSO *ROLAND PENROSE*

I once saw Picasso make a drawing for two friends whose wedding we were celebrating. As I stood beside him it appeared out of nothing like magic before my eyes. The precision with which his hand traced a line on the blank paper made me feel that the drawing of two clasped hands with a dove hovering above them that emerged had been there already and that he was retracing its invisible presence, so definitive and unhesitating was the line that came from his pencil. Years later I was able to witness that he never lost his talent, this amazing accord between hand and eye. The moment when the invisible took shape could indeed come suddenly and spontaneously, but he did not always allow it to happen in this way. He once said to Herbert Read when they met at an exhibition of children's drawings, 'At their age I could draw like Raphael, but I have spent all these years learning to draw like them.' Drawing could be a long and dramatic process of exploration, a tentative approach with all the value of a surprise attack on the elusive nature of reality. It was never the method of a craftsman patiently arriving at perfection according to set rules, but a creative struggle. 'We are not executants; we live our work,' is Picasso's own description of the difference between the painstaking draughtsman and the achievements of the creative artist.

In the selection of drawings that we have in this exhibition, all of which were, for one or another reason, kept among his possessions and which have in some cases never before been shown to the public, there are studies ruminated during long periods, often repeated with drastic variations, and closely connected with the subversive activity of his thought, with problems he had been digesting, playing with, changing and seeing from new angles over periods of varying length and intensity. Sometimes they form a sequence and sometimes they reappear as isolated eruptions, the renewed outburst of a theme that had continued to obsess him throughout his life.

The novelty and excitement of cubist inventions was never forgotten. They reappear throughout in modified form, and his impersonations of characters such as Harlequin, the artist with his model and the Minotaur, come and go according to his inner thoughts, influenced inevitably by his love affairs and major events in the outer world such as war and political outrage.

These works demand careful study because drawings in general and Picasso's drawings in particular can give access to the artist's thought from the kindling of an idea to the fire it produces in finished works. On these they shed a flood of light whether in paintings, sculpture, or any new form they may suggest. In the work of Picasso they are the forerunners of the great flow of his achievements throughout.

We are particularly fortunate to have so generous a spread of drawings from the cubist period. During these years he was not rich and was able to keep very few of his paintings, but many of the drawings that accompanied them, fertile in the advent of a

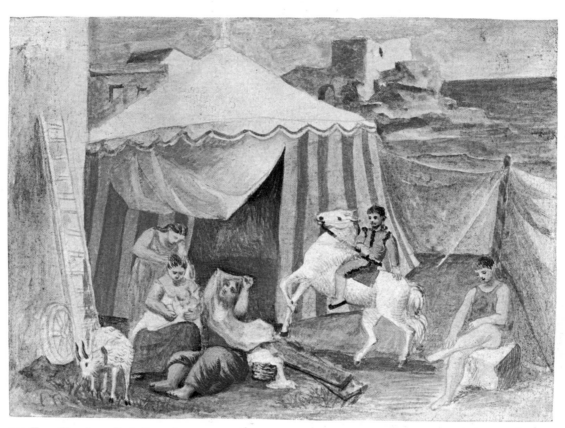

290 Travelling circus. Paris, December 1922

209 Sailors in a brothel. Paris, winter 1906–7

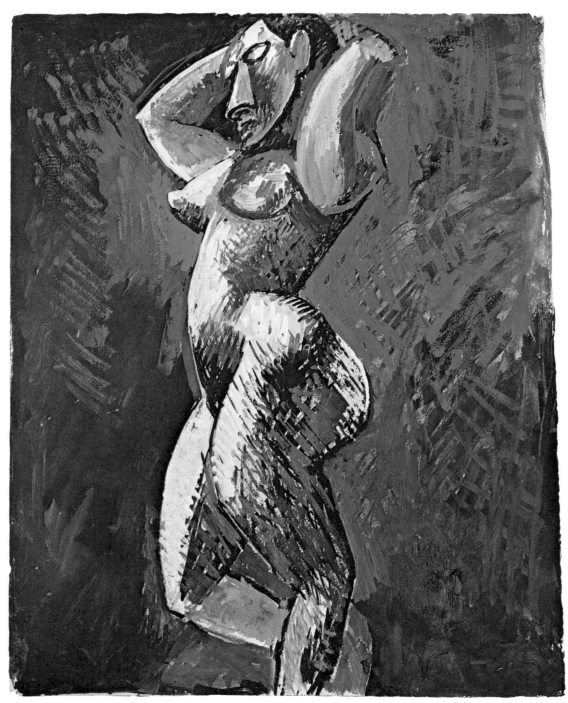

216 Nude with raised arms. Paris, spring 1908

250 Composition. Paris, winter 1912–13

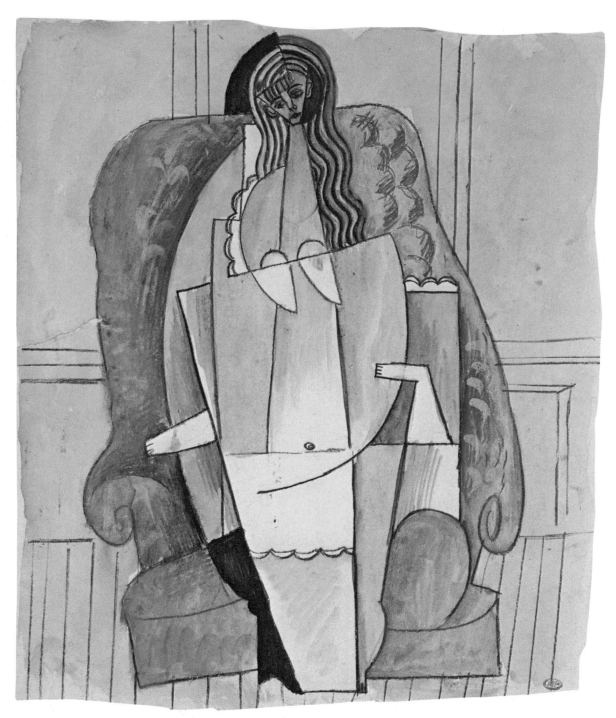

255 Study for 'Woman in an armchair'. Paris, autumn 1913

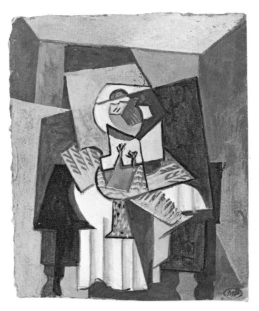

274 Still life on a table. Paris, 1919

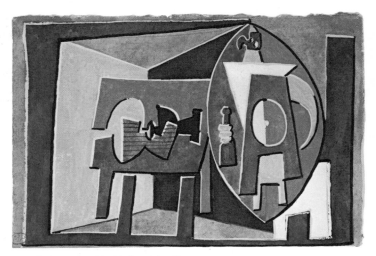

281 Guitar on a table. Paris, 26 April 1920

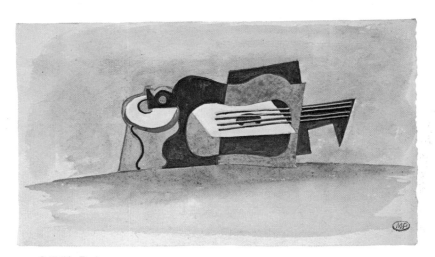

272 Still life. Paris, 1919

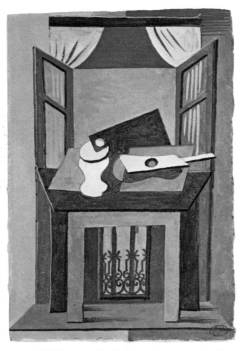

273 Still life on a table in front of an open window. Paris, 1919

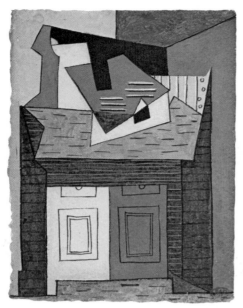

276 Still life on a sideboard. [Juan-les-Pins], 1920

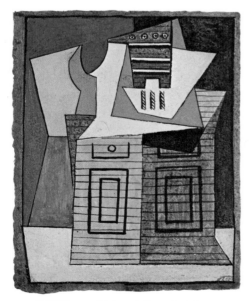

277 Still life on a sideboard. [Juan-les-Pins], 1920

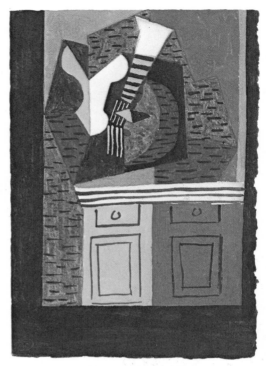

280 Guitar and sideboard. Paris, 19 February 1920

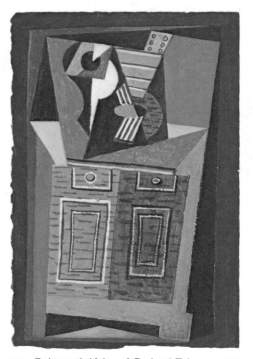

279 Guitar and sideboard. Paris, 18 February 1920

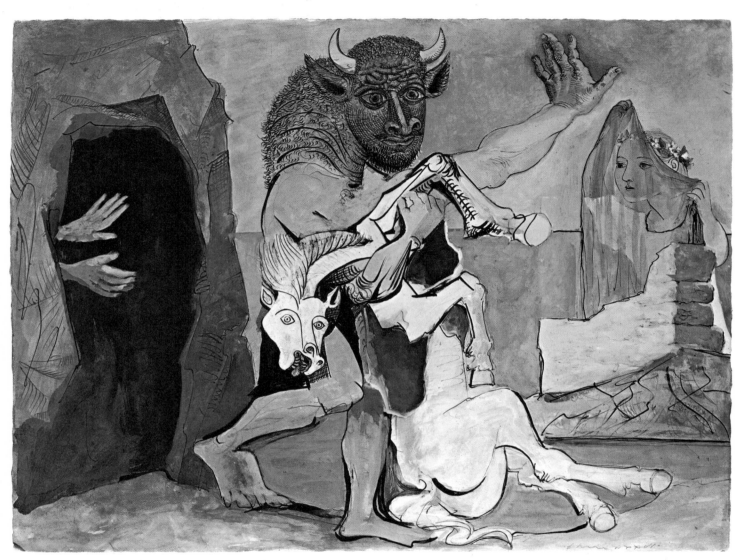

324 Minotaur and dead mare before a grotto. Juan-les-Pins, 6 May 1936

276 Still life on a sideboard. [Juan-les-Pins], 1920

280 Guitar and sideboard. Paris, 19 February 1920

277 Still life on a sideboard. [Juan-les-Pins], 1920

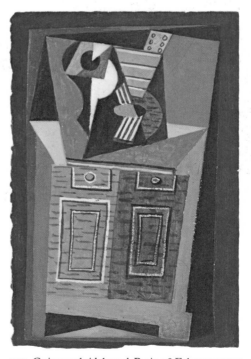

279 Guitar and sideboard. Paris, 18 February 1920

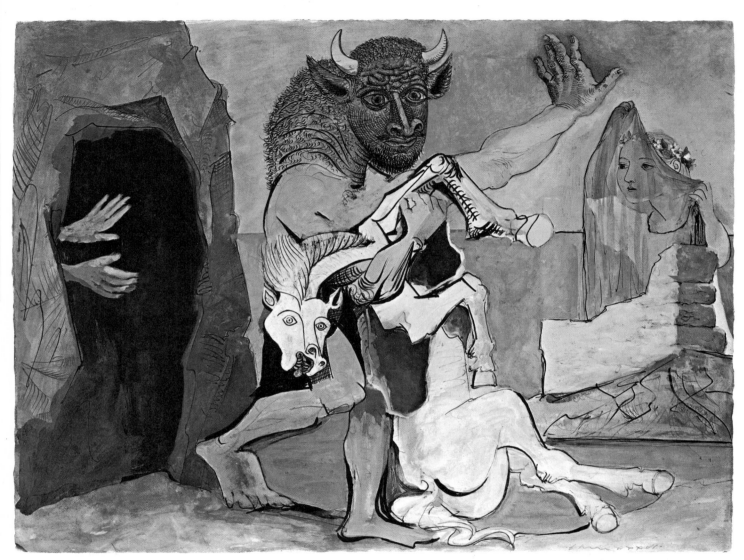

324 Minotaur and dead mare before a grotto. Juan-les-Pins, 6 May 1936

new conception of vision, stayed with him and now enable us to understand more of the development of this revolutionary trend. Realising how profoundly important this period was from a metaphysical point of view, it is important to notice that in his dissection of form he frequently returned to fundamental signs and objects such as numbers, letters, musical instruments, bottles, pipes or fruit, not to mention words from newspapers that appear as basic guides. These signs were the genesis of the language to which he was giving life. They remind us of the fact that Picasso never divorced painting from the basic reality of daily life. 'Like all Spanish painters,' I once heard him say, 'I am a realist,' implying that reality lay beneath the surface and could only be perceived by an assimilation of our daily view of the world with a deep probing into all that lies beneath appearances.

If we compare two 'surrealist' drawings of 1934 (319–20) with a few lines from a poem he wrote in 1936 (321) we may understand something of the nature of his thought:

> on the curtain unhooked from flying hands by the hair of the open sea
> the ladder of the perfume of leaves of verbena
> fixed by the cries of swallows in their geometric flights of desire
> the *pot au feu* at the full gallop of the prism
> flower-weapon driven into the heart
> expires its indifference

such metaphors crowding together present new visions of our daily experience.

In the climate of startling kaleidoscopic change through the work of Picasso there are however certain obsessive themes that recur throughout. There is one of which this exhibition gives us important evidence. It is a theme which has been largely ignored owing to the accepted belief that Picasso was a revolutionary and an atheist who was intent on a revaluation of conventional standards, a man who saw with new vision the time-honoured or dishonoured myths of religion. This theme, which from the evidence of his drawings must have moved him deeply from early youth to old age, was the crucifixion, being both a violent, unspeakable crime and the traditional act of renewal of life. The evidence of his passionate interest is to be found, except for one small painting of 1930, only in his drawings. It reappears spasmodically, separated by long gaps, but is always treated with passionate intensity. It is to be found first in a drawing made in 1890 when he was nine years old, again in 1896 and 1903. Then after a long gap it reappears with more force in 1918 (268). Apart from the great painting *The Dance* of 1925 (now in the Tate Gallery), about which critics have with some reason claimed that the theme is fundamentally based on the idea of crucifixion, it was in 1932 that he became engrossed in a long series of variations on the *Isenheim Crucifixion* of Grünewald, in which Picasso transforms human bodies into anthropomorphic shapes of stone or bone (299–306). This series appears to be an episode, an enquiry into the possibilities of translating the theme into sculptural abstractions, but already in 1926–7 there were drawings that show that Picasso was passionately contemplating a form of representation more closely allied to the pre-Christian and traditional symbols contained in the myth and to the indescribable human suffering inseparable from the story. In 1930 there appeared the only painting dedicated to the crucifixion (77), a cryptic work with violent contrasts of colour, which he always kept in his

possession. But during the year when the defeat of the Spanish Republic began to seem certain the most violent expression of his fury appeared. The drawing dated 21 August 1938 (332) is probably the most imaginative and blasphemous comment on the drama of crucifixion ever made and at the same time the most enlightened, candid version of this sadistic death sentence. It is also a compassionate and astonishing story of rebirth. This is followed by a series of twelve drawings made in the fifties in which the ancient Christian legend became linked with wit to the archaic ritual of the bullfight.

It is impossible for any exhibition to give a complete survey of a life work so vast and significant in all its variety, but we have here, thanks to the admirable choice among thousands of drawings made originally by Dominique Bozo for the new Musée Picasso, an excellent opportunity to enlarge our knowledge of many aspects of Picasso's drawings formerly scarcely known, and we can perceive more clearly his ardent wish to open to us a more complete and truthful vision of reality. We can follow his ability to draw portraits which continue to live before our eyes and the invention of new anatomies due to his destruction of the conventional canons of beauty, which arise from his desire to destroy in order to recreate. Finally we can enjoy the disquieting power of his humour, which like poetry lives in the crannies of the unconscious; all this reveals to us a more intense understanding of his genius.

7 June XXXVI

on the curtain unhooked from flying hands by the hair of the open sea
the ladder of the perfume of leaves of verbena
fixed by the cries of swallows in their geometric flights of desire
the *pot au feu* at the full gallop of the prism
flower-weapon driven into the heart
expires its indifference
his costume powders the cup made in the form of an eagle's head
with snows of music with arrows of the harlequin
the scythe harvester of stars
arms beneath the embroidery of the sleeves of the bodice
unties the knot of vipers of the tree of the watching lights fallen asleep
on the slow fires cutting the odour of the silence
hanging from the slats of the blind
a kind of drum beating the call to arms to the mathematical point of his love
in the astonished eye of the bull wings spread
swimming naked in the odour of the blue strangled at the neck of the sun in dust
hidden under the bed shivering
mired in the shadow of the lash of the whip stammered by the bloodless wind
cowering in the ball of memories thrown in the ash
at the instant when the wheel balances its chance

15 June XXXVI

laughs the garlic with its colour of star dead leaf

laughs with its mocking air to the rose the dagger
that its colour drives in the garlic of the star in dead leaf

laughs with its malicious air to the dagger of the roses the odour
of the star falling in dead leaf

the garlic of the wing

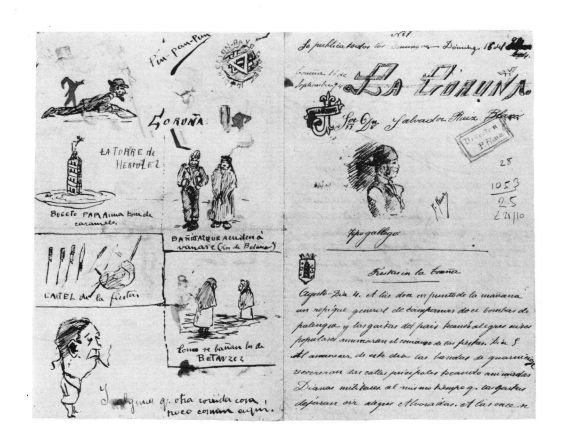

187 (recto and verso) 'La Coruña'. La Coruña, 16 September 1894

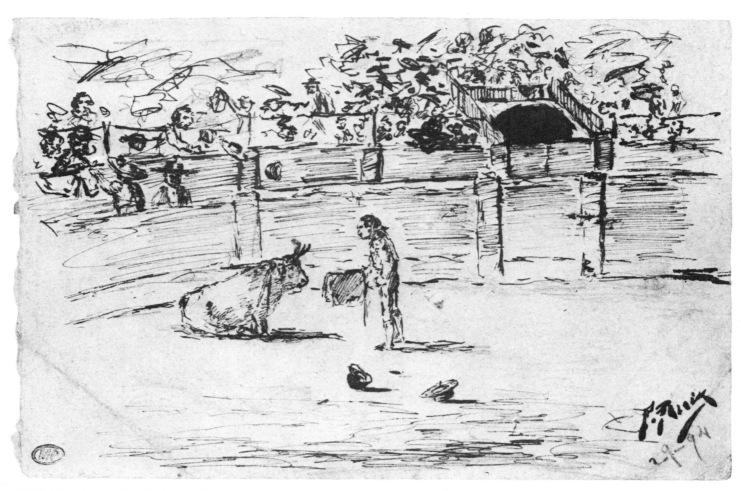

186 Bullfight. La Coruña, 2 September 1894

188 Study of a torso, after a plaster cast. La Coruña, 1894–5

192 Study for 'Evocation'. Paris, 1901

191 The prisoner. Paris, 1901

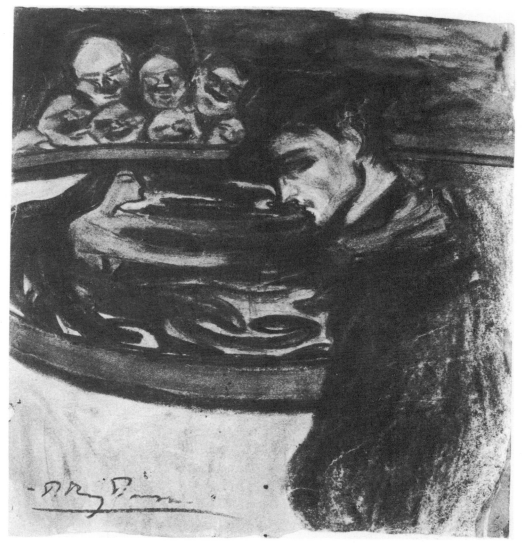

190 Young man, woman and grotesque heads. Barcelona, 1898

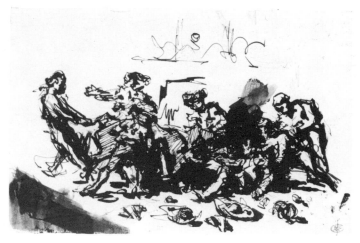

189 Bull-running. Barcelona, 1896

196 The plain and simple story of Max Jacob and his glory, or virtue's reward. Paris, 13 January 1903

194 Erotic scenes. 1902

200 Caricature: the dance of Salome. [Paris, 1904]

199 Caricature: the duel. [Paris, 1904]

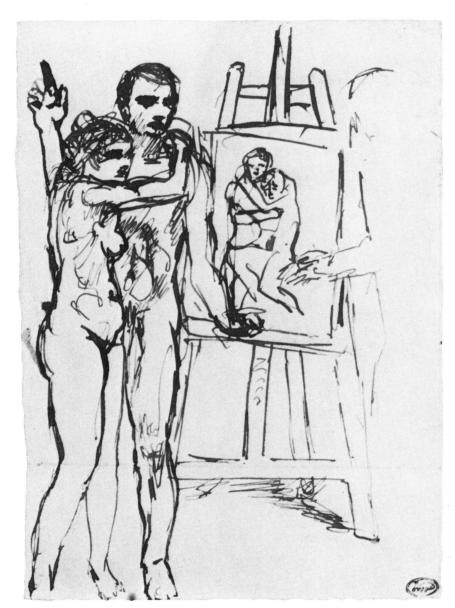

197 Study for 'La Vie'. Barcelona, 1903

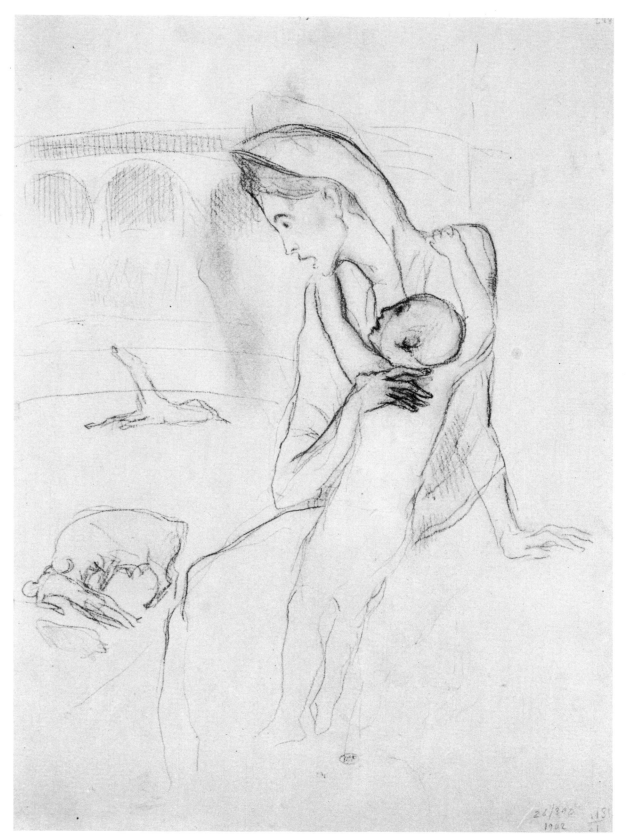

193 Death of the bullfighter. Barcelona, 1902

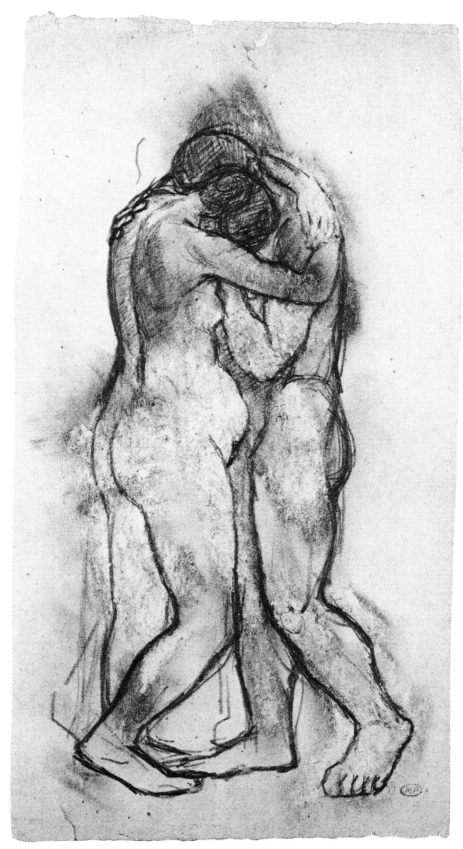

198 Study for 'The Embrace'. Barcelona, 1903

195 Women and child. Paris, 1903

201 Clown and acrobats. Paris, 1905

114

202 Obliging woman. [Paris], 1905

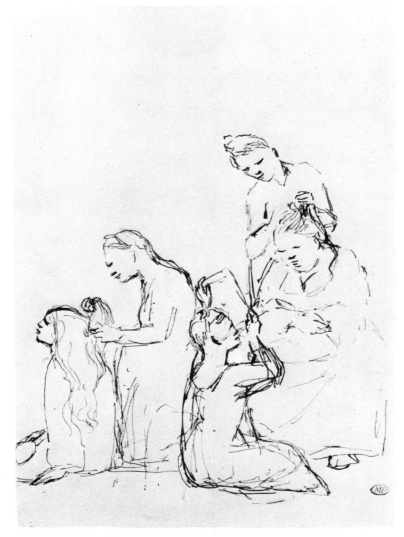

203 Women dressing their hair. [Gosol – Paris], 1906

208 Nude study for 'Les Demoiselles d'Avignon'. Paris, 1906

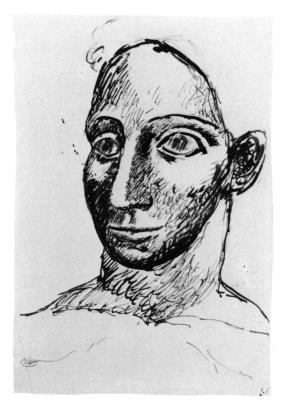

205 Head of a woman. [Gosol – Paris], 1906

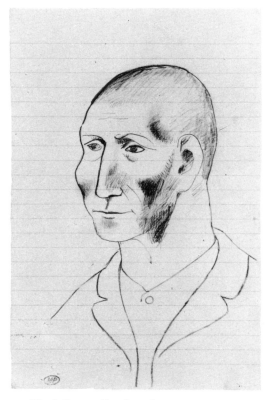

204 Head of a man. Gosol, 1906

206 Seated woman. Paris, autumn 1906

207 Study for 'Two nude women'. Paris, autumn 1906

208 (verso) Head of a man. Paris, 1906

210 Study for 'Les Demoiselles d'Avignon'. Paris, 1907

211 Study for 'Les Demoiselles d'Avignon'. Paris, 1907

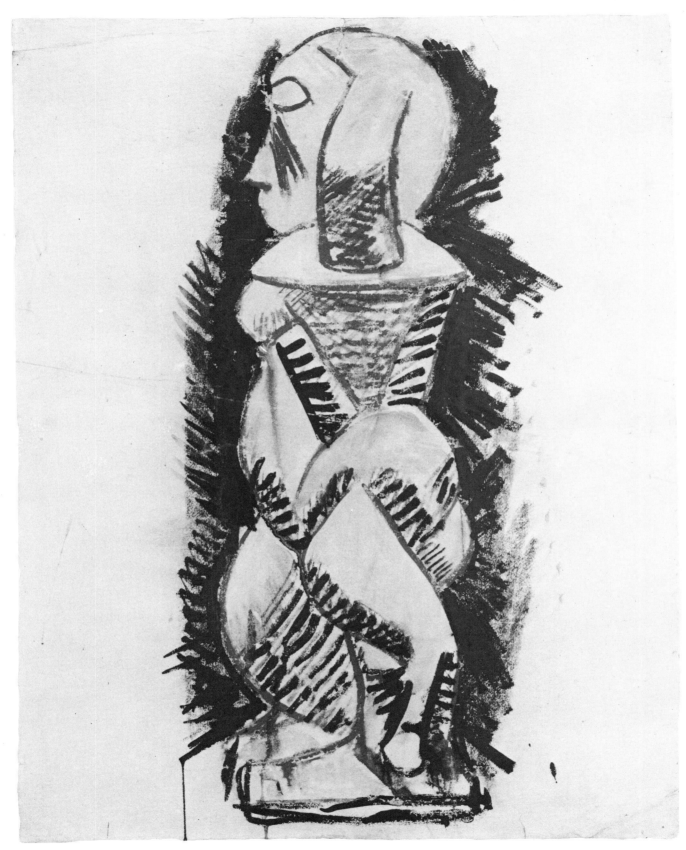

212 Standing nude in profile. Paris, summer 1907

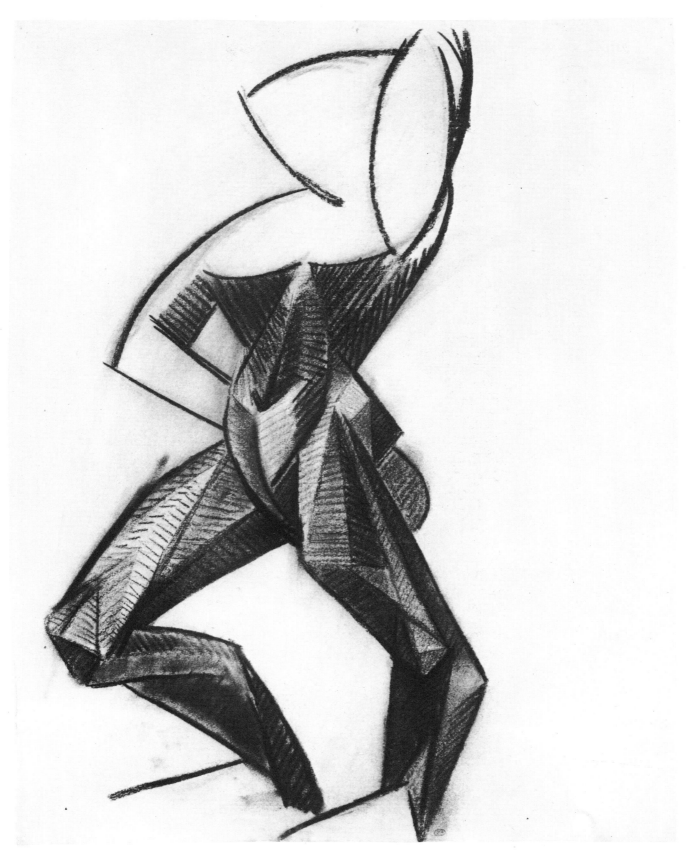

214 Standing nude. Paris, 1907–8

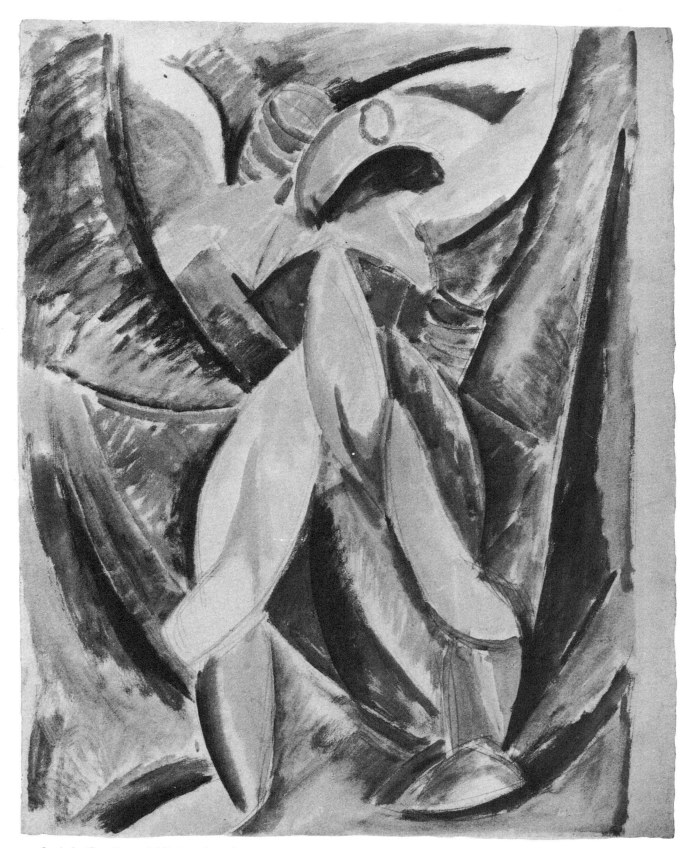

215 Study for 'Standing nude'. Paris, early 1908

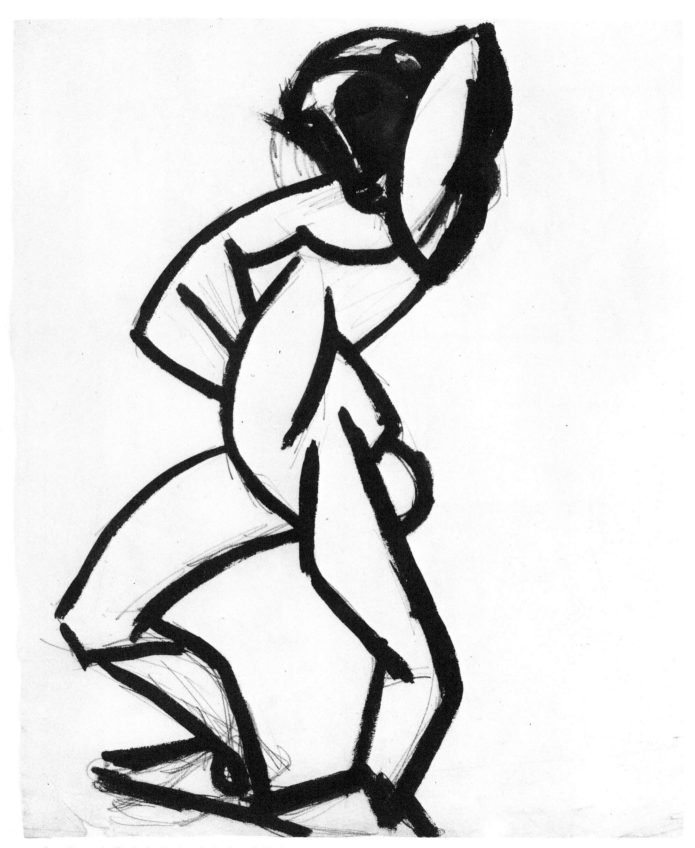

213 Standing nude (Study for 'Bathers in the forest'). Paris, 1907

218 Study for 'Three women'. Paris, spring 1908

217 Study for 'Three women'. Paris, spring 1908

219 Study for 'Three women'. Paris, spring 1908

221 Study for 'Three women'. Paris, spring 1908

220 Study for 'Three women'. Paris, spring 1908

222 Study for 'Bathers in the forest'. Paris, spring 1908

223 Study for 'Bathers in the forest'. Paris, spring 1908

227 Women in the forest. Paris, 1909

226 Study for 'Carnival at the bistro'. Paris, early 1909

225 Study for 'Carnival at the bistro'. Paris, winter 1908–9

224 Study for 'Carnival at the bistro'. Paris, late 1908

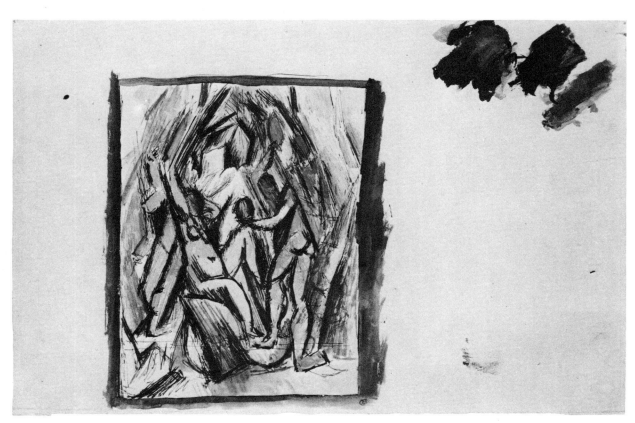

228 Nudes in the forest. Paris, 1909

230 Houses and palm trees. Barcelona, 1909

229 Seated nude. 1909

231 Head of Fernande (study for sculpture). Horta de Ebro, summer 1909

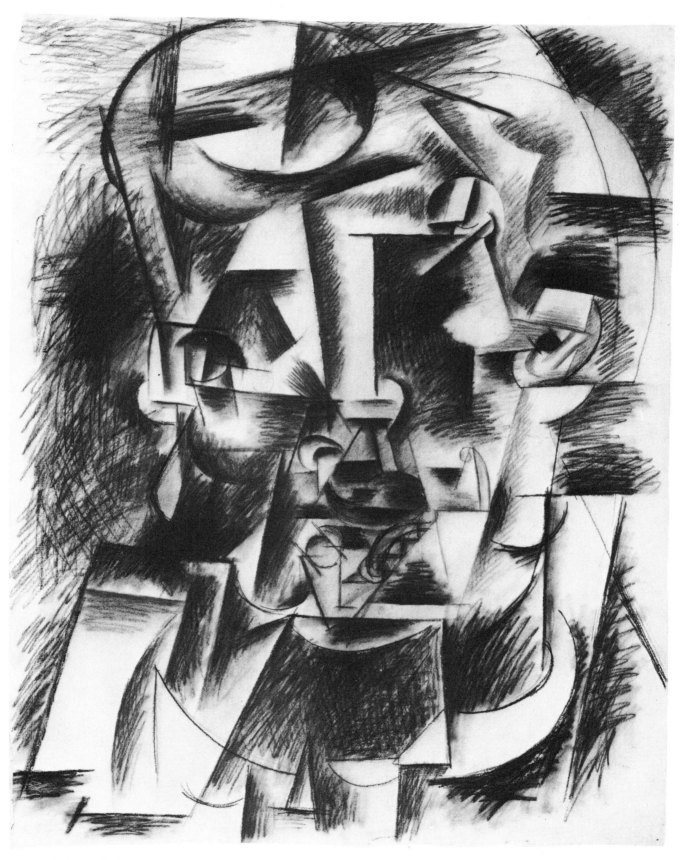

232 Head of a man. Paris, 1910

234 Seated figure. 1910

235 Sleeping nude. 1910

233 Standing figure. 1910

236 Man with clarinet. Céret, summer 1911

237 Man with guitar. [Paris – Céret], 1911

238 Still life with bunch of keys. [Paris-Céret], spring 1912

243 Guitar player. Paris, 1912

242 Still life with guitar. [Sorgues], 1912

241 Man with violin. Sorgues, summer 1912

244 Guitar player. Sorgues, 1912

247 Still life on a table. 1912

239 Man with violin. Céret, spring 1912

245 Man with clarinet. Sorgues, 1912

246 Man with clarinet. [Sorgues], 1912

240 Man with mandolin. Sorgues, summer 1912

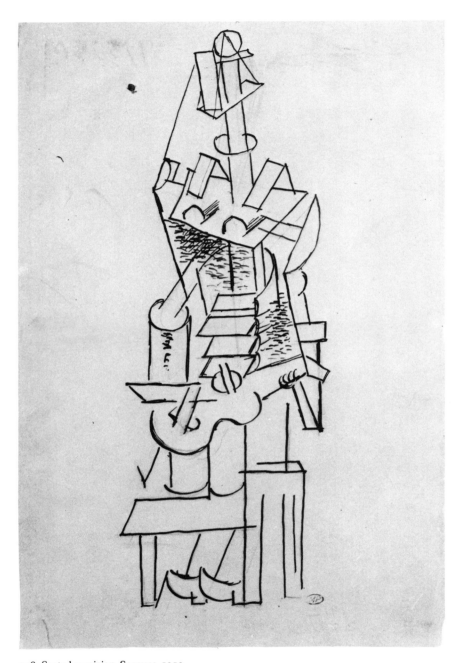

248 Seated musician. Sorgues, 1912

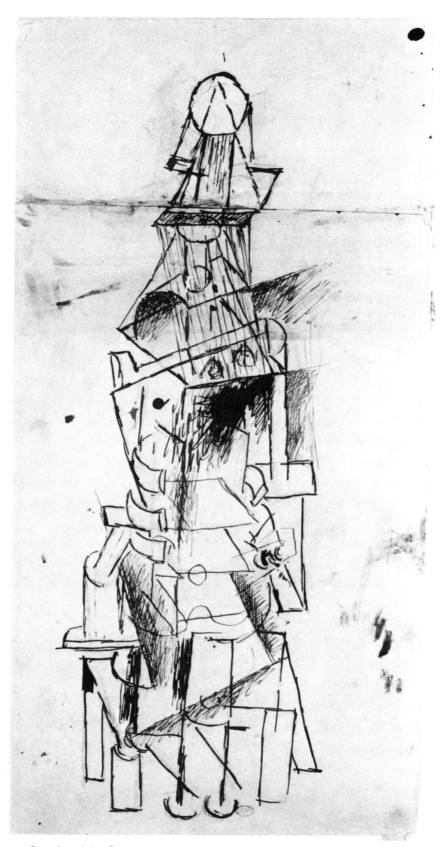

249 Seated musician. Sorgues, 1912

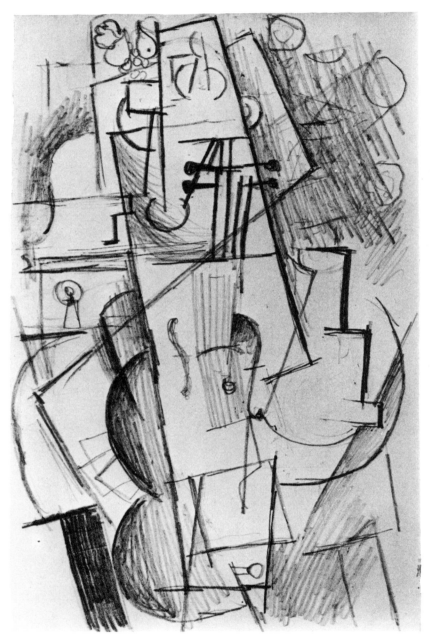

252 Still life on a table. Paris, 1913

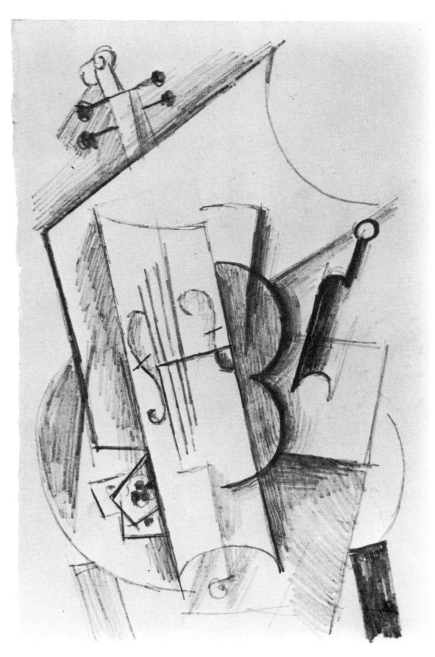

253 Still life: violin, bottle and playing cards (Study for 'Guitar and bottle of Bass').
Paris, 1913

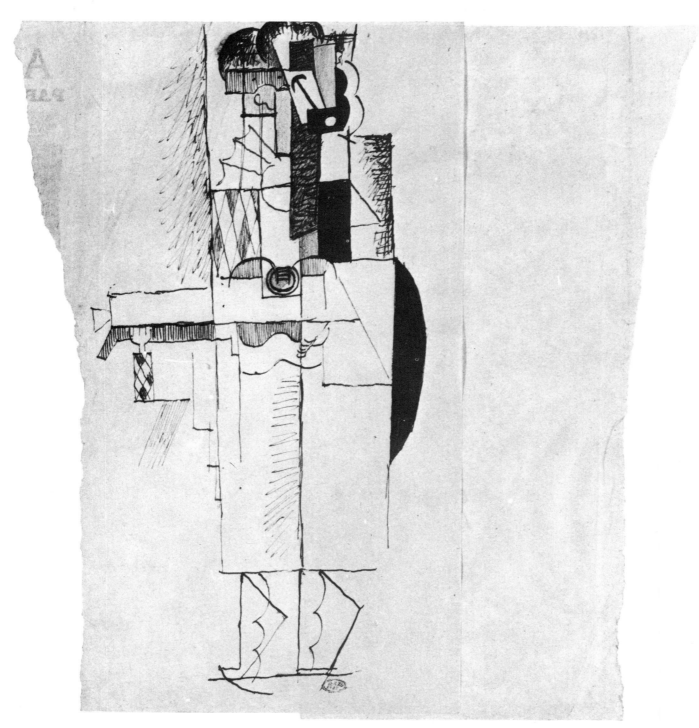

251 Guitar player. Paris, 1912–13

256 Elements of collage: glasses. Paris, 1914

257 Three still-life studies. 1914

260 Smoker seated at a table. Avignon, summer 1914

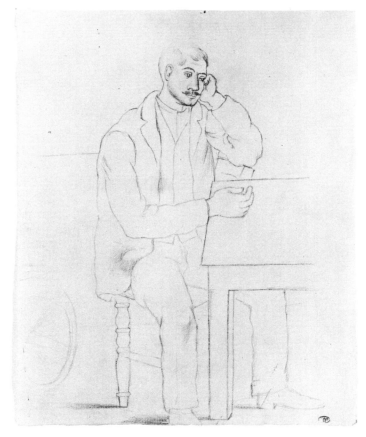

258 Man seated at a table. Avignon, summer, 1914

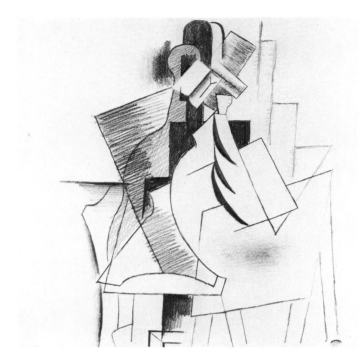

263 Man seated at a table. Avignon, summer 1914

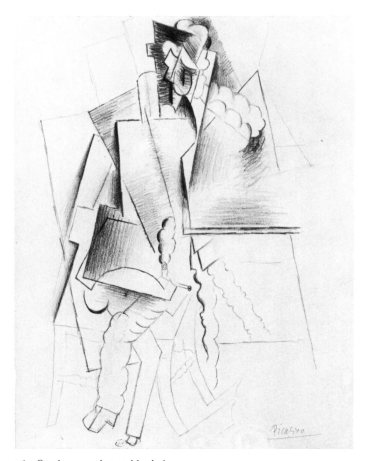

261 Smoker seated at a table. Avignon, summer 1914

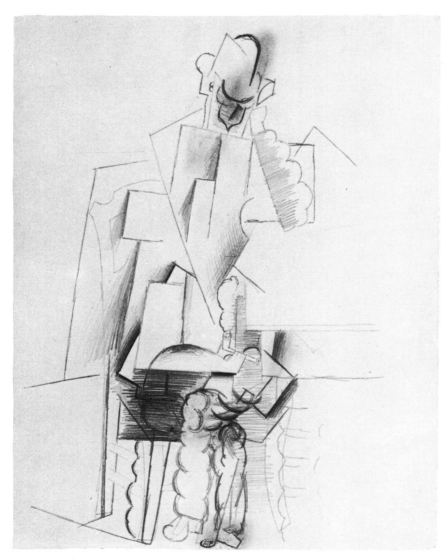

262 Smoker seated at a table. Avignon, summer 1914

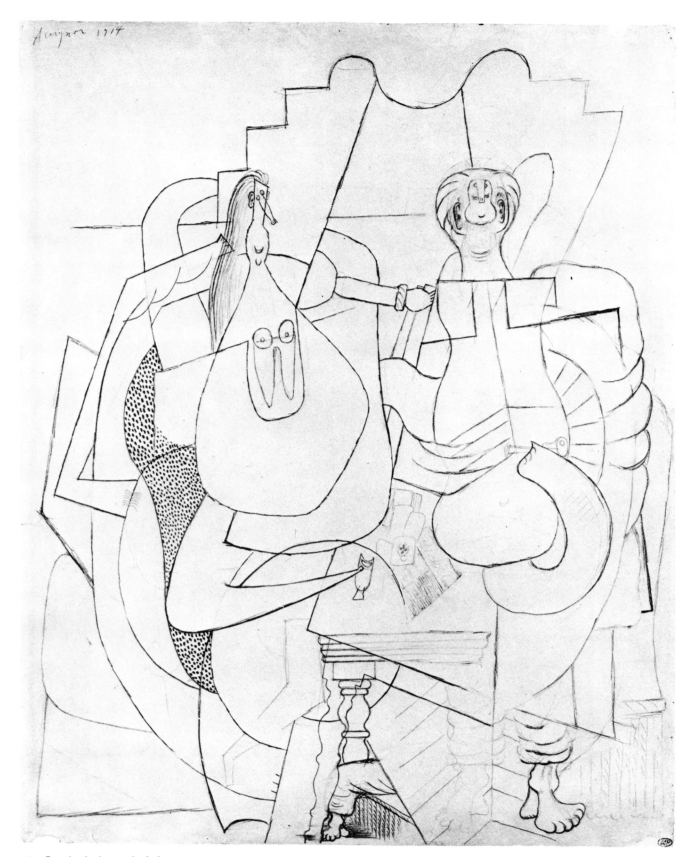

265 Couple playing cards. Avignon, summer 1914

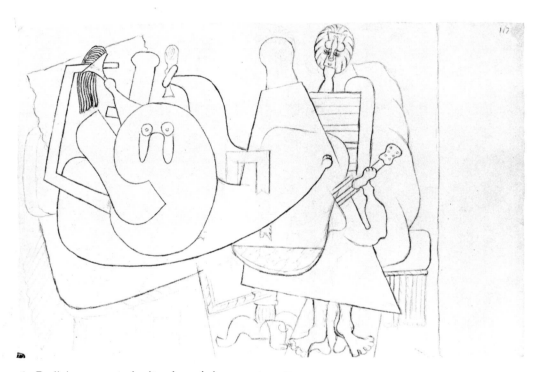

264 Reclining woman and guitar player. Avignon, summer 1914

259 Bottle and glass. Paris, 1914

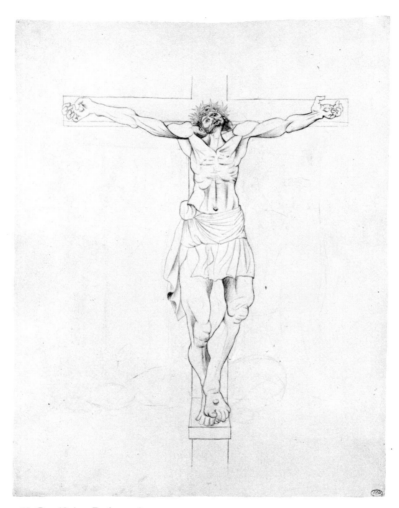

268 Crucifixion. Paris, 1918

266 Seated figure. Paris, 1915

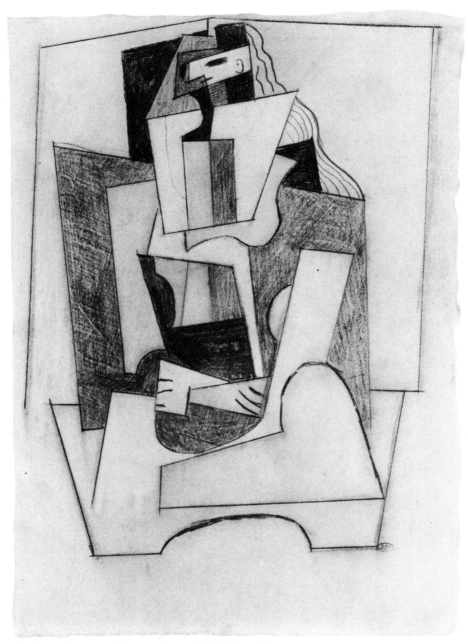

269 Bust of a woman with crossed arms. [Biarritz], 1918

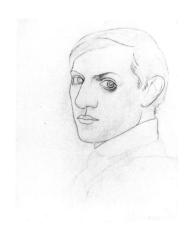

267 Self-portrait. Paris, [1917]

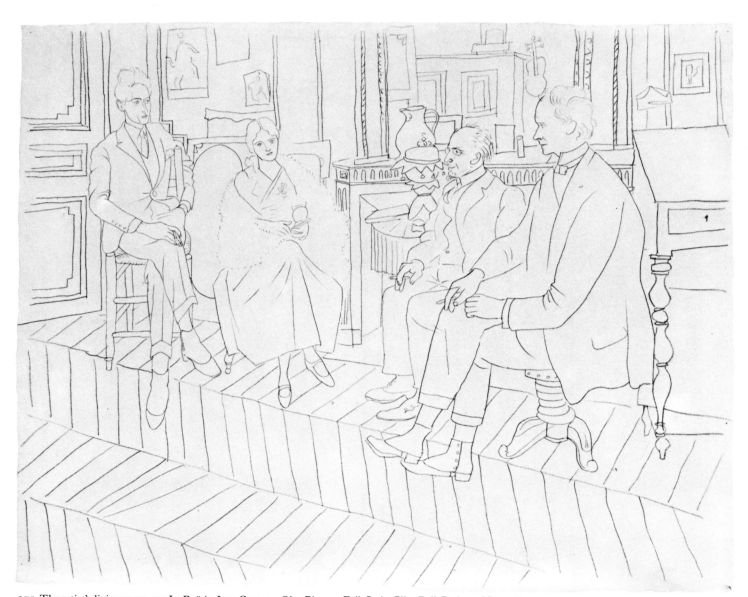

275 The artist's living room, rue La Boëtie: Jean Cocteau, Olga Picasso, Erik Satie, Clive Bell. Paris, 21 November 1919

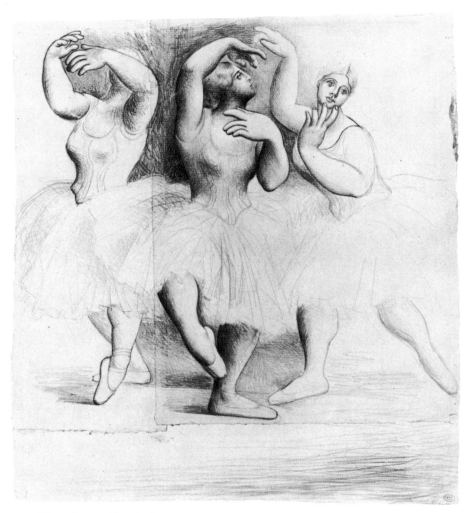

271 Three dancers. [London], 1919

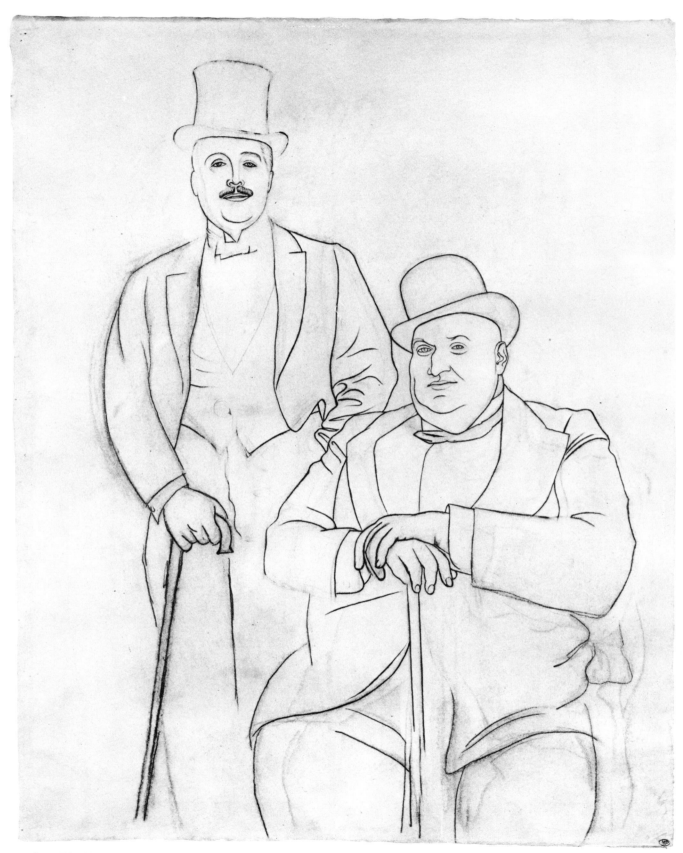

270 Serge Diaghilev and Alfred Seligsberg. [London], summer 1919

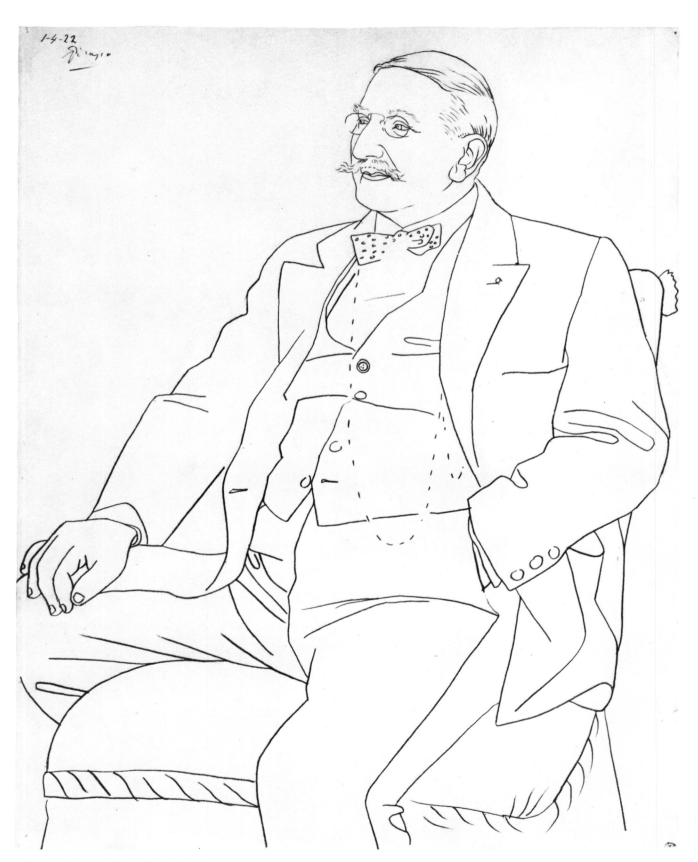

288 Portrait of Léon Bakst. Paris, 1 April 1922

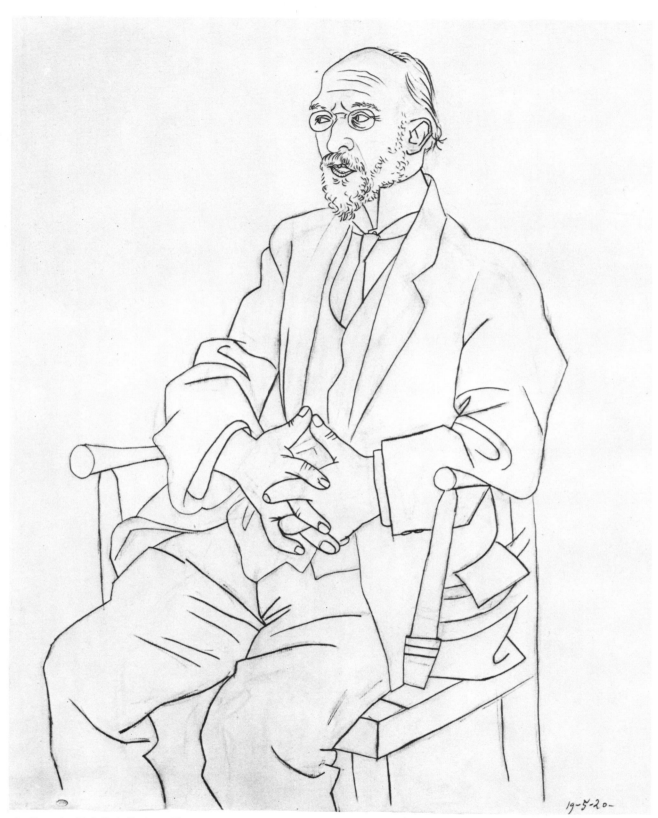

282 Portrait of Erik Satie. Paris, 19 May 1920

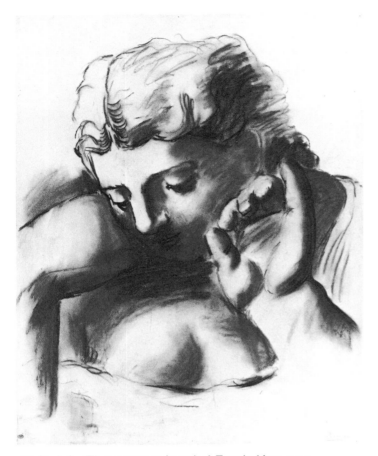

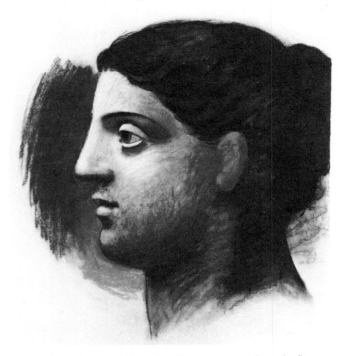

287 Head of a woman (Study for 'Three women at the spring').
Fontainebleau, August 1921

286 Study for 'Three women at the spring'. Fontainebleau, 1921

278 Study of hands. Paris, 1920

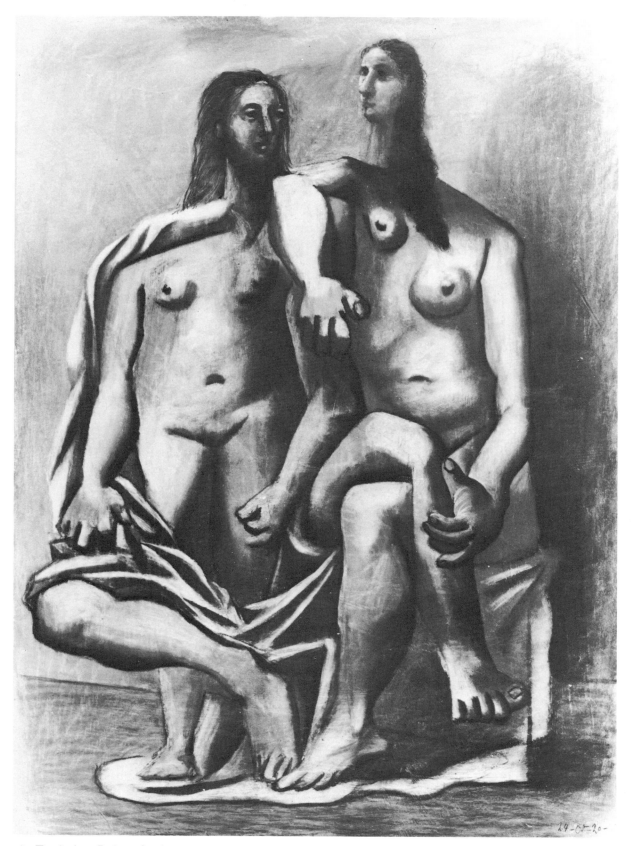

284 Two bathers. Paris, 24 October 1920

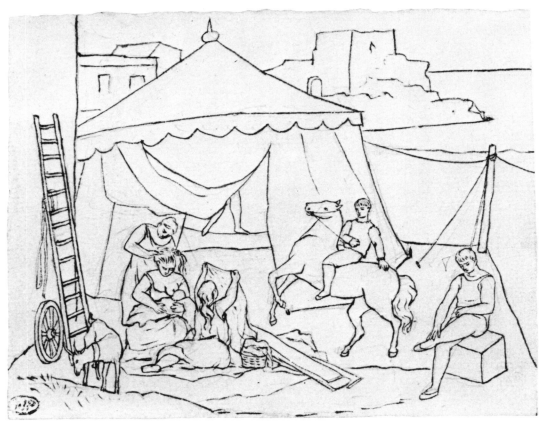

289 Travelling circus. Paris, December 1922

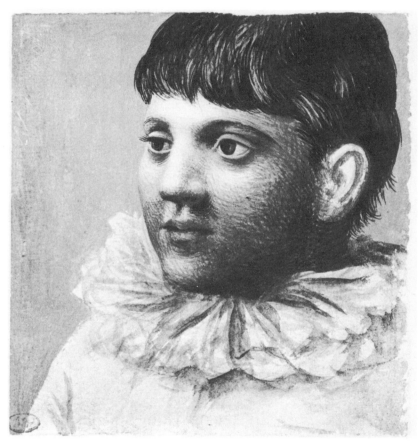

291 Portrait of a child as Pierrot. Paris, 27 December 1922

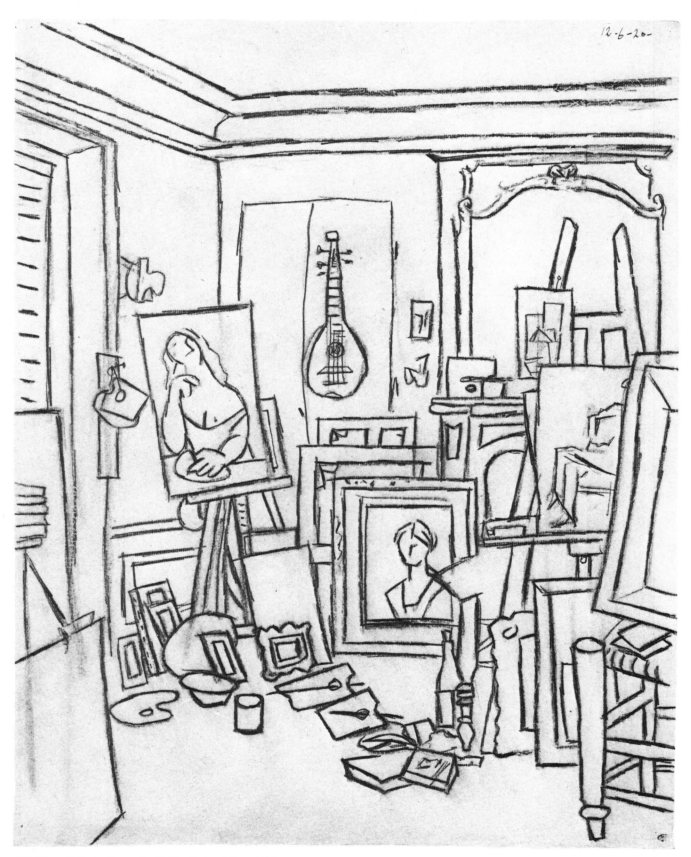

283 The artist's studio, rue La Boëtie. Paris, 12 June 1920

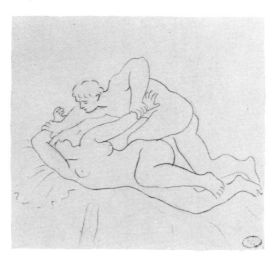

293 Embrace. 1925

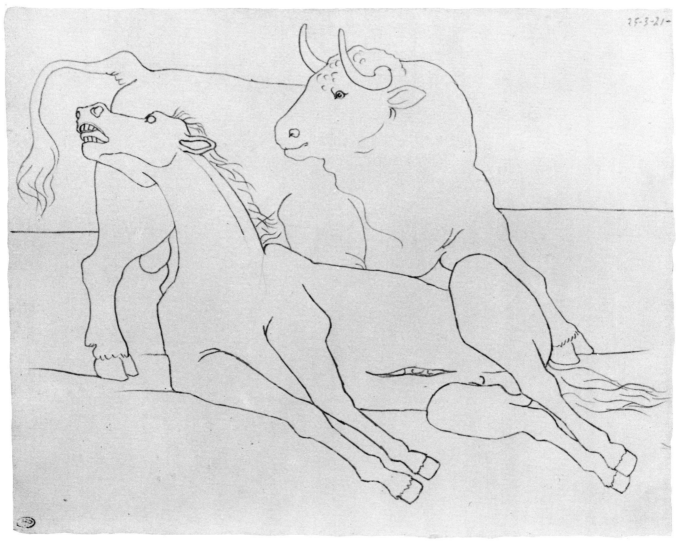

285 Bull and wounded horse. Paris, 25 March 1921

294 The painter and his model. Paris, 11 February 1928

295 The painter and his model. Paris, 12 February 1928

297 The painter and his model. Boisgeloup, 9 November 1930

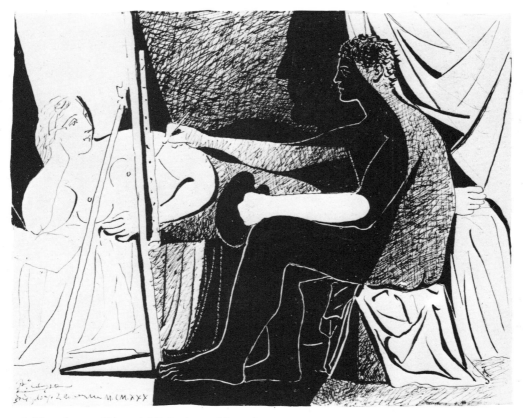

296 The painter and his model. Boisgeloup, 2 November 1930

299 Crucifixion, after Grünewald. Boisgeloup, 17 September 1932

300 Crucifixion, after Grünewald. Boisgeloup, 17 September 1932

302 Crucifixion, after Grünewald. Boisgeloup, 19 September 1932

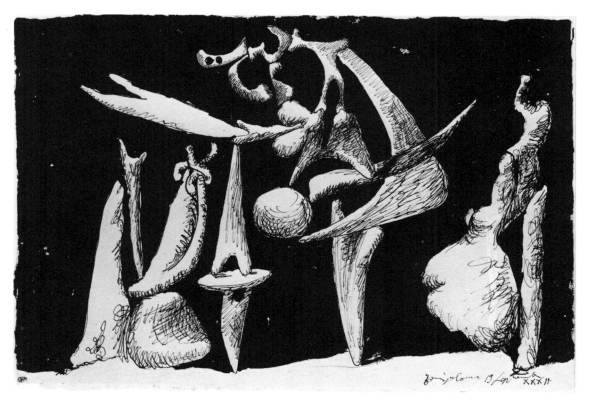

303 Crucifixion, after Grünewald. Boisgeloup, 19 September 1932

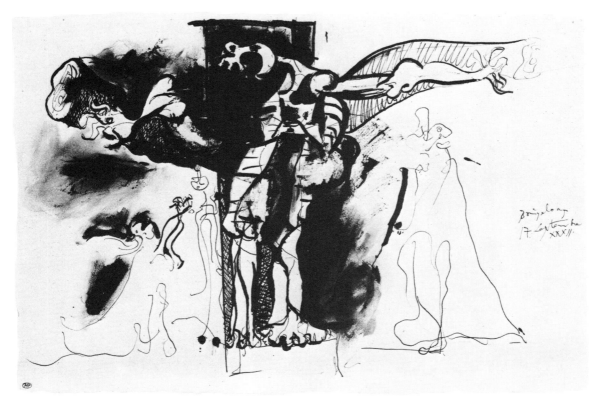

301 Crucifixion, after Grünewald. Boisgeloup, 17 September 1932

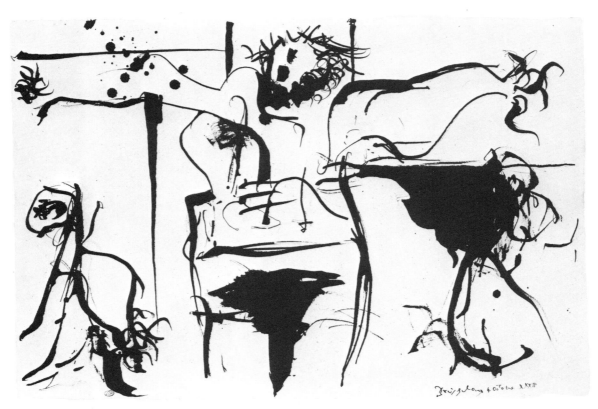

304 Crucifixion, after Grünewald. Boisgeloup, 4 October 1932

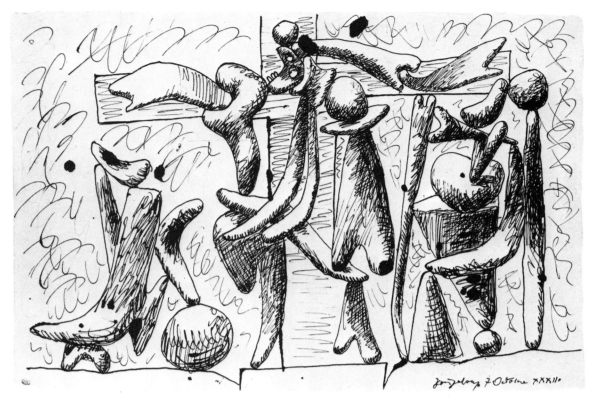

306 Crucifixion, after Grünewald. Boisgeloup, 7 October 1932

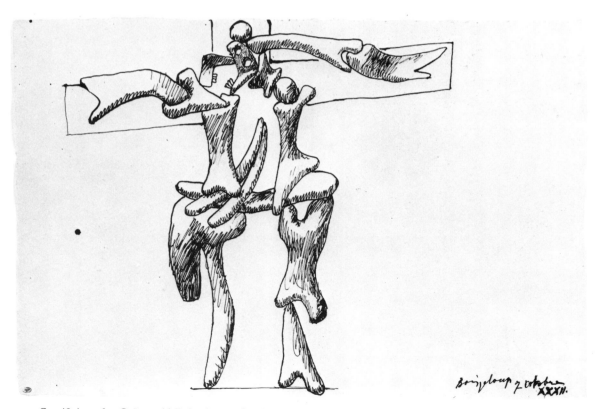

305 Crucifixion, after Grünewald. Boisgeloup, 7 October 1932

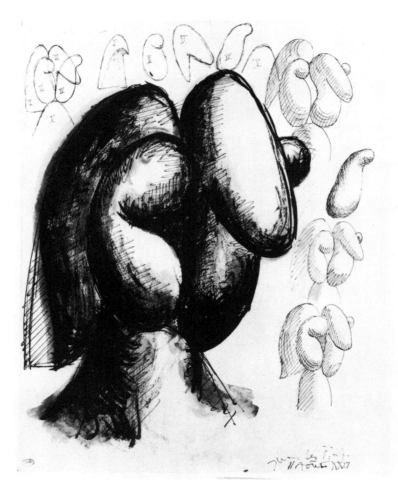

298 Study for a sculpture (Head of a woman). Juan-les-Pins, 11 August 1931

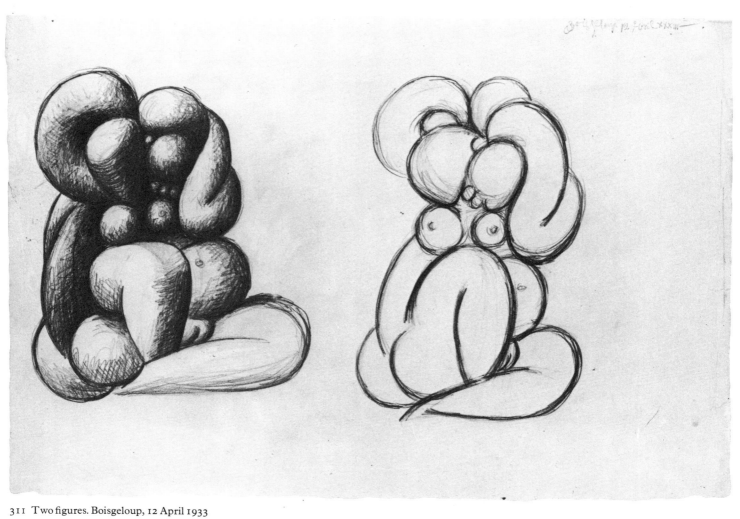

311 Two figures. Boisgeloup, 12 April 1933

309 Construction: seated woman. Paris, 28 February 1933

307 Three women VI (from the suite 'An Anatomy'). Paris, 27 February 1933

310 Three women IX (from the suite 'An Anatomy'). Paris, 1 March 1933

308 Three women VII (from the suite 'An Anatomy'). Paris, 27 February 1933

314 Figures making love. Boisgeloup, 21 April 1933

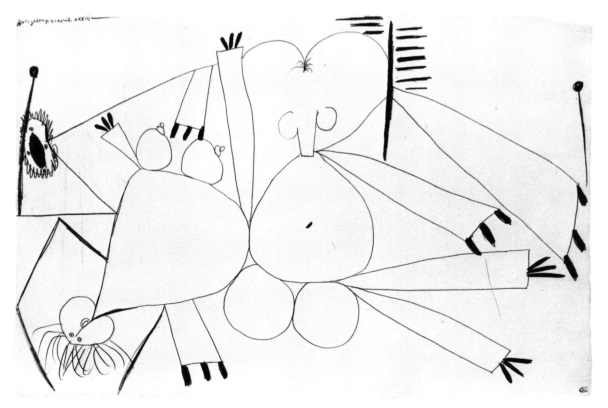

313 Figures making love. Boisgeloup, 21 April 1933

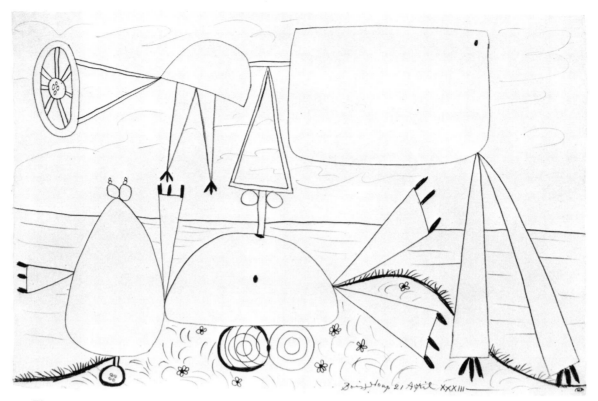

315 Figures making love. Boisgeloup, 21 April 1933

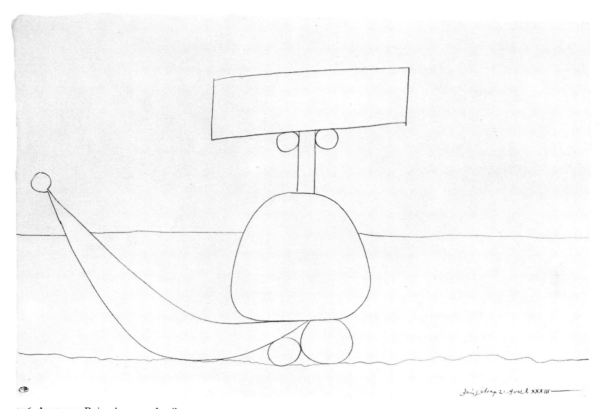

316 Anatomy. Boisgeloup, 21 April 1933

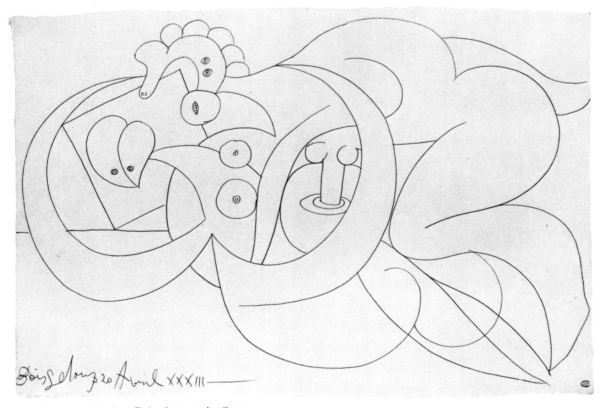

312 Figures making love. Boisgeloup, 20 April 1933

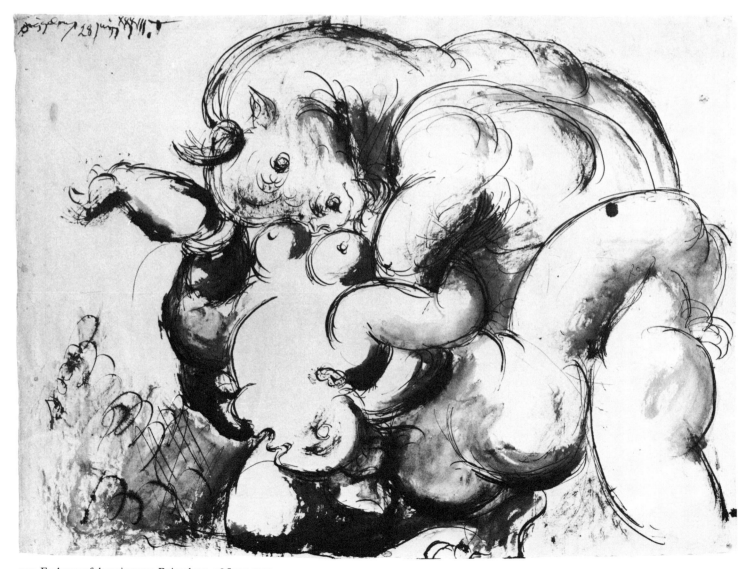

317 Embrace of the minotaur. Boisgeloup, 28 June 1933

318 Reclining nude by a window. Paris, 7 February 1934

319 Construction with swallows. Paris, 10 February 1934

320 Construction with swallows. Paris, 10 February 1934

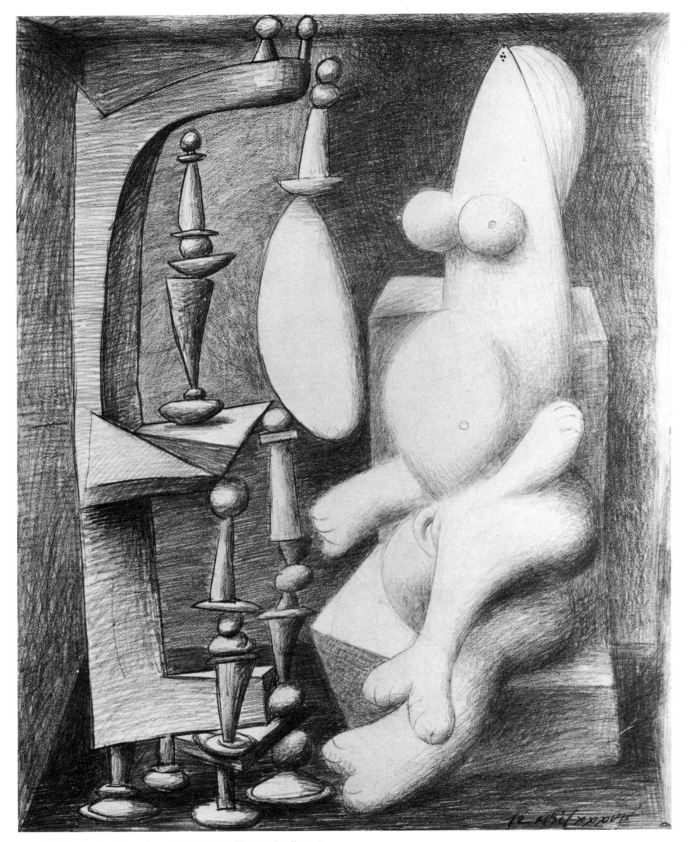

323 Nude in front of a dressing-table. Juan-les-Pins, 12 April 1936

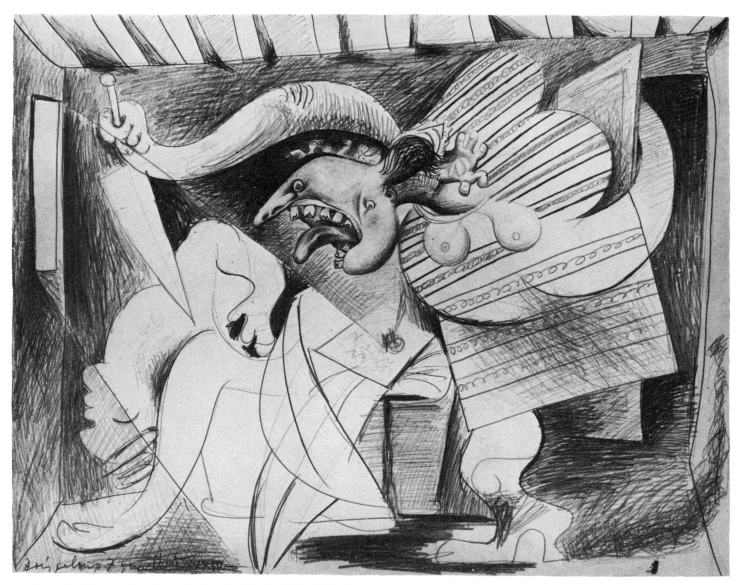

322 Study for 'Woman with stiletto, after David's "Death of Marat"'. Boisgeloup, 7 July 1934

321 Poems and horse's head. Paris, June 1934 (poems dated 7 and 15 June 1936).
See p.101 for a translation of the poems

326 Minotaur, horse and bird. Paris, 5 August 1936

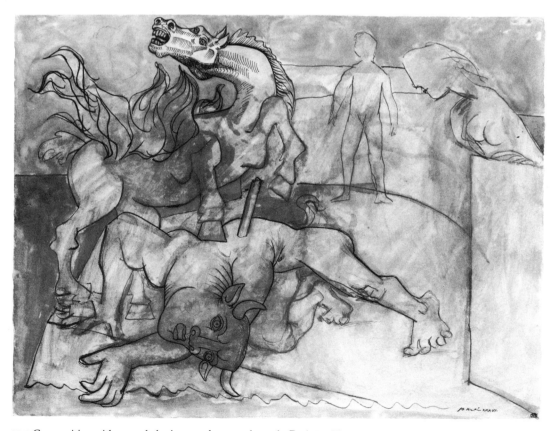

325 Composition with wounded minotaur, horse and couple. Paris, 10 May 1936

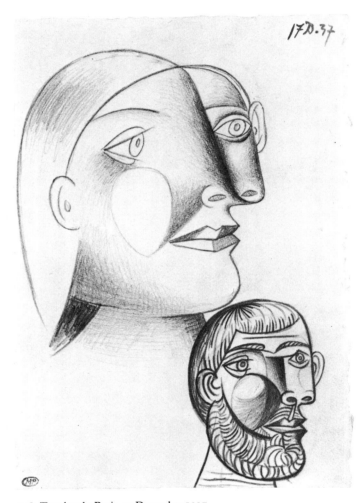

328 Two heads. Paris, 17 December 1937

329 Head of a woman. Paris, 13 June 1938

330 Bather opening a beach cabin. Paris, 20 June 1938

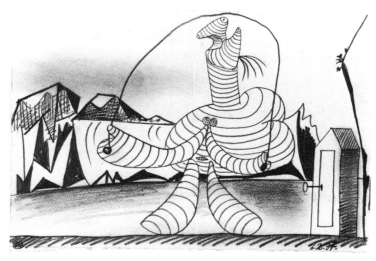

327 Bather. Paris, 6 February 1937

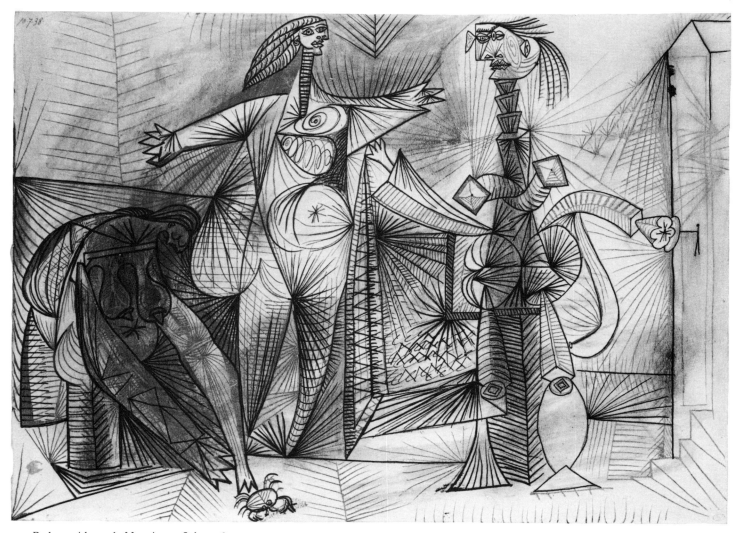

331 Bathers with a crab. Mougins, 10 July 1938

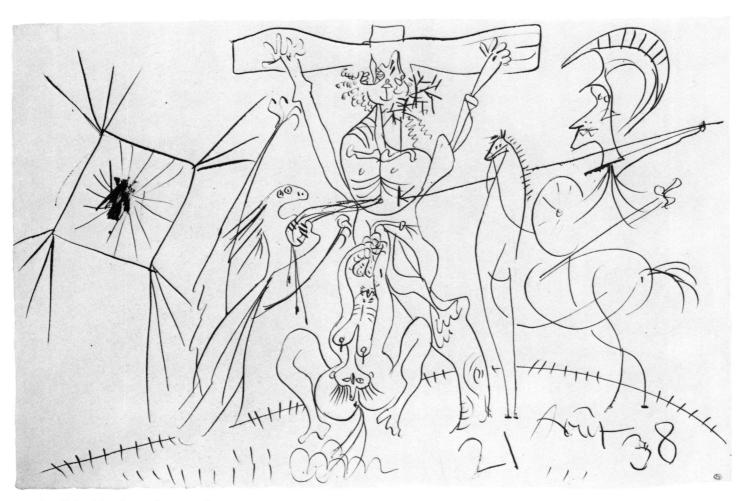

332 Crucifixion. Mougins, 21 August 1938

333 Two women with a sunshade. [Paris], 8 October 1938

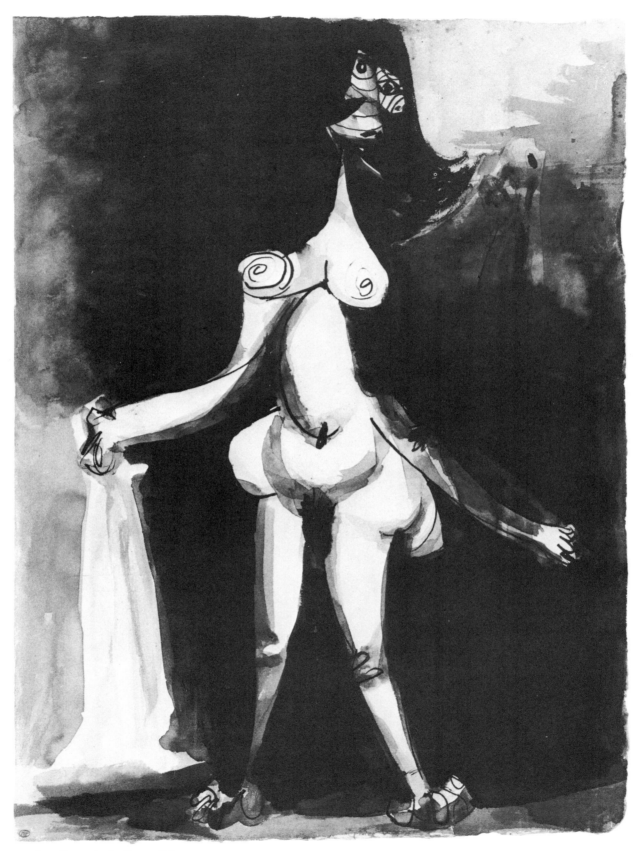

334 Standing nude. Antibes, 19 July 1939

335 The street-cleaner. Royan, 8 January 1940

338 Study for 'Man with a sheep'. Paris, 26 March 1943

337 Study for 'Man with a sheep'. [Paris], 19 February 1943

339 The tree. Paris, 4 January 1944

341 The judgement of Paris. Paris, 7 April 1951

342 Drawing after Delacroix's 'Femmes d'Alger'. Paris, 25 December 1954 I

343 Drawing after Delacroix's 'Femmes d'Alger'. Paris, 26 December 1954 XI

344 Drawing after Delacroix's 'Femmes d'Alger'. Paris, 28 December 1954

345 Drawing after Delacroix's 'Femmes d'Alger'. Paris, 28 December 1954 II

346 Drawing after Delacroix's 'Femmes d'Alger'. Paris, 28 December 1954 IV

347 Drawing after Delacroix's 'Femmes d'Alger'. Paris, 28 December 1954 V

207

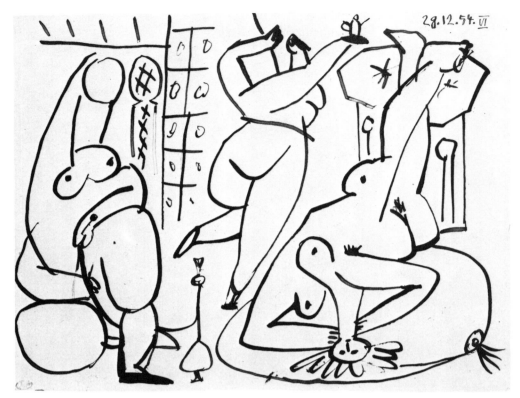

348 Drawing after Delacroix's 'Femmes d'Alger'. Paris, 28 December 1954 VI

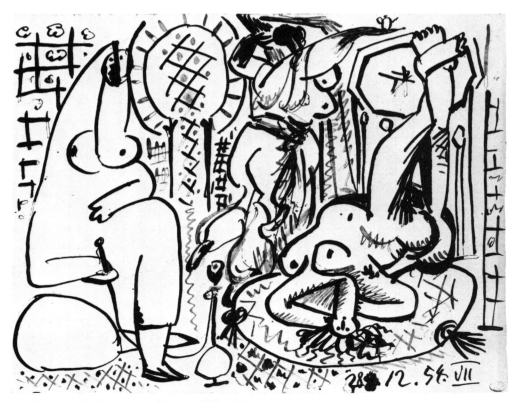

349 Drawing after Delacroix's 'Femmes d'Alger'. Paris, 28 December 1954 VII

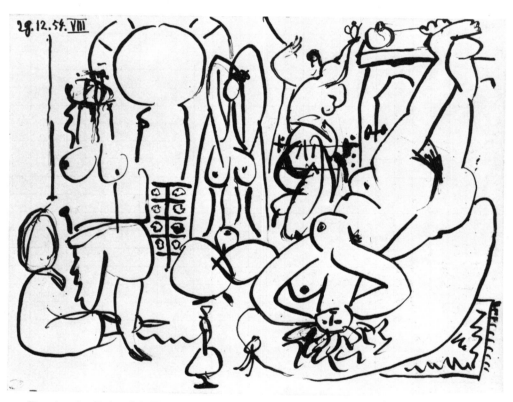

350 Drawing after Delacroix's 'Femmes d'Alger'. Paris, 28 December 1954 VIII

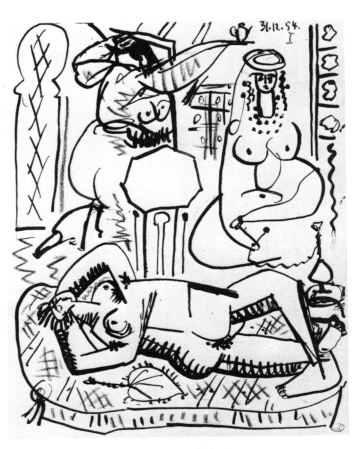

351 Drawing after Delacroix's 'Femmes d'Alger'.
Paris, 31 December 1954 I

352 Drawing after Delacroix's 'Femmes d'Alger'.
Paris, 31 December 1954 II

353 Drawing after Delacroix's 'Femmes d'Alger'. Paris, 7 January 1955 II

354 Drawing after Delacroix's 'Femmes d'Alger'. Paris, 7 January 1955 III

355 Drawing after Delacroix's 'Femmes d'Alger'. Paris, 7 January 1955 IV

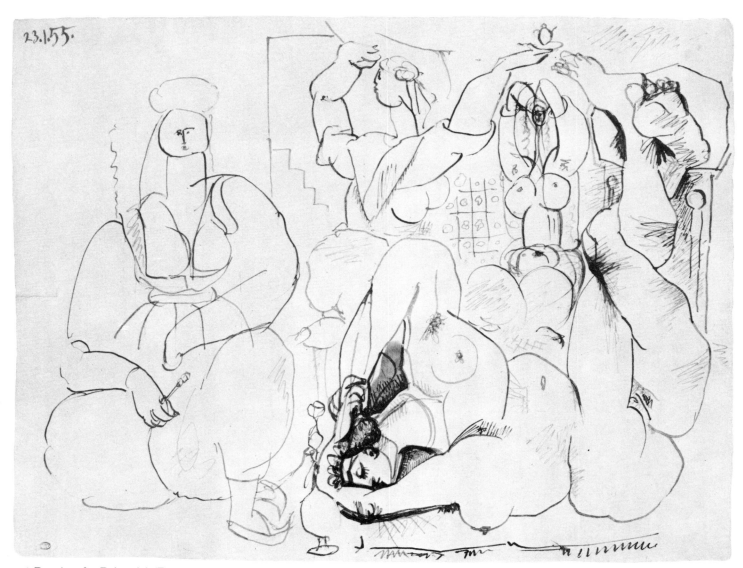

356 Drawing after Delacroix's 'Femmes d'Alger'. Paris, 23 January 1955

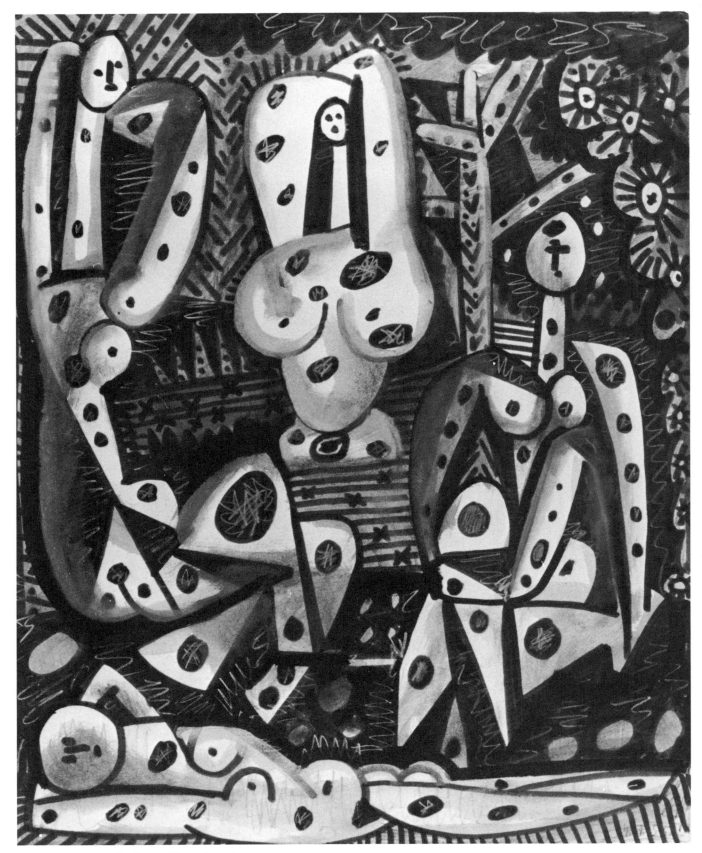

357 Four women in a landscape. [Cannes], 4 July 1955

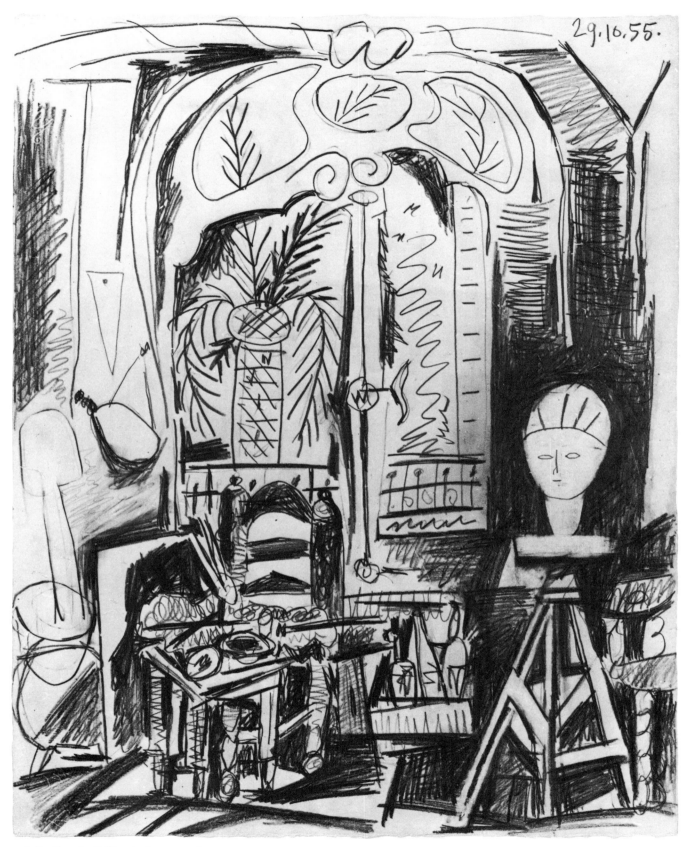

29.10.55.

358 Studio at La Californie. Cannes, 29 October 1955

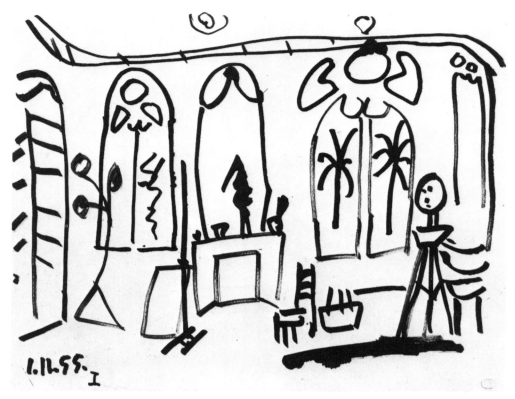

359 La Californie: studio I. Cannes, 1 November 1955

360 La Californie: studio II. Cannes, 1 November 1955

361 La Californie: studio v. Cannes, 1 November 1955

362 La Californie: studio VI. Cannes, 1 November 1955

363 La Californie: studio VII. Cannes, 1 November 1955

364 Study for 'Rape of the Sabines' after Poussin. [Cannes], 26 October 1962

CATALOGUE

The catalogue entries are arranged by medium: paintings, sculpture, drawings and graphics. Works are listed in chronological order within each section. Works included in *Pablo Picasso: A Retrospective* (New York, Museum of Modern Art, 1980) follow the dating assigned therein. Where the place or date of execution is not certain, this is enclosed in square brackets.

Dimensions are given in centimetres; height precedes width, followed, in the case of sculpture, by depth.

Unless otherwise stated, drawings, watercolours and gouaches are on paper, for which sheet sizes are given. For graphics, plate or composition sizes appear.

Dates for sculptures in bronze refer to the original facture.

MP refers to the Musée Picasso inventory number.

For graphics:
G Geiser, Bernhard, *Picasso Peintre-Graveur*, vol. I (1899–1931), vol. II (1932–4). Bern, 1933–68.
B Bloch, Georges, *Pablo Picasso: Catalogue of the Printed Graphic Work*, vol. I (1904–67), vol. II (1966–9), vol. IV (1970–2). Bern, Kornfeld et Klipstein, 1968–9.
M Mourlot, Fernand, *Picasso Lithographe*, vol. I (1919–47), vol. II (1947–9), vol. III (1949–56). Monte Carlo, André Sauret, 1949–56.

Where works are reproduced, the page number is shown in brackets at the end of the entry.

For reasons of conservation the works originally catalogued as numbers 30 (Head of a harlequin, 1913. MP377) and 79 (Object with a palm leaf, 1930. MP129) cannot be included in the exhibition. A number of additional works have, however, been included with the numbers 10a, 93a and 95a.

PAINTINGS

1 Girl with bare feet
La fillette aux pieds nus
La Coruña, [winter] 1895
Oil on canvas, 74.5 × 49.5
MP2

2 The death of Casagemas
La mort de Casagemas
Paris, summer 1901
Oil on wood, 27 × 35
MP3 (p.32)

3 Self-portrait
Autoportrait
Paris, late 1901
Oil on canvas, 80 × 60
MP4 (p.30)

4 The two brothers
Les deux frères
Gosol, summer 1906
Gouache on cardboard, 80 × 59
MP7 (p.33)

5 Young nude boy
Jeune garçon nu
Paris, autumn 1906
Oil on canvas, 67 × 44
MP6 (p.33)

6 Self-portrait
Autoportrait
Paris, autumn 1906
Oil on canvas, 65 × 54
MP8 (p.13)

7 Seated nude (Study for 'Les Demoiselles d'Avignon')
Nu assis
Paris, winter 1906–7
Oil on canvas, 131 × 104
MP10 (p.34)

8 Nude with raised arms seen from behind
Nu de dos aux bras levés
Paris, spring 1907
Oil and charcoal on paper mounted on canvas, 134 × 86
MP12 (p.41)

9 Nude with raised arms
Nu de face aux bras levés
Paris, spring 1907
Oil, charcoal and pencil on paper mounted on canvas, 132 × 80
MP13 (p.35)

10 Head of a sailor (Study for 'Les Demoiselles d'Avignon')
Buste de Marin
Paris, spring 1907
Oil on cardboard, 53.5 × 36.5
MP15 (p.14)

10a Woman with joined hands
Buste de femme aux mains jointes
Paris, early 1907
Oil on canvas, 90 × 71
MP16

11 Bust of a woman
Buste de femme
Paris, spring 1907
Oil on canvas, 59 × 47
MP18 (p.35)

12 Mother and child
Mère et enfant
Paris, summer 1907
Oil on canvas, 81 × 60
MP19 (p.15)

13 Landscape
L'arbre
Paris, summer 1907
Oil on canvas, 93 × 92
MP21 (p.36)

14 Sleeping nude
Nu couché
Paris, spring 1908
Oil on wood, 27 × 21
MP22

15 Standing nude
Nu debout
Paris, spring 1908
Oil on wood, 27 × 21
MP23 (p.36)

16 Head of a man
Tête d'homme
Paris, late 1908
Gouache on wood, 27 × 21
MP25

47 Landscape at Juan-les-Pins
Paysage de Juan-les-Pins
Juan-les-Pins, summer 1920
Oil on canvas, 48 × 68
MP68

48 Bathers looking at an aeroplane
Baigneuses regardant un avion
Juan-les-Pins, summer 1920
Oil on wood, 73 × 92.5
MP69 (p.53)

49 Reading the letter
La lecture de la lettre
[Paris], 1921
Oil on canvas, 184 × 105
MP72 (p.56)

50 Dancing couple
La danse villageoise
[Paris, 1921–2]
Pastel and oil on canvas, 140 × 85.5
MP73 (p.18)

51 Three women at the spring
Trois femmes à la fontaine
Fontainebleau, summer 1921
Oil and sanguine on canvas, 201 × 161
MP74 (p.57)

52 Bullfight
Corrida
[1922]
Oil and pencil on wood, 13.6 × 19
MP77

53 Women running on the beach
(used in 1924 for curtain of the ballet
Le train bleu)
Deux femmes courant sur la plage
(La course)
Dinard, summer 1922
Oil on wood, 34 × 42.5
MP78 (p.53)

54 The pipes of Pan
La flûte de Pan
Antibes, summer 1923
Oil on canvas, 205 × 174.5
MP79 (p.58)

55 Family by the sea
Famille au bord de la mer
Antibes, summer 1923
Oil on wood, 17.5 × 20.2
MP80 (p.55)

56 Mandolin on a table
Mandoline sur une table
[Paris, spring] 1924
Oil and sand on canvas, 96.5 × 130
MP82

57 Paulo as Harlequin
Paul en arlequin
Paris, 1924
Oil on canvas, 130 × 97.5
MP83 (p.59)

58 The embrace
Le baiser
Juan-les-Pins, summer 1925
Oil on canvas, 130 × 97
MP85 (p.19)

59 Guitar
Guitare
Paris, spring 1926
Assemblage of canvas, nails, string and
knitting needle on painted wood,
130 × 97
MP86

60 Guitar
Guitare
Paris, 2 May 1926
Assemblage of cardboard, paper,
string, net, lead ball, ink and gouache
on cardboard, 19.5 × 24.5
MP91

61 Guitar
Guitare
Paris, May 1926
Assemblage of string, nails and button
with pencil, ink and oil on cardboard,
24.7 × 12.3
MP95

62 The painter and his model
Le peintre et son modèle
[Paris], 1926
Oil and charcoal on canvas, 172 × 255.7
MP96 (p.60)

63 Woman in an armchair
Femme dans un fauteuil
Cannes, summer 1927
Oil on canvas, 130 × 98
MP99 (p.61)

64 Figure
Figure
[1927–8]
Oil on wood, 130 × 97
MP101 (p.20)

65 Minotauromachy: horse
Figure de la minotauromachie: le cheval
[Paris], April 1928
Oil on canvas, 162 × 130
MP105 (p.61)

66 Bathers
Baigneuses
Dinard, 6 August 1928
Oil on canvas, 22 × 14
MP106

67 Bather opening a beach cabin
Baigneuse ouvrant une cabine
Dinard, 9 August 1928
Oil on canvas, 32.8 × 22
MP107 (p.63)

68 Bathers on the beach
Baigneuses sur la plage
Dinard, 12 August 1928
Oil on canvas, 21.5 × 40.5
MP108

69 Bathers with beach ball
Joueurs de ballon sur la plage
Dinard, 15 August 1928
Oil on canvas, 24 × 34.9
MP109 (p.63)

70 Bathers playing with a beach ball
Baigneuses jouant au ballon
Dinard, 20 August 1928
Oil on canvas, 21.7 × 41.2
MP110 (p.63)

71 The studio
L'atelier
Paris, early 1929
Oil on canvas, 162 × 130.5
MP111

72 Woman in a red armchair
Femme au fauteuil rouge
Paris, 1929
Oil on canvas, 65 × 54
MP112

73 Nude in a red armchair
Grand nu au fauteuil rouge
Paris, 5 May 1929
Oil on canvas, 195 × 130
MP113 (p.21)

74 Large bather
Grande baigneuse
Paris, 26 May 1929
Oil on canvas, 195 × 129.5
MP115

75 The kiss
Le baiser
Dinard, 25 August 1929
Oil on canvas, 22 × 14
MP117

76 Bather with beach ball
Baigneuse au ballon
Dinard, 1 September 1929
Oil on canvas, 21.8 × 14
MP118

77 Crucifixion
La Crucifixion
Paris, 7 February 1930
Oil on wood, 50 × 65.5
MP122 (p.22)

78 Construction with bather and profile
Tableau-relief: baigneuse et profil
Juan-les-Pins, 14 August 1930
Cardboard and vegetable matter sewn
and glued on rear of canvas stretcher
and coated with sand, 27.4 × 35.5 × 3
MP125 (p.66)

80 Figures by the sea
Figures au bord de la mer
Paris, 12 January 1931
Oil on canvas, 130.5 × 195.5
MP131 (p.67)

81 The kiss
Le baiser
Paris, 12 January 1931
Oil on canvas, 61 × 50.5
MP132

82 Still life on a pedestal table
Grande nature morte au guéridon
Paris, 11 March 1931
Oil on canvas, 194 × 130
MP134 (p.24)

83 Woman with stiletto, after David's
'Death of Marat'
La femme au stylet
[Paris], 19–25 December 1931
Oil on canvas, 46 × 61
MP136 (p.23)

84 Reading
La lecture
Boisgeloup, 2 January 1932
Oil on canvas, 130 × 97
MP137

85 Woman seated in a red armchair
Femme assise dans un fauteuil rouge
Boisgeloup, 1932
Oil on canvas, 130 × 97.5
MP139 (p.68)

86 Boisgeloup in the rain
Boisgeloup sous la pluie
Boisgeloup, 30 March 1932
Oil on cloth, 44.5 × 83
MP141

87 Sleeping nude
Nu couché
Boisgeloup, 4 April 1932
Oil on canvas, 130 × 161
MP142 (p.68)

88 Bullfight: death of the bullfighter
Corrida: la mort du torero
Boisgeloup, 19 September 1933
Oil on wood, 31.2 × 40.3
MP145 (p.71)

89 Nude asleep in a landscape
Nu dans un jardin
Boisgeloup, 4 August 1934
Oil on canvas, 162 × 130
MP148 (p.25)

90 Girl reading
Femme lisant
Paris, 9 January 1935
Oil and enamel on canvas,
161.5 × 129.5
MP149 (p.71)

91 Portrait of a young girl
Portrait de jeune fille
Juan-les-Pins, 3 April 1936
Oil on canvas, 55 × 46
MP150 (p.74)

92 Sleeping woman before green shutters
(Marie-Thérèse Walter)
Dormeuse aux persiennes
Juan-les-Pins, 25 April 1936
Oil on canvas, 54 × 65
MP152 (p.74)

93 Head
Tête
Juan-les-Pins, 1 May 1936
Oil on canvas, 61 × 50
MP154

93a Lady in a straw hat
Le chapeau de paille au feuillage bleu
Juan-les-Pins, 1 May 1936
Oil on canvas, 61 × 50
MP155

94 Women in an interior
Femmes dans un intérieur
Juan-les-Pins, 2 May 1936
Oil on canvas, 61 × 50
MP156 (p.74)

95 Dora Maar seated
Portrait de Dora Maar
[Paris-Mougins], 1937
Oil on canvas, 92 × 65
MP158 (p.75)

95a Bather with book
Grande baigneuse au livre
Paris, 18 February 1937
Oil, pastel and charcoal on canvas,
130 × 97
MP160

96 Two nudes on the beach
Deux femmes nues sur la plage
Paris, 1 May 1937
Indian ink and gouache on wood,
22 × 27
MP163

97 Weeping woman
La femme qui pleure
Paris, 18 October 1937
Oil on canvas, 55 × 46
MP165

98 Suppliant
La suppliante
Paris, 18 December 1937
Gouache and Indian ink on wood,
24 × 18.5
MP168 (p.75)

99 Maïa with a doll
Maya à la poupée
Paris, 16 January 1938
Oil on canvas, 73 × 60
MP170

100 The farmer's wife
La fermière
Paris, 23 March 1938
Charcoal and oil on canvas, 120 × 235
MP173 (p.78)

101 Man with an ice-cream cone
Homme au chapeau de paille et au cornet de glace
[Mougins], 30 August 1938
Oil on canvas, 61 × 46
MP174 (p.76)

102 Cat and bird
Chat saisissant un oiseau
Paris, 22 April 1939
Oil on canvas, 81.6 × 100
MP178

103 Bust of a woman in a striped hat
Buste de femme au chapeau rayé
Paris, 3 June 1939
Oil on canvas, 81 × 54
MP180 (p.76)

104 Woman in a blue hat
Femme au chapeau bleu
Royan, 3 October 1939
Oil on canvas, 65 × 49.5
MP181

105 Woman in a hat
Buste de femme au chapeau
Paris, 9 June 1941
Oil on canvas, 92 × 60
MP188 (p.78)

106 Child with lobster
Jeune garçon à la langouste
Paris, 21 June 1941
Oil on canvas, 130.5 × 96.5
MP189 (p.78)

107 Square Henri IV
Le Vert-Galant
Paris, 25 June 1943
Oil on canvas, 64.5 × 92
MP190 (p.81)

108 Large sleeping nude
Grand nu couché
Paris, 28 June 1943
Oil on canvas, 130 × 195.5
MP191

109 Pitcher and skeleton
Pichet et squelette
Paris, 18 February 1945
Oil on canvas, 74 × 92
MP194 (p.79)

110 Woman in an armchair
Femme dans un fauteuil
Paris, 3 July 1946
Oil on canvas, 130 × 97
MP197 (p.81)

111 Skull, sea urchins and lamp on a table
Crâne, oursins, lampe sur une table
[Antibes-Paris], 27 November 1946
Oil on wood, 81 × 100
MP198 (p.81)

112 Owl in an interior
Chouette dans un intérieur
Paris, 7 December 1946
Oil on wood, 81 × 100
MP199

113 The kitchen
La cuisine
Paris, 9 February 1948
Oil on canvas, 175 × 252
MP200 (p.82)

114 The goat
La chèvre
Vallauris, 1950
Oil and charcoal on wood, 93 × 230
MP201

115 Smoke over Vallauris
Fumée à Vallauris
Vallauris, 12 January 1951
Oil on canvas, 59.5 × 73
MP202 (p.84)

116 Goat's skull, bottle and candle
Crâne de chèvre, bouteille et bougie
Paris, 25 March 1952
Oil on canvas, 89 × 116
MP206 (p.83)

117 The shadow
L'ombre
Vallauris, 29 December 1953
Oil and charcoal on canvas,
130.5 × 96.5
MP208 (p.26)

118 Women at their toilet
Femmes à la toilette
Cannes, 4 January 1956
Oil on canvas, 195.5 × 129.5
MP210

119 The studio at Cannes
L'atelier de Cannes
Cannes, 30 March 1956
Oil on canvas, 114 × 146
MP211 (p.27)

120 The bay of Cannes
La baie de Cannes
Cannes, 19 April–9 June 1958
Enamel on canvas, 130 × 195
MP212 (p.28)

121 Still life with bull's head
Nature morte à la tête de taureau
Cannes, 25 May–9 June 1958
Oil on canvas, 162.5 × 130
MP213

122 Le déjeuner sur l'herbe, after Manet
Le déjeuner sur l'herbe d'après Manet
Vauvenargues,
3 March–20 August 1960
Oil on canvas, 129 × 195
MP215 (p.85)

123 Le déjeuner sur l'herbe, after Manet
Le déjeuner sur l'herbe d'après Manet
Mougins, 13 July 1961
Oil on canvas, 60 × 73
MP217 (p.85)

124 Sleeping nude
Nu couché
Mougins, 14 June 1967
Oil on canvas, 195 × 130
MP219 (p.87)

125 The kiss
Le baiser
Mougins, 26 October 1969
Oil on canvas, 97 × 130
MP220

126 Family
La famille
Mougins, 30 September 1970
Oil on canvas, 162 × 130
MP222

127 Cavalier with pipe
Le matador
Mougins, 4 October 1970
Oil on canvas, 145.5 × 114
MP223

128 Mother and child
Maternité
Mougins, 30 August 1971
Oil on canvas, 162 × 130
MP226 (p.87)

129 Landscape
Paysage
Mougins, 31 March 1972
Oil on canvas, 130 × 162
MP227 (p.88)

130 Musician
Musicien
Mougins, 26 May 1972
Oil on canvas, 195 × 130
MP229

SCULPTURES

131 The jester
Le fou
Paris, 1905
Bronze, 40 × 35 × 23
MP231 (p.40)

132 Head of a woman (Fernande)
Tête de femme (Fernande)
Paris, 1906
Bronze, 35 × 24 × 22.5
MP234

133 Head of a woman
Tête de femme
Paris, 1906–7
Bronze, 10 × 8.5 × 9
MP235

134 Figure
Figure
Paris, 1907
Painted wood, 81 × 23.2 × 21
MP238 (p.40)

135 Three nudes
Trois nus
Paris, 1907
Wood, 32 × 15.4 × 3.2
MP240

136 Seated nude
Nu assis
Paris, 1908
Bronze, 11 × 8.5 × 10.5
MP241

137 Head of a woman (Fernande)
Tête de femme (Fernande)
Paris, autumn 1909
Bronze, 40.5 × 24 × 26
MP243 (p.42)

138 Guitar
Construction: guitare
Paris, [autumn] 1912
Cardboard, pasted paper, canvas,
string, oil and pencil, 33 × 16.3 × 7.5
MP244 (p.43)

139 Mandolin and clarinet
Construction: mandoline et clarinette
Paris, 1914
Painted wood and pencil, 58 × 36 × 23
MP247 (p.43)

140 Bottle of Bass, glass and newspaper
Construction: bouteille de Bass,
verre et journal
Paris, spring 1914
Painted tinplate and paper,
20.7 × 13.5 × 8
MP249 (p.49)

141 Glass and die
Construction: verre et dé
Paris, spring 1914
Painted wood, 17 × 16.2 × 5.5
MP252

142 Bottle of Anis del Mono and fruit bowl
with bunch of grapes
Construction: bouteille d'anis del Mono
et compotier avec grappe de raisin
Paris, [autumn] 1915
Wood, metal and charcoal,
36.2 × 28 × 21.5
MP254

143 Violin and bottle on a table
Construction: violon et bouteille sur une
table
Paris, winter 1915–16
Painted wood, nails, string and
charcoal, 45.5 × 41.5 × 19
MP253 (p.43)

144 Fruit bowl and guitar
Construction: compotier et guitare
Paris, 1919
Painted cardboard, 21.5 × 34.5 × 22
MP257 (p.43)

145 Guitar
Construction: guitare
Paris, 1924
Painted sheet metal and wire,
111 × 63.5 × 26.6
MP260

146 Bather (Metamorphosis I)
Métamorphose I
Paris, 1928
Bronze, 22.6 × 18 × 11.5
MP261 (p.62)

147 Head
Construction: tête
Paris, October 1928
Painted metal, 18 × 11 × 7.5
MP263 (p.65)

148 Wire construction (offered as a
maquette for a monument to
Guillaume Apollinaire)
Construction
Paris, late 1928
Metal wire, 50.5 × 18.5 × 40.8
MP264 (p.65)

149 Head
Tête
Paris, 1930
Iron, brass and bronze,
83.5 × 40.5 × 36
MP269

150 Head of a woman
Tête de femme
Paris, 1930–1
Painted iron, sheet metal, springs and
found objects (colanders),
100 × 37 × 59
MP270 (p.65)

151 Construction
Construction
Paris, 1931
Iron and wire, 26 × 11.5 × 11.5
MP271

152 Seated woman
Femme assise
Boisgeloup, 1931
Wood, 17.8 × 2.1 × 2.5
MP280

153 Seated woman
Femme assise
Boisgeloup, 1931
Wood, 18 × 4.5 × 3.5
MP281

154 Seated woman
Femme assise
Boisgeloup, 1931
Wood, 15.8 × 3.4 × 3
MP282

155 Standing woman
Femme debout
Boisgeloup, 1931
Wood, 20 × 3.4 × 4.2
MP283

156 Seated woman
Femme assise
Boisgeloup, 1931
Bronze, 81 × 20 × 25.5
MP286

157 Seated woman
Femme assise
Boisgeloup, 1931
Bronze, 42.5 × 14.5 × 23.4
MP287

158 Bust of a woman
Buste de femme
Boisgeloup, 1931
Bronze, 77.5 × 42 × 43.5
MP298 (p.69)

159 Head of a woman
Tête de femme
Boisgeloup, 1931–2
Bronze, 86 × 32 × 48.5
MP300 (p.69)

160 Bather
Baigneuse
Boisgeloup, 1932
Bronze, 70 × 40.2 × 32
MP289

161 Reclining woman
Baigneuse allongée
Boisgeloup, 1932
Bronze, 19 × 70.5 × 31.3
MP290 (p.70)

162 Head of a woman
Tête de femme
Boisgeloup, 1932
Bronze, 70.5 × 40.5 × 31.5
MP292 (p.69)

163 Bust of a woman
Buste de femme
Boisgeloup, 1932
Bronze, 62 × 26 × 38
MP294 (p.69)

164 Head of a woman
Tête de femme
Boisgeloup, 1932
Bronze, 128.5 × 54.5 × 62.5
MP302 (p.69)

165 Bather
Baigneuse
Boisgeloup, 1932
Bronze, 58 × 28.5 × 20.5
MP305 (p.70)

166 Woman leaning on her elbow
Femme accoudée
Boisgeloup, 1933
Bronze, 63 × 42.5 × 28.2
MP313

167 Woman with leaves
Femme au feuillage
[Boisgeloup], 1934
Bronze, 38 × 18.7 × 25.8
MP314

168 The water carrier
La porteuse de jarre
Le Tremblay-sur-Mauldre, 1935
Painted wood, objects and nails on a
cement base, 60 × 12.5 × 17
MP315

169 Cat
Chat
Paris, 1943
Bronze, 36 × 17.5 × 55
MP324

170 Death's head
Tête de mort
Paris, 1943
Bronze and copper, 25 × 21 × 31
MP326 (p.79)

171 Woman with an orange
La femme à l'orange
Paris, 1943
Bronze, 180.5 × 75 × 67.5
MP327

172 Head of a bull
Assemblage: tête de taureau
Paris, 1943
Assemblage of bicycle saddle and
handlebars, 33.5 × 43.5 × 19
MP330 (p.79)

173 Man with a sheep
L'homme au mouton
Paris, 1944
Bronze, 222.5 × 78 × 78
MP331 (p.80)

174 Pregnant woman
Femme enceinte
Vallauris, 1949
Bronze (after assemblage of plaster and
iron bar), 130 × 37 × 11.5
MP334

175 Woman with baby carriage
La femme à la poussette
Vallauris, 1950
Bronze (after assemblage of cake pans,
terracotta, stove plate and pushchair),
203 × 145 × 61
MP337

176 Pregnant woman (second state)
La femme enceinte
Vallauris, 1950–9
Bronze, 109 × 30 × 34
MP338 (p.82)

177 She-goat
La chèvre
Vallauris, 1950
Bronze (after assemblage of palm leaf,
ceramic flowerpots, wicker basket,
metal elements and plaster),
120.5 × 72 × 144
MP340 (p.83)

178 Goat's skull, bottle and candle
Crâne de chèvre, bouteille et bougie
Vallauris, 1951
Painted bronze, 77.5 × 88 × 54
MP341

179 The small owl
La petite chouette
Vallauris, 1953
Original plaster (plaster, tools, nails
and screws), 26.5 × 18.2 × 12.7
MP347

180 Head of a woman (maquette for a
monument)
Tête de femme
Vallauris, 1954
Cut and painted sheet metal,
87 × 27.5 × 42
MP351

181 Head
Tête
Cannes, 1958
Bronze, 50.5 × 21.8 × 19.5
MP358

182 Woman with outstretched arms
(maquette for a monument)
Femme aux bras écartés
Cannes, 1961
Cut, folded and painted sheet metal,
183 × 177.5 × 72.5
MP360 (p.86)

183 Seated pierrot
Pierrot assis
Cannes, 1961
Cut, folded and painted sheet metal,
134.5 × 57 × 57
MP364

184 Woman with hat
Femme au chapeau
Cannes, 1961 (painted Mougins, 1963)
Cut, folded and painted sheet metal,
127 × 74 × 40
MP365 (p.86)

185 Head of a woman
Tête de femme
Mougins, 1962
Cut, folded and painted sheet metal,
33 × 24 × 16
MP366

DRAWINGS

186 Bullfight
Corrida
La Coruña, 2 September 1894
Pen and ink, 12.7 × 19.2
MP401 (p.103)

187 'La Coruña'
'La Coruña'
La Coruña, 16 September 1894
Ink, 21 × 26.6
MP402 (p.102)

188 Study of a torso, after a plaster cast
Etude académique d'après l'antique
La Coruña, 1894–5
Charcoal, 49 × 31.5
MP405 (p.104)

189 Bull-running
Course de taureau
Barcelona, 1896
Pen and Indian ink, 14.6 × 22.1
MP408 (p.107)

190 Young man, woman and grotesque
heads
Jeune homme, femme et grotesques
Barcelona, 1898
Charcoal, coloured pencils and
watercolour, 34.5 × 31.5
MP419 (p.107)

191 The prisoner
Le prisonnier
Paris, 1901
Brush, wash and Indian ink,
31.6 × 21.6
MP430 (p.106)

192 Study for 'Evocation'
Etude pour 'L'évocation'
Paris, 1901
Pencil and charcoal, 41.8 × 29.2
MP442 (p.105)

193 Death of the bullfighter
La mort du toréador
Barcelona, 1902
Black lead, 37.2 × 26.8
MP451 (p.111)

194 Erotic scenes
Scènes érotiques
1902
Brush and Indian ink, 20.4 × 31.2
MP452 (p.108)

195 Women and child
Femmes et enfant
Paris, 1903
Pencil, pen and Indian ink, 23.3 × 16.6
MP455 (p.113)

196 The plain and simple story of Max
Jacob and his glory, or virtue's reward
*Histoire claire et simple de Max Jacob et
sa gloire ou la récompense de la vertu*
Paris, 13 January 1903
Pen and Indian ink, 19.2 × 28.2
MP468 (p.108)

197 Study for 'La Vie'
Etude pour 'La Vie'
Barcelona, 1903
Pen and Indian ink, 15.9 × 11.2
MP473 (p.110)

198 Study for 'The Embrace'
Etude pour 'L'Etreinte'
Barcelona, 1903
Black lead, 31.5 × 17
MP474 (p.112)

199 Caricature: the duel
Caricature: le duel
[Paris, 1904]
Brush and Indian ink, 27.3 × 34.5
MP486 (p.109)

200 Caricatures: the dance of Salome
Caricatures et musiciens nus
[Paris, 1904]
Indian ink, 25.5 × 33
MP491 (p.109)

201 Clown and acrobats
Bouffon et acrobates
Paris, 1905
Watercolour on grey paper, 23.8 × 15.7
MP504 (p.114)

202 Obliging woman
Personnage féminin
[Paris], late 1905
Brush and Indian ink, 21 × 13.5
MP487 (p.115)

203 Women dressing their hair
Femmes se coiffant
[Gosol-Paris], 1906
Pen and Indian ink, 25.3 × 17.6
MP512 (p.115)

204 Head of a man
Tête d'homme
Gosol, 1906
Pencil, 21 × 13.2
MP518 (p.117)

205 Head of a woman
Tête de femme
[Gosol-Paris], 1906
Brush and Indian ink, 21.2 × 13.6
MP519 (p.117)

206 Seated woman
Femme assise de face
Paris, autumn 1906
Conté crayon, 62.8 × 47.7
MP521 (p.118)

207 Study for 'Two nude women'
Etude pour 'Deux femmes nues'
Paris, autumn 1906
Conté crayon, 63.2 × 48
MP522 (p.119)

208 Nude study for 'Les Demoiselles
d'Avignon'
*Etude de nu pour 'Les Demoiselles
d'Avignon'*
Paris, 1906
Brush and Indian ink, 48.2 × 31.7
MP528 (p.116, verso p.119)

209 Sailors in a brothel
Marins en bordée
Paris, winter 1906–7
Gouache and charcoal, 64.2 × 49.4
MP532 (p.92)

210 Study for 'Les Demoiselles
d'Avignon'
Etude pour 'Les Demoiselles d'Avignon'
Paris, 1907
Pen and Indian ink, 8.2 × 9
MP533 (p.120)

211 Study for 'Les Demoiselles
d'Avignon'
Etude pour 'Les Demoiselles d'Avignon'
Paris, 1907
Pen and Indian ink, 8.7 × 9
MP534 (p.121)

212 Standing nude in profile
Nu debout de profil
Paris, summer 1907
Pastel, gouache and watercolour,
63 × 47.8
MP546 (p.122)

213 Standing nude (Study for 'Bathers in
the forest')
*Nu debout (Etude pour 'Baigneuses dans
la forêt')*
Paris, 1907
Gouache and black lead, 62.6 × 48.3
MP557 (p.125)

214 Standing nude
Nu debout
Paris, 1907–8
Charcoal, 62.7 × 48.5
MP554 (p.123)

215 Study for 'Standing nude'
Etude pour 'Nu debout'
Paris, early 1908
Watercolour and black lead,
62.6 × 47.8
MP568 (p.124)

216 Nude with raised arms
Nu aux bras levés
Paris, spring 1908
Gouache, 32 × 25
MP575 (p.93)

217 Study for 'Three women'
Etude pour 'Trois femmes'
Paris, spring 1908
Pen and Indian ink, 32.2 × 24.4
MP580 (p.126)

218 Study for 'Three women'
Etude pour 'Trois femmes'
Paris, spring 1908
Gouache, pen, Indian ink and
charcoal, 31 × 24.5
MP586 (p.126)

219 Study for 'Three women'
Etude pour 'Trois femmes'
Paris, spring 1908
Indian ink wash and watercolour,
32.9 × 25
MP587 (p.126)

220 Study for 'Three women'
Etude pour 'Trois femmes'
Paris, spring 1908
Black lead, 32.5 × 24.7
MP588 (p.127)

221 Study for 'Three women'
Etude pour 'Trois femmes'
Paris, spring 1908
Gouache and black lead, 32.5 × 24.7
MP590 (p.126)

222 Study for 'Bathers in the forest'
Etude pour 'Baigneuses dans la forêt'
Paris, spring 1908
Pen and Indian ink, 10.7 × 13.1
MP600 (p.128)

223 Study for 'Bathers in the forest'
Etude pour 'Baigneuses dans la forêt'
Paris, spring 1908
Charcoal, 47.7 × 60.2
MP604 (p.128)

224 Study for 'Carnival at the bistro'
Etude pour 'Carnaval au bistrot'
Paris, late 1908
Pen and Indian ink, 32 × 49.5
MP621 (p.131)

285 Bull and wounded horse
Taureau et cheval blessé
Paris, 25 March 1921
Pencil, 24.5 × 30.5
MP958 (p.171)

286 Study for 'Three women at the spring'
Etude pour 'Les femmes à la fontaine'
Fontainebleau, 1921
Charcoal and sanguine, 64.3 × 49
MP964 (p.166)

287 Head of a woman (Study for 'Three women at the spring')
Tête de femme (Etude pour 'Les femmes à la fontaine')
Fontainebleau, August 1921
Pastel, 63.5 × 47.5
MP969 (p.166)

288 Portrait of Léon Bakst
Portrait de Léon Bakst
Paris, 1 April 1922
Pencil, 64.7 × 49.2
MP974 (p.164)

289 Travelling circus
Cirque forain
Paris, December 1922
Pen, Indian ink and black lead, 11.2 × 14.2
MP980 (p.168)

290 Travelling circus
Cirque forain
Paris, December 1922
Gouache and black lead, 11 × 14.5
MP981 (p.91)

291 Portrait of a child as Pierrot
Portrait d'enfant en pierrot
Paris, 27 December 1922
Watercolour and gouache, 11.7 × 11.5
MP982 (p.169)

292 Guitar
Guitare
Juan-les-Pins, 1924
Oil, pen and Indian ink, 30 × 22.5
MP1000 (p.64)

293 Embrace
Etreinte
1925
Pencil, 10.9 × 11.5
MP1008 (p.171)

294 The painter and his model
Le peintre et son modèle
Paris, 11 February 1928
Pen and Indian ink, 21.3 × 26.9
MP1026 (p.172)

295 The painter and his model
Le peintre et son modèle
Paris, 12 February 1928
Pen, Indian ink and wash, 23.5 × 33.5
MP1027 (p.172)

296 The painter and his model
Le peintre et son modèle
Boisgeloup, 2 November 1930
Brush, pen and Indian ink on a drawing book cover, 23 × 29
MP1050 (p.173)

297 The painter and his model
Le peintre et son modèle
Boisgeloup, 9 November 1930
Pen and Indian ink on cardboard, 12.1 × 18.1
MP1048 (p.173)

298 Study for a sculpture (Head of a woman)
Etude pour une sculpture (Tête de femme)
Juan-les-Pins, 11 August 1931
Pen and Indian ink wash, 33 × 25.5
MP1056 (p.178)

299 Crucifixion, after Grünewald
La Crucifixion
Boisgeloup, 17 September 1932
Indian ink wash, 34.3 × 51.4
MP1071 (p.174)

300 Crucifixion, after Grünewald
La Crucifixion
Boisgeloup, 17 September 1932
Indian ink wash, 34.7 × 51.5
MP1072 (p.174)

301 Crucifixion, after Grünewald
La Crucifixion
Boisgeloup, 17 September 1932
Pen, Indian ink and Indian ink wash, 34.5 × 51.3
MP1073 (p.176)

302 Crucifixion, after Grünewald
La Crucifixion
Boisgeloup, 19 September 1932
Pen and Indian ink, 34.1 × 51
MP1074 (p.175)

303 Crucifixion, after Grünewald
La Crucifixion
Boisgeloup, 19 September 1932
Pen, Indian ink and wash, 34.5 × 51.5
MP1075 (p.175)

304 Crucifixion, after Grünewald
Etude pour 'La Crucifixion'
Boisgeloup, 4 October 1932
Pen and Indian ink, 34 × 51
MP1079 (p.176)

305 Crucifixion, after Grünewald
Etude pour 'La Crucifixion'
Boisgeloup, 7 October 1932
Pen and Indian ink, 34.5 × 51.2
MP1081 (p.177)

306 Crucifixion, after Grünewald
Etude pour 'La Crucifixion'
Boisgeloup, 7 October 1932
Pen and Indian ink, 34 × 51
MP1082 (p.177)

307 Three women VI (from the suite 'An Anatomy')
Construction: trois femmes
Paris, 27 February 1933
Black lead, 20 × 27.5
MP1094 (p.180)

308 Three women VII (from the suite 'An Anatomy')
Construction: trois femmes
Paris, 27 February 1933
Black lead, 20 × 27.3
MP1095 (p.181)

309 Construction: seated woman
Construction: femme assise
Paris, 28 February 1933
Black lead, 20 × 27
MP1089 (p.179)

310 Three women IX (from the suite 'An Anatomy')
Construction: trois femmes
Paris, 1 March 1933
Black lead, 19.5 × 27
MP1097 (p.180)

311 Two figures
Deux figures
Boisgeloup, 12 April 1933
Pencil, 34.5 × 51
MP1100 (p.179)

312 Figures making love
Anatomie: étreinte
Boisgeloup, 20 April 1933
Black lead, 34.5 × 50.5
MP1106 (p.184)

313 Figures making love
Anatomie: étreinte II
Boisgeloup, 21 April 1933
Black lead, 34 × 51.5
MP1111 (p.182)

314 Figures making love
Anatomie: étreinte III
Boisgeloup, 21 April 1933
Black lead, 35.4 × 51.2
MP1110 (p.182)

369 Bust of a woman
Buste de femme
1905–6
Four impressions of a woodcut, three
printed in colour, 21.9 × 13.8
G211; B1304

370 Bust of young woman facing left,
three-quarters view
*Buste de jeune femme de trois-quarts à
gauche*
1906
Woodcut, 55.7 × 38.5
G212

371 Kahnweiler plate
Cliché Kahnweiler
1914
Seven states of an engraving (three
proofs of seventh state), 10.8 × 9.9
G40 I–VII

372 Group of three women
Groupe de trois femmes
1922–3
Drypoint and etching, printed in
colour, 17.8 × 13
G102 V

373 The Three Graces II
Les Trois Grâces II
1922–3
Etching, 32.5 × 19.7
G105; B59

374 The beach III
La plage III
22 November 1932
Three impressions of an etching,
15.8 × 11.8
G267

375 The rescue II
Le sauvetage II
18 December 1932
Etching, 16 × 20
G273; B245 (p.73)

376 The rescue III
Le sauvetage III
18 December 1932
Four impressions of an etching,
20.7 × 23
G274; B246

377 The diver
La plongeuse
December 1932
Etching with collage, 14 × 11.3
G277; B1322

378 The diver
La plongeuse
December 1932
Etching with collage, 14 × 11.3
G277; B1322

379 Flautist and sleeper I
Flûtiste et dormeuse I
January 1933
Etching, printed in colour, 15 × 18.8
G287 XXXI

380 Flautist and sleeper XXXII
Flûtiste et dormeuse XXXII
January 1933
Monotype, printed in colour, 15 × 18.8
G495

381 Flautist and sleeper XXXVIII
Flûtiste et dormeuse XXXVIII
January 1933
Monotype, 15 × 18.8
G501

382 Head of a woman
Tête de femme
16 February 1933
Drypoint, 31.8 × 22.9
G288 IV

383 Head of a woman
Tête de femme
February 1933; printed 1942
Drypoint, 31.8 × 22.9
G288 XX

384 Head of a woman V, VI, VII
Tête de femme V, VI, VII
16 February 1933
Three monotypes, 31.8 × 22.9
G555–7

385 Head of a woman VIII
Tête de femme VIII
February 1933
Monotype, 31.8 × 22.9
G558

386 Game on the beach
Jeu sur la plage
7 March 1933
Drypoint, 28 × 17.9
G293

387 Game on the beach
Jeu sur la plage
March 1933
Monotype, 28 × 17.9
Not in Geiser

388 The sculptor at rest
*La Suite Vollard: Le repos du
sculpteur III*
3 April 1933
Etching, 19.3 × 26.7
G326 I; B173

389 Model and large sculpture from the
back
*La Suite Vollard: Modèle et grande
sculpture de dos*
4 May 1933
Two states of a scraped etching,
36.8 × 19.2
G345 III–IV; B186

390 Model and surrealist sculpture
*La Suite Vollard: Modèle et sculpture
surréaliste*
4 May 1933
Etching, 26.8 × 19.3
G346 I; B187

391 Bacchanal with minotaur
*La Suite Vollard: Scène bacchique au
minotaure*
18 May 1933
Etching, 29.7 × 36.6
G351 II; B192

392 Sleeping minotaur contemplated by a
woman
*La Suite Vollard: Minotaure endormi
contemplé par une femme*
18 May 1933
Four states of an etching, 19.4 × 26.8
G352 I–IV; B193

393 Minotaur attacking an Amazon
*La Suite Vollard: Minotaure attaquant
une Amazone*
23 May 1933
Etching, 19.4 × 26.8
G356 III; B195 (p.72)

394 Wounded minotaur VI
La Suite Vollard: Minotaure blessé VI
26 May 1933
Etching, 19.2 × 26.7
G363 I; B196

395 Dying minotaur
La Suite Vollard: Minotaure mourant
30 May 1933
Etching, 19.6 × 26.8
G366 I; B198

396 Minotaur caressing a sleeping woman
*La Suite Vollard: Minotaure caressant
une dormeuse*
18 June 1933
Drypoint, 30 × 37
G369 II; B201

397 Lysistrata: Kinesias and Myrrhina
Lysistrata: Cinésias et Myrrhine
17 January 1934
Etching, 22.2 × 15.3
G389 I; B269

398 Rembrandt with palette
La Suite Vollard: Rembrandt à la palette
27 January 1934
Etching, 27.8 × 19.8
G406 III; B208

399 Female bullfighter I
Femme torero I
12 June 1934
Etching, 49.7 × 69.9
G425; B1329

400 Blind minotaur guided by a little girl in the night
La Suite Vollard: Minotaure aveugle guidé par une fillette dans la nuit
November 1934
Aquatint and scraper, 24.7 × 34.7
G437 II; B225

401 Blind minotaur guided by a little girl in the night
La Suite Vollard: Minotaure aveugle guidé par une fillette dans la nuit
November 1934
Aquatint, scraper and drypoint, printed in colour, 24.7 × 34.7
G437 IIIa (p.72)

402 Blind minotaur guided by a little girl in the night
La Suite Vollard: Minotaure aveugle guidé par une fillette dans la nuit
November 1934; printed in 1939
Aquatint, scraper and drypoint, 24.7 × 34.5
G437 IIIb

403 At the cabaret
Au cabaret
11 November 1934
Etching and scraper, 23.8 × 29.9
G439

404 At the cabaret
Au cabaret
11 November 1934
Etching and scraper, 23.8 × 29.9
G439

405 Minotauromachy
La Minotauromachie
1935
Five states of a scraped etching, 49.8 × 69.3
B288 I–V (p.73)

406 Proof of plate comprising illustrations for *La Barre d'Appui* by Paul Eluard
Paris, Editions Cahiers d'Art, 1936
Three etchings and one engraving, 15.8 × 10.5
B295a

407 Faun unveiling a woman
Faune dévoilant une femme
12 June 1936
Six states of an etching with aquatint, 31.7 × 41.7
B230 I–VI

408 Dream and lie of Franco I
Sueño y Mentira de Franco I
8 January 1937
Etching, 31.4 × 42.1
B297 I (p.77)

409 Dream and lie of Franco II
Sueño y Mentira de Franco II
8–9 January 1937
Etching, 31 × 42
B298 I (p.77)

410 Dream and lie of Franco II
Sueño y Mentira de Franco II
8–9 January and 25 May 1937
Etching and aquatint, 31 × 42
B298 II

411 Weeping woman
La femme qui pleure
2 July 1937
Seven states of an etching with aquatint and drypoint, 72.3 × 49.3
B1333 I–VII

412 Weeping woman I
La femme qui pleure I
4 July 1937; printed in 1949
Drypoint and aquatint, 35 × 24.8
Not in Bloch

413 Weeping woman II
La femme qui pleure II
4 July 1937
Drypoint, 34.7 × 24.6
Not in Bloch

414 Woman with tambourine
La femme au tambourin
1938
Scraped etching with aquatint, 66.5 × 51.4
B310 VI

415 Afat
1938
Four engravings with etching and two arabesques in wash, 15 × 25
From *Afat*, 66 sonnets by Iliazd
Paris, Le Degré Quarante et un, 1940
B316

416 Woman in an armchair I
Femme au fauteuil I
1939
Two states of a scraped aquatint with engraving, 34.2 × 22.4
B322 I, III

417 Head of a woman with necklace
Tête de femme au collier
1939
Aquatint, printed in colour, 30 × 23.8
B1335

418 Head of a woman I
Tête de femme I
1939
Aquatint, printed in colour, 30 × 23.7
B1337

419 Head of a woman II
Tête de femme II
1939
Aquatint, printed in colour, 30 × 23.8
B1338

420 Head of a woman III
Tête de femme III
1939
Aquatint, printed in colour, 30 × 23.6
B1339

421 The burial of Count Orgaz
9 June 1939
Engraved frontispiece for *El entierro del Conde de Orgaz*, 35 × 24.5
Barcelona, Ediciones de la Cometa, 1962
B1465

422 Seated woman with hat
Femme au chapeau assise
1940
Aquatint, printed in colour, 30.5 × 24
Not in Bloch

423 Seated woman with hat
Femme au chapeau assise
1940
Aquatint, 30.5 × 24
Not in Bloch

424 The monkey
Le singe
1941–2
Etching from *Textes de Buffon*, Paris, Martin Fabiani, 1942
36 × 28
B339

425 The ostrich
L'autruche
1941–2
Etching from *Textes de Buffon*,
Paris, Martin Fabiani, 1942
36 × 28
B343

426 Group with goat (family)
Groupe avec chèvre (famille)
14 July 1942
Etching and drypoint, 44.8 × 64
Not in Bloch

427 Head of a young boy
Tête de jeune garçon
7 November 1945
Lithograph, second state, 29 × 23
M8; B378

428 The circus
Le cirque
23 December 1945
Lithograph, second state, 29 × 39
M24; B385

429 David and Bathsheba, after Cranach
the Elder
David et Bethsabée
30 March 1947
Lithograph, final state, 64 × 49
M109; B440

430 Woman in an armchair I
Femme au fauteuil I
13 December 1948
Lithograph, 65 × 50
M134 II

431 David and Bathsheba, after Cranach
the Elder
David et Bethsabée
29 May 1949
Lithograph, first state, 76 × 56
M109 *bis*; B442

432 Bust of a woman, after Cranach the
Younger
Buste de femme d'après Cranach le Jeune
1958
Linoleum cut, printed in colour,
65 × 53.5
B859

433 Bacchanal
Bacchanale
25 November 1959
Linoleum cut, printed in colour,
53 × 64
B930

434 Fauns and goat
Faunes et chèvre
1959
Linoleum cut, printed in colour,
53 × 64
B934

435 Le déjeuner sur l'herbe
Le déjeuner sur l'herbe
4 July 1961
Linoleum cut, 53.5 × 64
B1023

436 Large head of a woman with decorated
hat
Grande tête de femme au chapeau orné
1962
Linoleum cut, printed in colour,
64 × 53
B1077

437 Large female nude
Grand nu de femme
1962
Linoleum cut, printed in colour,
64 × 53
B1085

438 Still life under a lamp
Nature morte sous la lampe
1962
Linoleum cut, printed in colour,
64 × 53
B1102

439 Etching
Eau-forte
16, 17, 18, 19, 20, 21, 22 March 1968
39.5 × 56.5
B1481 (p.86)

440 Etching and drypoint
Eau-forte et pointe sèche
5, 6, 7, 9 May 1968
41.5 × 49
B1544

441 Etching and drypoint
Eau-forte et pointe sèche
16 May 1968 VI
33.5 × 50
B1577

442 Etching and drypoint
Eau-forte et pointe sèche
31 May 1968 III
20 × 25.5
B1613

443 Etching, drypoint and scraper
Eau-forte, pointe sèche et grattoir
15, 16, 17, 18, 19, [20–31] January,
[1], 6 February 1970
32 × 42
B1858

444 Etching
Eau-forte
20 January 1970
48 × 60
B1859

445 Etching and scraper
Eau-forte et grattoir
25 January, 15 February 1970
23 × 33
B1860

446 Etching, aquatint and scraper
Eau-forte, aquatinte et grattoir
3 February IV, [5, 6 March] 1970
50 × 42
B1865

447 Etching and scraper VIII
Eau-forte et grattoir VIII
11, 28 February, 3, 16, 30 March 1970
51 × 64
B1868

448 Etching, drypoint and scraper III
Eau-forte, pointe sèche et grattoir III
11 March VI, 17, 28 March 1971
37 × 49.5
B1934

449 Mezzotint
Manière noire
15, 16, 18 March 1970
32 × 42
B1878

450 Etching and drypoint
Eau-forte et pointe sèche
25 March 1971 I
21 × 15
B1947

451 Drypoint and scraper (second state)
Pointe sèche et grattoir (état II)
1, 2, 3, 4 May 1971
37 × 50
B1972

452 Aquatint, drypoint and scraper
Aquatinte, pointe sèche et grattoir
7, 10 June 1971
23 × 31
B2004

453 Etching, drypoint, aquatint and
scraper
*Eau-forte, pointe sèche, aquatinte et
grattoir*
1, 5 March 1972
37 × 50
B2010

CHRONOLOGY

This chronology is extracted primarily from that prepared by Jane Fluegel for *Pablo Picasso: A Retrospective* (New York, Museum of Modern Art, 1980). We gratefully acknowledge Miss Fluegel for permission to use the material here, and refer the reader to the Museum of Modern Art catalogue for more detailed information.

1881 25 October: Born Pablo Ruiz Picasso in Málaga, son of Don José Ruiz Blasco, a painter and art teacher, and Doña María Picasso y López.

1891 September: Family moves to La Coruña on the Atlantic coast. Studies drawing and painting under his father.

1892–5 Attends School of Fine Arts in La Coruña. In 1894 keeps journals which he calls *La Coruña* and *Asul y Blanco*, illustrated with portraits and caricatures.

1895 September: Family moves to Barcelona. Admitted to advanced classes at School of Fine Arts (La Lonja). Winter: Starts first large 'academic' canvas, *First Communion* (Museo Picasso, Barcelona); exhibited 1896.

1897 June: Shows *Science and Charity* (Museo Picasso, Barcelona) in National Exhibition of Fine Arts in Madrid. September: Leaves for Madrid and enrolls in Royal Academy of San Fernando, where he remains through the winter.

1898 Mid-June: First visit to Horta, in the Ebro valley.

1899 February: Returns to Barcelona. Begins to frequent Els Quatre Gats, a bohemian artists' café. Makes first etching.

1900 Shares studio with Carles Casagemas in Riera de San Juan. 1 February: first one-man exhibition at Els Quatre Gats. October: Leaves for Paris with Casagemas. First Paris work, *Le Moulin de la Galette* (Guggenheim Museum, New York). Meets the dealers Pedro Mañach and Berthe Weill. 20 December: Departure for Barcelona and Málaga. Casagemas returns to Paris; Picasso goes on to Madrid.

1901 17 February: Suicide of Casagemas; Picasso deeply affected. March: First of four issues of *Arte Joven* (Madrid), with Picasso as art editor and illustrator. April–May: Leaves for Barcelona, then Paris. Moves into Casagemas's old studio, 130*ter* bvd de Clichy. June: Exhibition of pastels at Sala Parés, Barcelona. 24 June: Two-man exhibition with Iturrino at Galeries Vollard, Paris. Meets Max Jacob during course of show. Start of Blue Period; circus, harlequin and maternity themes also introduced in his paintings.

1902 January: Returns to Barcelona. Rejoins circle at Els Quatre Gats, and about this time meets Julio Gonzales. 1–15 April: First exhibition at Berthe Weill, Paris. October: Returns to Paris with Sebastián Junyer-Vidal. Shares small room with Max Jacob at 87 bvd Voltaire. Period of poverty; many drawings as canvas is too expensive.

1903 January: Returns to Barcelona. Highly productive period.

1904 Spring: Leaves for Paris with Sebastián Junyent. Moves into 'Bateau-Lavoir', 13 rue Ravignan. Autumn: Meets Fernande Olivier, his mistress for next seven years, André Salmon, and soon Guillaume Apollinaire. Start of Rose Period.

1905 25 February–6 March: Rose period pictures shown at Galeries Serrurier, Paris, in three-man exhibition. Summer: Visits Holland at invitation of Tom Schilperoort. Autumn: Meets Gertrude and Leo Stein, and becomes a frequent visitor at their salons. 18 October: Opening of Salon d'Automne, at which 'scandal' of Fauves erupts.

1906 March: Vollard buys most of Rose Period canvases. Spring: Meets Matisse through the Steins, and soon Derain. Before May: Sees Louvre exhibition of Iberian sculptures recently excavated from Osuna. May: Leaves with Fernande for Barcelona. They spend the summer in Gosol, in the Pyrenees. Works become stylized under influence of Iberian figures. 22 October: Death of Cézanne.

1907 Late April–May: Begins work on painting later known as *Les Demoiselles d'Avignon* (Museum of Modern Art, New York); final state early July. May or June: Visits ethnographic museum (Trocadéro); sees and is soon influenced by African sculptures there. Summer: Meets Daniel-Henry Kahnweiler. October or November: Meets Braque through Apollinaire.

1908 September: Braque, under influence of *Demoiselles*, submits Cézannesque but highly abstract landscapes to Salon d'Automne. Matisse, on jury, reportedly says he is 'making little cubes'. Later the term 'Cubist', coined by Vauxcelles, comes into use. November: Gives banquet honouring the Douanier Rousseau.

1909 Spring–Summer: Goes to Spain with Fernande, returning to Horta de Ebro. Most crucial and productive period during which Analytic Cubism is first fully defined. Autumn: Returns to Paris and moves to 11 bvd de Clichy.

1910 April–May: 4 works shown at gallery Müvészház, Budapest. May: Exhibition at Galerie Notre-Dame-des-Champs, Paris. Late June: Travels to Cadaqués with Fernande; later joined by Derain and his wife. Start of 'high' Analytic Cubism. 1–15 September: With Braque, shows at Galerie Thannhauser, Munich (3 works). 2 September: Death of the Douanier Rousseau. Early September: Returns to Paris. 8 November–15 January 1911: Included in *Manet and the Post-Impressionists* exhibition at Grafton Galleries, London, organized by Roger Fry.

1911 February: Kahnweiler publishes *Saint-Matorel* by Max
 Jacob with 4 etchings by Picasso.
 28 March–5 April: Exhibition at '291', Little Galleries
 of the Photo-Secession, New York; first American show.
 Early July: Travels to Céret in the French Pyrenees;
 Fernande, Max Jacob and Braque arrive early August.
 Autumn: Meets Eva Gouel (Marcelle Humbert) at the Steins;
 she soon becomes his mistress.

1912 January–May: Works exhibited in Moscow, Munich,
 Barcelona, London (Stafford Gallery), Berlin and Cologne.
 Spring: Creates *Guitar* (Museum of Modern Art, New York),
 a three-dimensional counterpart of Cubist painting.
 May: Makes first collage, *Still life with chair caning*.
 18 May: Leaves with Eva for Céret, but later settles in
 Sorgues; joined by the Braques in July. Transition to
 Synthetic Cubist work.
 October: Moves into new studio at 242 bvd Raspail with Eva.
 Autumn: Makes his first *papiers collés*.
 18 December: Letter of contract with Kahnweiler.

1913 February: First large retrospective, Galerie Thannhauser.
 17 February–15 March: *International Exhibition of Modern
 Art*, 69th Regiment Armory, New York (8 works).
 17 March: Publication of Apollinaire's *Les peintres
 cubistes: Méditations esthétiques*.
 Mid-march: Departs for Céret with Eva and Max Jacob.
 3 May: Death of father in Barcelona. Attends funeral.
 August: Finds new flat at 5^bis rue Schoelcher, Paris.
 Returns to Céret and is joined by Juan Gris and his wife.
 End of year: Vladimir Tatlin visits his studio.

1914 2 March: 12 works included in 'Peau de l'Ours' auction.
 Summer: With Eva in Avignon. Produces many drawings in
 styles ranging from naturalistic to Cubist and 'Surrealist'.

1915 Spring: Eva's health starts to deteriorate.
 November: Léonce Rosenberg begins to sell Picasso's
 pictures in absence of Kahnweiler.
 December: Varèse brings Jean Cocteau to visit the studio.
 14 December: Eva dies.

1916 5 February: Cabaret Voltaire opens in Zurich; beginning
 of Dada movement. Picasso contributes to first and only
 issue of *Cabaret Voltaire* in June.
 Late May: Introduced to Serge Diaghilev by Cocteau.
 June or July: Moves to Montrouge (Seine).
 July: First exhibition of *Les Demoiselles d'Avignon* at
 Salon d'Antin, Paris, organized by André Salmon.
 24 August: Agrees to design décor for *Parade*, a ballet
 for Diaghilev's Ballets Russes with scenario by Cocteau,
 music by Erik Satie and choreography by Léonide Massine.
 31 December: Helps to organize banquet in honour of
 Apollinaire on occasion of publishing *Le Poète assassiné*;
 Picasso was model for character of the artist.

1917 16 January: Visits family in Barcelona.
 17 February: With Cocteau leaves for Rome to work on
 Parade with Ballets Russes. Meets Stravinsky, Bakst and
 Olga Koklova. Visits Naples, Pompeii and Florence.
 18 May: *Parade* opens at Théâtre du Châtelet, Paris.
 Beginning of June: In love with Olga, follows Ballets
 Russes to Madrid and Barcelona.
 November: Returns to Montrouge with Olga.

1918 23 January–15 February: Exhibition *Matisse-Picasso*,
 Galerie Paul Guillaume, Paris; preface by Apollinaire.
 Spring: Moves to Hôtel Lutétia.
 18 May: Meets Marcel Proust and James Joyce.
 12 July: Marries Olga. They spend honeymoon in Biarritz.
 Late September: Returns to Paris.
 9 November: Apollinaire dies of Spanish influenza, two
 days before Armistice is signed.
 Mid-November: Moves to 23 rue La Boëtie.

1919 April or May: Joan Miró visits studio.
 Early May: Leaves for London to design *Le Tricorne* for
 Ballets Russes (music, De Falla; choreography, Massine).
 22 July: *Tricorne* opens at Alhambra Theatre, London.
 Late Summer: Holiday with Olga at Saint-Raphaël, on the
 Riviera. Works in Cubist and realist modes.
 20 October: Opening of exhibition at Galerie Paul
 Rosenberg, Paris (several shows there to 1939).
 December: Agrees to work with Diaghilev and Stravinsky
 on *Pulcinella*; opens at Paris Opéra, 15 May 1920.

1920 22 February: Kahnweiler returns from exile in Switzerland;
 during year he publishes *Der Weg zum Kubismus*, and in
 September opens new gallery.
 Summer: Spent at Juan-les-Pins with Olga (as also in
 1924, 1925, 1926, 1930 and 1931).

1921 4 February: Birth of son Paulo.
 April: Publication in Munich of Maurice Raynal's *Pablo
 Picasso*, the first monograph on the artist.
 Summer: In Fontainebleau with Olga and Paulo. Figures in
 paintings become increasingly classical and monumental.

1922 Beginning of year: Jacques Doucet buys *Les Demoiselles
 d'Avignon* at urging of André Breton and Louis Aragon.
 Summer: Spent in Dinard (Brittany) with Olga and Paulo.
 20 December: Cocteau's *Antigone* with Picasso décor opens.

1923 Summer: Spent with Olga and Paulo in Cap d'Antibes, where
 they are joined by his mother. Meets André Breton.

1924 18 June: *Mercure* opens in Paris with décor and costumes
 by Picasso, music by Satie, choreography by Massine; some
 Surrealists protest at his involvement with 'aristocratic'
 event, but Breton and others defend Picasso.
 20 June: *Le Train Bleu* with drop curtain by Picasso opens.
 October: Breton's *Manifeste du surréalisme* published.
 December: Founding of review *La Révolution surréaliste*;
 Picasso is included in the first issue.

1925 1 March: Death of Ramon Pichot.
 March–April: Visits Monte Carlo with Olga and Paulo.
 June: Completes *The Dance* (Tate Gallery).
 1 July: Death of Erik Satie.
 July: Breton publishes 'Le Surréalisme et la Peinture',
 with first reproduction of *Les Demoiselles d'Avignon*.
 14 November: Opening of *La Peinture Surréaliste*, Galerie
 Pierre, Paris; in this first group exhibition of Surrealist
 work Picasso shows Cubist pictures.

1926 January: First issue of *Cahiers d'Art*, founded by
 Christian Zervos, with whom a long friendship begins.
 October: Visits Barcelona.
 Studio theme emerges in his work.

1927　11 January: Meets 17-year-old Marie-Thérèse Walter;
six months later they become lovers.
11 May: Death of Juan Gris.
Summer: Spent at Cannes with Olga and Paulo.
Winter: Makes first etching for Balzac's *Le Chef d'oeuvre
inconnu* commissioned by Vollard; published 1931.
27 December: Exhibition at Galerie Pierre, Paris, opens.

1928　1 January: First appearance of Minotaur theme in his work.
Beginning of year: Models *Bather (Metamorphosis I)*, first
three-dimensional sculpture since 1914.
March: Renews acquaintance with Julio Gonzales. By May,
is frequenting his studio to learn welding technique.
Summer: Spent at Dinard with Olga and Paulo; also secretly
settles Marie-Thérèse there.

1929　Spring: Salvador Dali's first visit to Picasso.

1930　18 January–2 March: *Painting in Paris*, first exhibition
at Museum of Modern Art, New York (14 works by Picasso).
March: Group exhibition of collages at Galerie Goëmans,
Paris, which includes Picasso; preface by Aragon.
April: Special number of *Documents* devoted to Picasso.
September: Series of etchings for Ovid's *Metamorphoses*
commissioned by Albert Skira; published 1931.
Autumn: Marie-Thérèse installed at 44 rue La Boëtie.

1931　April: Major retrospective, *Thirty Years of Pablo Picasso*,
Alex Reid & Lefevre, London.
May: Takes possession of château de Boisgeloup (bought in
June 1930); converts stable into sculpture studio. Models
in clay and plaster and continues to weld.

1932　16 June–30 July: Major retrospective at Galeries Georges
Petit, Paris, selected by Picasso; travels to Kunsthaus,
Zurich. Zervos publishes special number of *Cahiers d'Art*
to coincide with show. Meets Brassaï during show.
Summer: Olga and Paulo stay at Juan-les-Pins, while
Picasso apparently spends summer at Boisgeloup.
October: Zervos publishes first volume of Picasso
catalogue raisonné; 33 volumes will appear, 1932–78

1933　1 June: First issue of *Minotaure*, named by André Masson
and Georges Bataille; Picasso makes collage for cover.
Summer: July spent at Cannes with Olga and Paulo; they go
on to Barcelona, returning to Paris early September.
Autumn: Fernande Olivier publishes her memoirs, *Picasso
et ses amis*. Bernhard Geiser publishes *Picasso, peintre-
graveur*, catalogue raisonné of engravings and lithographs.

1934　Late August: Holiday in Spain with Olga and Paulo;
visits museum of Catalan art, Barcelona.

1935　20 February–20 March: Exhibition of 1912–14 *papiers
collés* at Galerie Pierre, Paris; catalogue by Tzara.
March: Meets Roland Penrose.
Spring: Makes most ambitious etching to date, the
Minotauromachy.
May: Stops painting until spring of following year.
June: Pregnancy of Marie-Thérèse becomes known. Olga
moves with Paulo to Hôtel California.
5 October: Marie-Thérèse gives birth to Maïa.
12 November: Jaime Sabartés returns to Paris from South
America and starts to handle Picasso's business affairs.

1936　January: Beginning of long friendship with Paul Eluard.
18 February: Opening of retrospective exhibition at Sala
Esteva, Barcelona.
2 March–19 April: Included in exhibition *Cubism and
Abstract Art*, Museum of Modern Art, New York, organized
by Alfred H. Barr Jr (32 works 1907–29).
25 March: Secretly departs with Marie-Thérèse and Maïa
for Juan-les-Pins, returning to Paris in early May.
18 July: Outbreak of Spanish Civil War. His anti-Franco
position is recognized by the Republicans, who name him
Director of the Prado Museum.
Early August: Departs for Mougins, on the Riviera. Begins
seeing Dora Maar, a photographer, later his mistress.
Autumn: Abandons studio at Boisgeloup, and at Vollard's
invitation works at his house at Le Tremblay-sur-Mauldre.
During the year: Exhibition at Zwemmer Gallery, London.

1937　January: With Dora Maar's help, finds new studio at
7 rue des Grands Augustins.
Republican government invites him to paint a mural for
the Spanish Pavilion at the Paris World's Fair.
February-early March: Works at Le Tremblay-sur-Mauldre.
26 April: German planes bombard Basque town of Guernica.
1 May: Begins sketches for Spanish Pavilion mural –
theme of Guernica bombardment. *Guernica* installed in
Pavilion mid-June; Pavilion inaugurated 12 July.
Summer: Special issue of *Cahiers d'Art* devoted to *Guernica*.
July–September: Stays at Mougins with Dora Maar.
Mid-October: Travels to Switzerland. Visits Paul Klee.
1–20 November: Exhibition *20 Years in the Evolution of
Picasso, 1903–1923* at Jacques Seligmann & Co, New York;
the Museum of Modern Art acquires *Les Demoiselles
d'Avignon* from exhibition.
19 December: *New York Times* publishes a statement by
Picasso defending the Spanish Republican government's
protection of Spain's art treasures.
Two exhibitions during 1937 at Zwemmer Gallery, London.

1938　Summer: Spent at Mougins with Dora Maar.
4–29 October: Exhibition of *Guernica* and studies at New
Burlington Galleries, London, under auspices of National
Joint Committee for Spanish Relief, organized by Roland
Penrose. Works subsequently shown at Whitechapel Art
Gallery, London, and in Leeds and Liverpool.
Winter: Confined to bed with severe attack of sciatica.

1939　13 January: Death of Picasso's mother in Barcelona.
17 January: 33 recent works shown at Paul Rosenberg's,
Paris; in March, 32 are shown at Rosenberg & Helft, London.
26 January: Barcelona surrenders to Franco.
5–29 May: *Guernica* and studies exhibited at Valentine
Gallery, New York (where he had shown several times since
1931) for benefit of Spanish Refugee Relief Campaign.
May–June: Exhibition *Picasso in English Collections* at
London Gallery; catalogue edited by E. L. T. Mesens and
Roland Penrose.
22 July: Death of Vollard. Picasso attends funeral.
Summer: Holiday with Dora in Antibes as guests of May Ray.
3 September: Britain and France declare war on Germany.
Autumn: Travels between Royan and Paris.
15 November–7 January 1940: Major retrospective *Picasso:
Forty Years of His Art*, including *Guernica* and studies,
Museum of Modern Art, New York, organized by Alfred H.
Barr Jr. Exhibition travels to several American cities.

1940 Continues to travel between Royan and Paris.
14 June: Germans enter Paris and, nine days later, Royan.
Autumn: Abandons apartment at rue La Boétie for duration of war and lives in studio at rue des Grands Augustins.

1941 14–17 January: Writes *Le Désir attrapé par la queue* (Desire Caught by the Tail), a farcical play, first performed 19 March 1944, at a reading organized by Michel and Louise Leiris.
Spring: Marie-Thérèse and Maïa return to Paris from Royan and settle in apartment on bvd Henri IV which Picasso visits at weekends.
Late in year: Converts bathroom of rue des Grands Augustins studio into sculpture studio.

1942 27 March: Death of Julio Gonzales. Picasso attends funeral.

1943 February–March: Makes sculptural assemblages from found objects.
May: Meets painter Françoise Gilot. By November she appears in his drawings.

1944 5 March: Death of Max Jacob in concentration camp.
Mid-August: Moves to bvd Henri IV to be with Marie-Thérèse and Maïa.
25 August: Liberation of Paris. Returns to studio on rue des Grands Augustins.
Autumn: Reunion with Eluard, Aragon and other Resistance friends.
5 October: Announces that he has joined Communist party.
7 October: Opening of Salon d'Automne ('Salon de la Libération'). Special gallery set aside to show Picasso's work; it is the first Salon in which he has participated. Demonstrations against him at the gallery, but National Writers' Committee circulates petition in his support.

1945 7 May: Germany surrenders.
11 May: André Malraux visits Picasso's studio.
15 June: Ballets des Champs-Elysées perform *Le Rendez-vous*, for which Brassaï, who does the décor, persuades Picasso to design the curtain.
20 June–18 July: Exhibition *Picasso Libre*, Galerie Louis Carré, Paris.
July: Leaves for Cap d'Antibes with Dora Maar. Buys house at Ménerbes for her. Returns to Paris in August.
2 November: In studio of Fernand Mourlot makes first of more than 200 lithographs he will do here over next three and a half years.
December: Exhibition of paintings by Picasso and Matisse at Victoria and Albert Museum; foreword by Zervos.
26 November: Reunited with Françoise.

1946 15 February–15 March: Participates in exhibition *Art et Résistance* at Musée National d'Art Moderne, Paris.
Mid-March: Joins Françoise in Golfe-Juan. Visits Matisse in Nice.
Late April: Returns to Paris with Françoise. She begins to live with him.
Early July: With Françoise stays in Ménerbes, then Cap d'Antibes and Golfe-Juan.
27 July: Death of Gertrude Stein.
August: Begins work on decoration of museum in Palais Grimaldi, Antibes, later renamed Musée Picasso.
Late November: Returns to Paris with Françoise.

1947 May: Donates 10 paintings to the Musée National d'Art Moderne, his first works in a French public collection.
15 May: Birth of Françoise's first child, Claude.
June: Leaves for Golfe-Juan with Françoise and Claude.
August: Begins to make ceramics in Vallauris, a village he and Dora Maar had discovered together in 1936.
Except for a brief visit to Paris, spends winter in Midi.

1948 Documentary film *Visite à Picasso* shot in Vallauris and at Musée Picasso in Antibes; produced by Paul Haesaerts.
Summer: Moves to La Galloise, above Vallauris, with Françoise.
25 August: Accompanied by Eluard, attends Congress of Intellectuals for Peace in Wroclaw, Poland, at invitation of Ilya Ehrenburg. Stays for two weeks.
Early September: Returns to Vallauris, then to Paris.
November: Exhibition of 149 ceramics at Maison de la Pensée Française, Paris.

1949 January: Publication of *Les Sculptures de Picasso*, with essay by Kahnweiler and photographs by Brassaï.
February: Aragon chooses lithograph of 'dove' for poster announcing Peace Congress to open in Paris in April.
19 April: Birth of daughter Paloma.
Spring: Returns to Vallauris.

1950 6 August: One of three casts of *Man with a sheep* (1944) placed in main square in Vallauris.
October: Attends 2nd World Peace conference in Sheffield.
November: Receives Lenin Peace Prize.
November–January 1951: Exhibition *Picasso: Sculptures, Dessins* at Maison de la Pensée Française, Paris; catalogue preface by Aragon.

1951 February: Returns to Paris from Vallauris.
Summer: Evicted from apartment at rue La Boétie; takes new space in 7 rue Gay-Lussac. Returns to Vallauris.
Winter: Spent in Paris with Françoise.

1952 April: Outraged by war in Korea, decides to decorate a 14th-century chapel in Vallauris as a temple of peace; installed 1954.
Summer: Spent in Vallauris; returns alone to Paris in late October as relationship with Françoise deteriorating.
18 November: Death of Eluard. Attends funeral.
Early December: Returns to Vallauris.

1953 Mid-January: Leaves for Paris.
30 January–9 April: Exhibition *Le Cubisme, 1907–1914* at Musée National d'Art Moderne, Paris; *Les Demoiselles d'Avignon* shown in Europe for first time since 1937.
Mid-February: Returns to Vallauris.
March: Françoise takes Claude and Paloma to Paris.
May–July: Major retrospective at Galleria Nazionale d'Arte Moderna, Rome, and in Milan; further retrospectives during year at Lyons (June) and São Paulo, Brazil (December–February 1954).
Summer: Françoise returns to Vallauris with her children.
Mid-August: With Maïa, arrives in Perpignan. Meets Jacqueline Roque.
Mid-September: Returns to Vallauris. Françoise leaves him at end of month, taking Claude and Paloma to Paris. Picasso takes up residence in rue des Grands Augustins.
November: Returns to Vallauris.

1954 April: Meets Sylvette David; makes many portraits of her.
8 September: Death of Derain.
Summer: Visits Perpignan, then returns to Paris and begins to live with Jacqueline.
3 November: Death of Matisse.
December: Starts series based on Delacroix's *Femmes d'Alger*.

1955 11 February: Death of Olga at Cannes.
May: Stays at Roussillon, Provence, with Jacqueline.
May–June: Exhibition *Picasso: 63 Drawings 1953–54, 10 Bronzes 1945–53* at Marlborough Fine Art Ltd, London.
June–October: Major retrospective *Picasso: Peintures 1900–1955* at Musée des Arts Décoratifs, Paris, organized by Maurice Jardot; modified version travels in Germany.
Summer: Henri-Georges Clouzot films *Le Mystère Picasso*.
Buys villa 'La Californie' overlooking Cannes.

1956 25 October: 75th birthday celebration in Vallauris.
Occasion also honoured in Moscow, where Ilya Ehrenburg organizes exhibition of Russian state-owned pictures.
22 November: With Edouard Pignon, Hélène Parmelin and seven others writes to Central Committee of French Communist party to protest against Russian intervention in Hungarian revolt; letter published in *Le Monde*.

1957 March–April: Opening exhibition at Kahnweiler's Galerie Louise Leiris in new quarters.
4 May–8 September: *Picasso: 75th Anniversary Exhibition* at Museum of Modern Art, New York.
6 July–2 September: Exhibition of drawings, gouaches and watercolours, 1898–1957, at Musée Réattu, Arles; catalogue by Douglas Cooper.
Autumn: Commissioned by UNESCO to decorate delegates' lounge of Paris headquarters; completed 29 March 1958.

1958 September: Buys 14th-century château de Vauvenargues, near Aix-en-Provence, where he works from 1959 to 1961.

1959 5 June: Dedication of monument to Apollinaire in garden of Saint-Germain-des-Prés, Paris.
Autumn: Experiments with linocuts, a medium he will work with repeatedly in 1962–3.

1960 6 July–18 September: Retrospective exhibition at Tate Gallery, organized by Arts Council of Great Britain; catalogue by Roland Penrose.
27 July: Museo Picasso, Barcelona, given formal constitution; opens to public March 1963.
15 October: Begins cartoons for decoration of Barcelona College of Architects; unveiled April 1962.
November: Designs large-scale sheet-metal sculpture from cut-and-folded paper encouraged by dealer Lionel Prejger; continues to work in medium over next three years.

1961 2 March: Marries Jacqueline Roque at Vallauris.
June: Moves into new villa, 'Notre-Dame-de-Vie', in hills above Cannes near Mougins.

1962 26 January–24 February: Exhibition of paintings from Vauvenargues, 1959–61, at Galerie Louise Leiris, Paris.
25 April–12 May: Exhibition *Picasso: An American Tribute*, cooperative venture held at nine New York galleries; a total of 309 works shown; catalogue by John Richardson.
1 May: Awarded Lenin Peace Prize for second time.

1963 31 August: Death of Braque.
11 October: Death of Cocteau.

1964 11 January–16 February: Retrospective *Picasso and Man* at Art Gallery of Toronto, organized by Jean Sutherland Boggs; catalogue by Boggs, John Golding, Robert Rosenblum and Evan H. Turner. Travels to Montreal.
15 January–15 February: Exhibition *Peintures 1962–1963* at Galerie Louise Leiris, Paris.
Spring: Françoise Gilot publishes chronicle *Life with Picasso* in collaboration with Carlton Lake; the book creates a rift between Picasso and his children.
23 May–5 July: Retrospective at National Museum of Modern Art, Tokyo. Travels to Kyoto and Nagoya.
During year: Completes model for giant sculpture for Chicago's new Civic Center; final version unveiled 1967.

1965 22 June–15 September: Exhibition *Picasso et le théâtre* at Musée des Augustins, Toulouse, organized by Denis Milhau; catalogue by Jean Cassou, Milhau, Robert Mesuret and Douglas Cooper.
November: Becomes ill and goes to Paris for ulcer operation; it is his last trip there.

1966 28 September: Death of Breton.
November: Malraux opens exhibition *Hommage à Pablo Picasso* organized by French government under direction of Jean Leymarie at Grand Palais and Petit Palais, Paris.

1967 Refuses French Legion of Honour.
Spring: Evicted from studio on rue des Grands Augustins.
9 June–13 August: Major exhibition of sculpture and ceramics at Tate Gallery, organized by Roland Penrose. Exhibition travels to New York.

1968 13 February: Death of Sabartés.
18 December–1 February 1969: Exhibition of 347 engravings (started the previous March) at Galerie Louise Leiris, Paris.

1969 April: 16 of 347 engravings published in *El Entierro del Conde de Orgaz* for which he also composes the text.

1970 January: Picasso family in Barcelona donates all paintings and sculptures in its possession to Museo Picasso.
1 May: Exhibition of recent works opens at Palais des Papes, Avignon, organized by Yvonne Zervos; catalogue by Christian Zervos.
12 May: Bateau-Lavoir destroyed by fire.
12 September: Death of Christian Zervos.

1971 23 April–5 June: Exhibition of 194 drawings made between 15 December 1969 and 12 January 1971 at Galerie Louise Leiris, Paris.
25 October: Picasso's 90th birthday. Selection of works placed on exhibition at Grande Galerie of the Louvre.

1972 Works at Mougins, chiefly on drawings and prints.
December: Exhibition of 172 drawings from 21 November 1971 to 8 August 1972 at Galerie Louise Leiris, Paris.

1973 24 January–24 February: Exhibition of 156 engravings from end 1970 to March 1972 at Galerie Louise Leiris.
8 April: Death of Pablo Picasso at Mougins.
10 April: Burial in grounds of château de Vauvenargues.